REVELATION

Photography is a prolongation of the Incarnation.
Father Marcel Dubois, Jerusalem, 2001

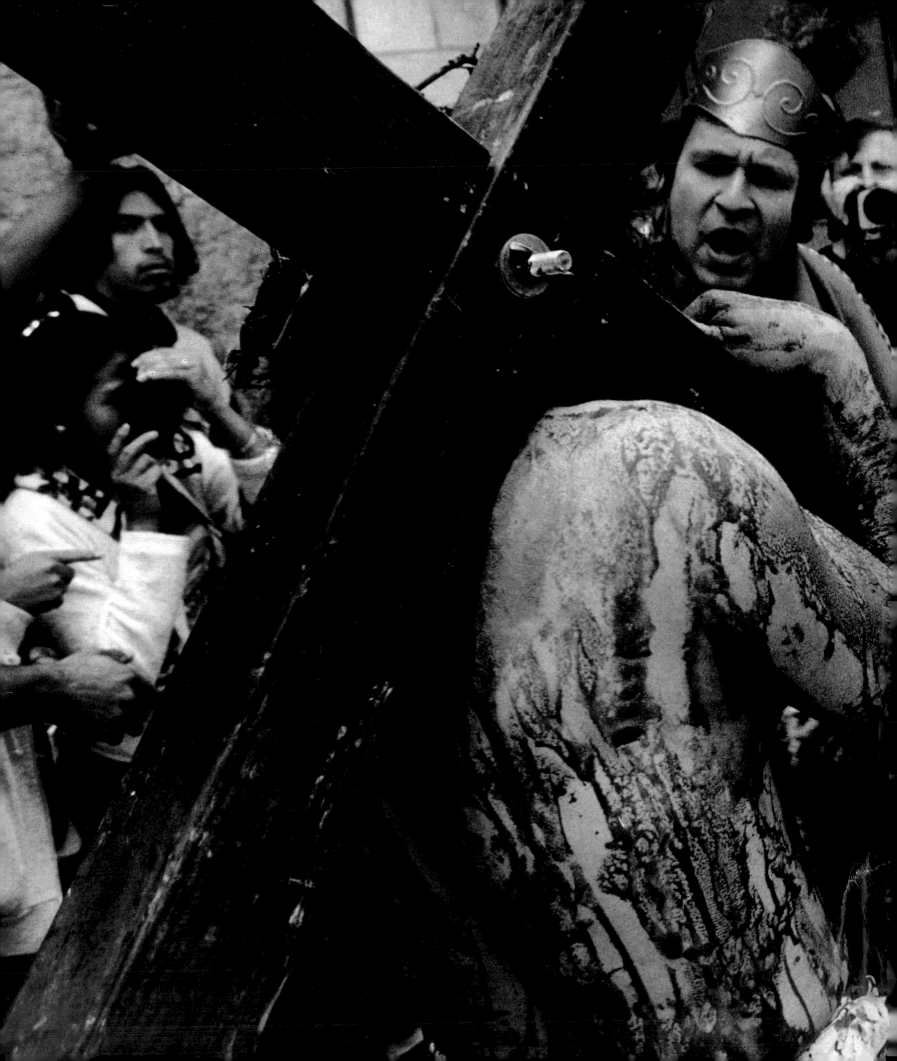

REVELATION

REPRESENTATIONS OF CHRIST IN PHOTOGRAPHY

NISSAN N. PEREZ

MERRELL

in association with

THE ISRAEL MUSEUM, JERUSALEM

First published 2003 by
Merrell Publishers Limited
42 Southwark Street
London SE1 1UN

in association with

The Israel Museum
Ruppin Street
91710 Jerusalem

Published on the occasion of the exhibition
Revelation: Representations of Christ in Photography

Exhibition itinerary

The Israel Museum, Jerusalem
22 May – 6 September 2003

British Library Cataloguing-in-Publication Data:
Perez, Nissan
Revelation : representations of Christ in photography
1.Jesus Christ – Art 2.Bible. N.T. – History of Biblical events 3.Photography, Artistic
I.Title II.Muzeon Yisrael
779.8'53

A catalogue record for this book is available from the Library of Congress

ISBN 1 85894 225 X

Jacket front: Annie Leibovitz, *The Sopranos*, 1999 (p. 147), detail
Jacket back: Giuseppe Enrie, *The Shroud of Turin*, 1931 (p. 30)
Pages 2–3: Joel Kantor, *Untitled*, 1999, gelatin silver print,
lent by the artist, Jerusalem

Produced by Merrell Publishers
Designed by Maggi Smith
Edited by Kirsty Seymour-Ure, Laura Hicks and Malka Jagendorf

Image scanning by Panorama Imaging Technologies, Jerusalem
Printed and bound in Italy

CONTENTS

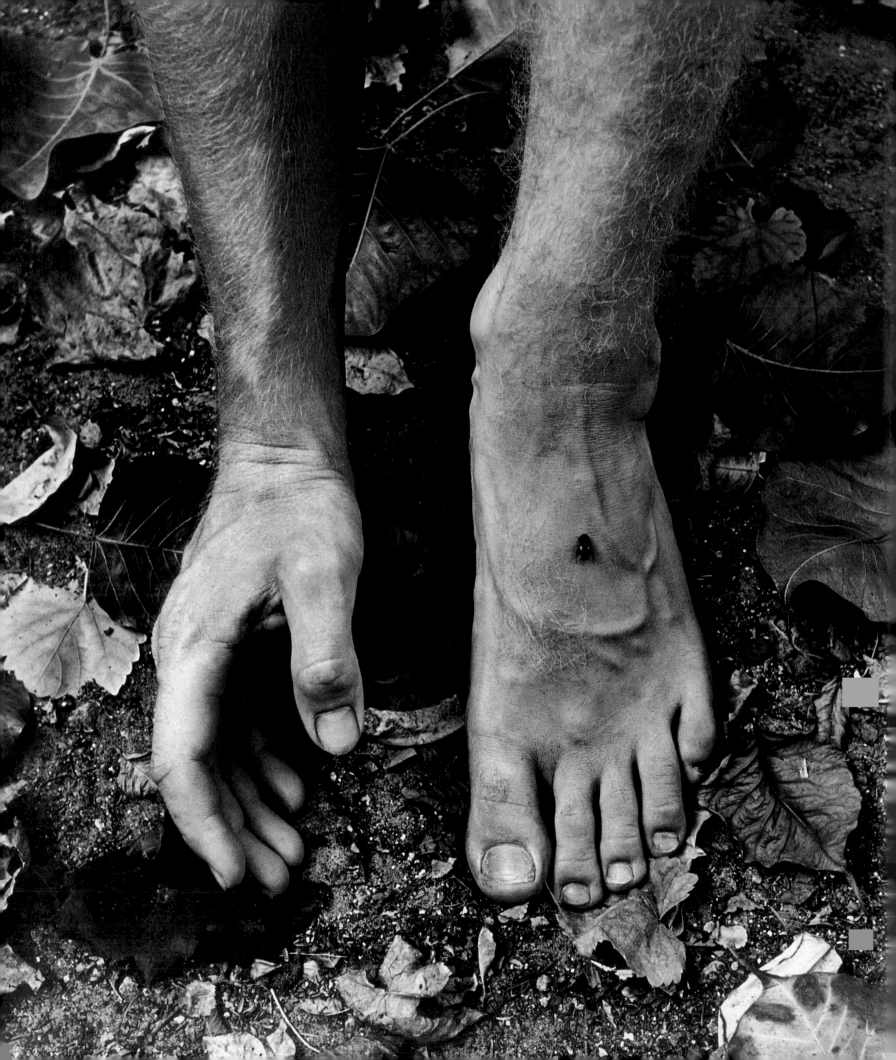

FOREWORD

From its very beginnings, photography developed and matured in the footsteps of other artistic media, painting in particular. Like the arts from which it took inspiration as to form and content, photography included in its repertoire many images with religious subject-matter. Yet this specific category of photographic imagery entails a fundamental paradox. By definition, photography is capable of depicting only tangible or visible realities, and the photographic artist, when attempting to illustrate ideas or historical events, must first create or re-create the scene to be photographed, in effect staging a *tableau vivant*.

The early history of photography includes a bounty of images relating to the life of Jesus and depicting events from the New Testament that were realized by this method. These examples range from individual self-portraits of photographers posing as Jesus or saints, to entire casts of characters acting out scenes from the Passion, to images of signs and symbols, such as the attributes of Christ, which allude to his presence. As the medium of photography became more sophisticated, it offered new ways to depict Jesus and to represent scenes of saintly content, and this practice continues today as an important dimension of the broadening application of photographic techniques in contemporary art.

The exhibition *Revelation: Representations of Christ in Photography* and its accompanying publication are a first, pioneering effort to research a subject that has not previously been addressed in such depth. This book and exhibition are in some ways a bold undertaking, since they chart a course through a chapter in the history of photography that calls for a particularly sensitive and understanding treatment of their subject. The fact that many photographers today continue to create works using Christian religious imagery suggests that both artists and public remain keenly interested in this genre, supporting the hope that our work will foster further research in this topic in photography. Given our unique perspective from Jerusalem, in the Holy Land, which witnessed the birth of Christianity some 2000 years ago, we also feel that The Israel Museum, which has collections that range from the archaeology of biblical times to works of contemporary artists in such new media as photography, may be best suited to undertake a project such as this.

We are profoundly indebted to the museums, private collectors, scholars and researchers worldwide and artists whose works of art and ideas contributed immeasurably to this project. We also extend our gratitude to Carla Emil and Richard Silverstein, San Francisco, and to the donors to the Museum's Exhibition Fund: Ruth and Leon Davidoff, Alice and Nahum Lainer, Hanno D. Mott and Helen and Jack Nash, whose support ensured our full realization of the exhibition and this book. And finally, we are deeply grateful to Nissan N. Perez, Horace and Grace Goldsmith Curator of Photography, for his special insight into the subject and for his creative commitment in conceiving and realizing this undertaking, and to Associate Curator Yudit Caplan and many other members of the Museum staff who participated in this challenging enterprise.

James S. Snyder
Anne and Jerome Fisher Director
The Israel Museum, Jerusalem

PREFACE

The evolution of Christian thought has been mirrored in the gradual development of Western religious art over the last twenty centuries, culminating in contemporary artistic creation and photography. The creative process in art is frequently considered by the makers to be an act of faith, and by extension the artists themselves become comparable to the divine creator. Very often this state of mind leads, in a most natural way, to the use of art as a vehicle to criticize religion and express doubt.

Creating this book and its accompanying exhibition in the Holy Land, and especially in Jerusalem where everything started and where the spirit still remains, is like closing the circle once again between alpha and omega. *Revelation: Representations of Christ in Photography* looks back at the photographic tradition from its very beginning and highlights tendencies that have often been ignored in the current art discourse, partly as a result of unspoken prohibitions in the predominantly secular international art community and the controversial nature of religious commentary and interpretation, especially in contemporary art.

In the course of the development of photography, individual artists have often utilized religious imagery, and for some of them the final works have become milestones in the history of the medium. But, in spite of the large number of such images created, there has not as yet been a comprehensive survey of this fascinating and intriguing aspect of photography. One of the most probable reasons is the wide range of religious/emotional reactions that a thorough investigation of the subject and the exposition of the images might provoke.

A large majority of artists in the West have been brought up in a Christian culture. However, this book (and consequently the exhibition) is not a study of the artists' religious backgrounds; nor does it investigate the possible differences between artists of various Christian persuasions – for Catholics, for instance, the visual holds a valued place, and explicit imagery is at the basis of religious preaching, while for Protestants the word takes precedence over all other content. This project is a visual survey independent of any faith or religion, and refers rather to the representation of Christ as a universal symbol in a general context of art culture.

Throughout the history of photography, images with religious themes have been an integral, accepted part of the medium's creative arsenal, especially during the nineteenth century and later in pictorialism. The reservoir of sacred themes still continued to be tapped in the twentieth century, accelerating to a remarkable degree up to the twenty-first, as is evident in contemporary art and photography.

Many of the artists' works featured here are absolutely unrelated to one another conceptually and thematically, and the images and their conception sway between the sacred and the profane. Yet they all address scenes, signs and symbols directly related to the Christian spirit and belief, where emotion predominates. The selection excludes images of churches or sacred artefacts and, with very few exceptions, photographs of religious processions or related rituals that constitute straightforward documentation. The focus is mainly on images reflecting a subjective approach, an interpretation and an active artistic exploitation of the subject.

This has been a perilous adventure. When dealing with such sensitive issues as faith and religion it is extremely difficult to ensure that every viewer will see and understand the idea, and agree with the proposed line of thought and action. It is my hope that readers and viewers will concede that the objective was purely an artistic analysis of the phenomenon, with no disrespect or offence intended.

The research and subsequent stages leading to the realization of the project are the result of teamwork among countless friends, colleagues, collectors and other professionals, to all of whom I extend my deep gratitude.

Gérard Lévy, of Paris, from the very beginning became an ally, an accomplice and a constant inspiration in my quest for ideas, images and information. His infallible flair always guided the research in the right direction. As important were the input and support of: Anthony Bannon, Rochester NY; Pierre Bonhomme, Paris; Serge Bramly, Paris; Michèle Chomette, Paris; Verna Curtis, Washington, D.C.; Dr Bodo von Dewitz, Cologne; Father Marcel Dubois, Jerusalem; Susan Ehrens, Oakland; Roy Flukinger, Austin TX; Jeffrey Fraenkel, San Francisco; Jerry Gorovoy, New York; Greta Gruber, New York and Jerusalem; André Gunthert, Paris; David

Haberstich, Washington, D.C.; Françoise Heilbrun, Paris; Adina Kamien, Jerusalem; Amalyah Keshet, Jerusalem; Robert Koch, San Francisco; Patricia Landeau, Paris; Yves Lebrec, Paris; Anne Lyden, Los Angeles; Peter McGill, New York; Weston Naef, Los Angeles; Gael Newton, Canberra; Stephen Perloff, Langhorne; Prof. Adele Reinhartz, Ontario; Jean-Michel Ribettes, Paris; Leland Rice, Oakland; Julie Saul, New York; Arturo Schwarz, Milan; Bruce Silverstein, New York; Shlomit Steinberg, Jerusalem; and Stephen and Connie Wirtz, San Francisco.

An important part of the works included in this project comes from the permanent collection of photographs of The Israel Museum, Jerusalem. They were collected over the years thanks to the generosity of our friends and donors worldwide: Mr and Mrs Dan Berley, New York; Paul Blanc, San Francisco; The Gorovoy Foundation, New York; Lynn Honickman, New York; Israel Discount Bank Fund, Tel Aviv; Patti and Frank Kolodny, New Jersey; Jan van Leeuwen, Bennekom; Gérard Lévy, Paris; Loushy Art & Editions, Tel Aviv; Martin Pomp, New York; Alain and Evelyn Roth, Herzliya; Michael S. Sachs, Westport CT; Gary Sokol, San Francisco; and The Vera and Arturo Schwarz Collection of Dada and Surrealist Art.

I am grateful to the many private collectors who agreed to lend rare and unique images to the exhibition, including Susan Ehrens and Leland Rice, Oakland; Gale Anne Hurd, Los Angeles; Sir Elton John, London; Serge Kakou, Paris; Gérard Lévy, Paris; Jane Levy Reed, San Francisco; Bruce Silverstein, New York; and those who preferred to remain anonymous.

The unconditional cooperation of numerous international institutions and galleries as well as the generosity of many artists who agreed to lend their works was invaluable. Special thanks are due to: Marina Abramovic, Amsterdam; Ace Gallery, Los Angeles and New York; Akademie der Künste, Berlin, Stiftung Archiv; Freddy Alborta, La Paz; Manuel Alvarez Bravo, Mexico City; America–Israel Cultural Foundation, Tel Aviv; Aperture Foundation Inc., Paul Strand Archive, New York; Batya Apollo, Kibbutz Gonen; Arièle Bonzon, Lyon; Brent Sikkema, New York; Canadian Museum of Contemporary Photography, Ottawa; Toni Catany, Barcelona; John Demos, Thessaloniki; Direction du Patrimoine Photographique, Paris; John Dugdale, New York; Dvir Gallery, Tel Aviv; Ecole Nationale Supérieure des Beaux-Arts, Paris; Bill Eppridge, New York; Fondazione Sandretto Re Rebaudengo per l'Arte, Italy; Fraenkel Gallery, San Francisco; Galerie 1900-2000, Paris; Galerie Jérôme de Noirmont, Paris; Galerie Kamel Mennour, Paris; Galerie Le Réverbère, Lyon; Galerie Michèle Chomette, Paris; Galerie

Rabouan-Moussion, Paris; George Eastman House, Rochester NY; The J. Paul Getty Museum, Los Angeles; Institut Catholique de Paris, Bibliothèque de Fels; Julie Saul Gallery, New York; Joel Kantor, Jerusalem; Herlinde Koelbl, Munich; Les Krims, New York; Laurence Miller Gallery, New York; Jan van Leeuwen, Bennekom; Annie Leibovitz, New York; Peter and Shawn Leibowitz, New York; Library of Congress, Washington, D.C., Prints & Photographs Division; Maison Européenne de la Photographie, Paris; Estate of Robert Mapplethorpe, New York; Kurt Markus, Roundup MT; Ilan Mizrahi, Jerusalem; Sigal Mordechai, Tel Aviv; Musée d'Orsay, Paris; Efrat Natan, Jerusalem; National Gallery of Australia, Canberra; Universidad de Navarra, Pamplona, Legado Ortiz Echagüe, Fundación Universitaria de Navarra; University of Oregon, Eugene, Special Collections & University Archives; Orlan, Paris; Pace/MacGill Gallery, New York; Paula Cooper Gallery, New York; Pierre et Gilles, Paris; PPOW Gallery, New York; Bettina Rheims, Paris; Humberto Rivas, Barcelona; Robert Koch Gallery, San Francisco; Geno Rodriguez, New York; Russell Burrows, New York; The Saatchi Gallery, London; Schocken Collection, Tel Aviv; Andres Serrano, New York; Simcha Shirman, Tel Aviv; Shoshana Wayne Gallery, Santa Monica; Société Française de Photographie, Paris; Frederick and Frances Sommer Foundation; Stephen Wirtz Gallery, San Francisco; Boaz Tal, Tel Aviv; Throckmorton Fine Art, Inc., New York; TimePix Representing the Life Collection, New York; Dean Tokuno, Yuba City; Tübingen Universitätsbibliothek; W. Eugene Smith Black Star TimePix, New York; White Cube Gallery, London; Estate of David Wojnarowicz, New York; Pat York, Los Angeles; Kimiko Yoshida, Paris; Lilja Zakirova, Heusden a/d Maas; Natale Zoppis; and Dr Frederick Zugibe, New York.

I should also like to thank Prof. Ora Limor and my colleagues Suzanne Landau, Stephanie Rachum, Judith Spitzer and Yigal Zalmona, who took the time to read the texts and provide remarks, advice and constructive criticism, and Prof. Adele Reinhartz for contributing her essay 'Jesus on the Silver Screen', which significantly enriches this book.

This work could not have been realized without the dedication of Yudit Caplan, Associate Curator of Photography; Andrea P. Meislin, Special Research Associate; Ziva Haller; and, last but not least, Carmela Teichmann, Aviva Kat and the committed staff of The Israel Museum.

Special gratitude is due to James S. Snyder, director of The Israel Museum, for his faith in this project and his support throughout.

Nissan N. Perez
Horace and Grace Goldsmith
Curator of Photography
The Israel Museum, Jerusalem

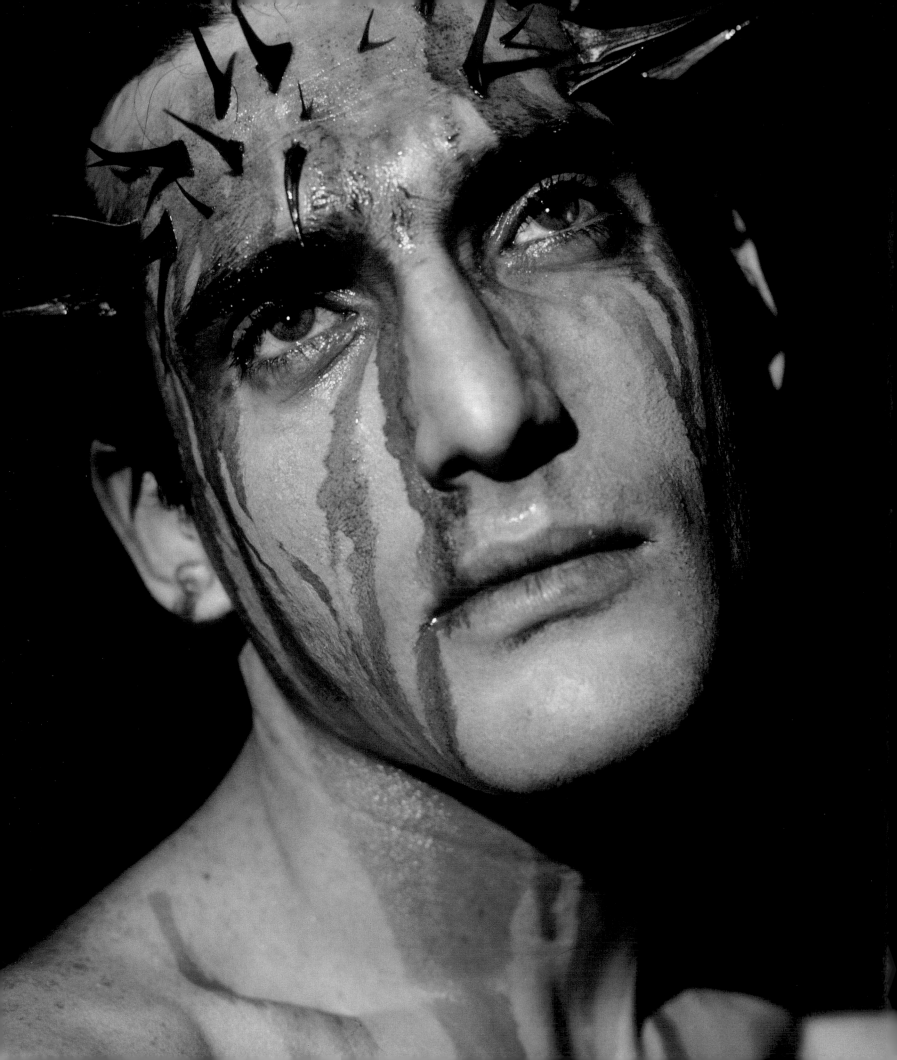

WHO DO YOU SAY I AM?

The Image of Christ in Photography

Nissan N. Perez

We, therefore, following the royal pathway and the divinely inspired authority of our Holy Fathers and the traditions of the Catholic Church (for, as we all know, the Holy Spirit indwells her), define with all certitude and accuracy that just as the figure of the precious and life-giving Cross, so also the venerable and holy images, as well in painting and mosaic as of other fit materials, should be set forth in the holy churches of God, and on the sacred vessels and on the vestments and on hangings and in pictures both in houses and by the wayside, to wit, the figure of our Lord God and Saviour Jesus Christ, of our spotless Lady, the Mother of God, of the honourable Angels, of all Saints and of all pious people.

The Second Council of Nicaea, 787[1]

If in the eighth century photography had already been a recognized means of image-making, the recommendations of the second Council of Nicaea in the year 787 regarding the creation of representations of the sacred figures would doubtless have included the camera art as part of the creative arsenal, taking advantage of its relatively low cost, ease of execution and immediacy, all of which allows for the mass production and fast dissemination of icons. Throughout history, and culminating during the Renaissance, Christian religious imagery has had a specific mission: to guide the devotion of the masses towards the objective set forth by the early Church, "For by so much more frequently as they are seen in artistic representation, by so much more readily are men lifted up to the memory of their prototypes, and to a longing after them … . For the honour which is paid to the image passes on to that which the image represents, and he who reveres the image reveres in it the subject represented."[2] It is almost a truism to say that Christian religious art, and especially painting, has had a greater influence on humankind and its culture than all the books on theology ever written.

The ideology of the Church and the principles it instituted and fostered made use of a logic opposite to Jean-Jacques Rousseau's axiom, formulated in the eighteenth century, which maintained that the less we see, the more we imagine. Since – in more than one sense – seeing is believing, by providing a plethora of images the Church to some extent inhibited independent thought and imagination. In the process "… the body [of Christ] has become a controlled and canonized vehicle of the divine … [and] has become a sort of ideograph".[3] The aim of the Church was to inundate the congregations of churchgoers and believers with explicit images endorsed by the religious establishment that would leave as little room as possible to individual imagination and interpretation. The importance given to artistic representations in Christianity is well expressed by Pope Gregory I who, at the end of the sixth century, declared that religious images were useful like the pictures in children's books, and that "painting can do for the illiterate what writing does for those who can read".[4] In this vein, photography could have become the perfect tool for the Church, since the physical similarity between subject and image, the photograph's straight relation to a tangible external reality, and the resulting confusion a photograph can create owing to the interchangeability of image and subject, could have had the power to quell any imaginative inclinations believers might have developed. For the artists of the times it was a matter of accepting historical, artistic and religious conventions and implementing them to the satisfaction of the local church for which the work had been commissioned. Naturally, over the ages, the basic character of the imagery and the symbolism changed and evolved in accordance with the times, the social and cultural conventions, and the specific needs of each era.

Besides being instrumental in the propagation of religious feeling among the masses, the ardent recommendation of the Council served two further purposes: to create a visible difference between Christianity and the other monotheistic religions, Judaism and Islam, which forbade the making of graven images in accordance with the Second Commandment; and to retort to the iconoclasts, who claimed that portraying Christ could not be permitted because, being the true image of God, he was "beyond description, beyond comprehension, beyond change, and beyond measure … [and therefore it was] illegitimate to portray in images",[5] and that, being spirit, God must be worshipped in spirit and truth (John 4:24).

The portrayal of Christ and the saints presented a problem and a challenge for even the most gifted artists. Although Vasari is notorious for his strong tendency to fictionalize, this situation is elegantly described in his account of Leonardo's *Last Supper*, "… which is a most beautiful and admirable work; to the heads of the Apostles in this picture the master gave so much beauty and majesty that he was constrained to leave that of Christ unfinished, being convinced that he could not impart to it the divinity which should appertain to and distinguish an image of the Redeemer … [therefore] there were still wanting to him two heads, one of which, that of the Saviour, he could not hope to find on earth, and had not yet attained the power of representing it to himself in imagination, with all that perfection of beauty and celestial grace which appeared to him to be demanded for the due representation of the Divinity incarnate."[6]

With its roots in France and England, and hence an invention deeply rooted in Christian culture, photography emerged in the realm of image-making, and unfolded from the mid-1800s in a very particular scientific, philosophical and artistic atmosphere. In the new era of scientific thought and materialistic culture influenced by Auguste Comte's positivism, by rationalism and by empiricism, the idea of a 'divine absolute' became less and less acceptable and credible, causing a distancing from questionable ideas and from texts considered unsubstantiated, such as the miracles recorded in the Bible. On a parallel path, Darwinism had an equally strong impact on the development of modern thought, challenging as it did the creation story in Genesis, which led to a questioning of dogmas and long-established religious values. Its repercussions extended well into the twentieth century. Just as the other visual art forms, especially painting, were in a period of transition from Romanticism to a more contemporary (and to some extent scientific) realism, so photography found itself in conflict with religious dogmatism, not only from the artistic/creative point of view in terms of what it depicted, and in what way, but also, as a modern method of image-making, in breaking with visual conventions and in harmonizing with the spirit of the times, which sought realism and the resulting mimetic truth.

Christian art is, of course, the visual rendition of theological thought. Yet, in the camera arts, the rhetoric of the photographic image differs greatly from that of conventional, classic sacred art, and this was especially noticeable at a time when traditional art was beginning to lose ground and impact – science, philosophy, the arts and thought in general began to drift away from religion as dogmas became less and less acceptable. As in the definition by the French cultural theorist Paul Virilio, the eighteenth century saw the end of the era of formal logic tied to the aesthetic of such traditional art forms as painting, print-making and architecture, while the nineteenth century heralded the beginning of the age of dialectic logic as expressed in the visual renditions of the new technologies of photography and, later, cinema.

This state of affairs does not necessarily imply the end of religion or the death of religious painting in the nineteenth century, but rather the dawn of a different spirit and manner of communicating such sentiments and ideas, as expressed in the groundbreaking works of Nicolas Poussin, Caspar David Friedrich, Eugène Delacroix, William Holman Hunt and Paul Gauguin.[7] Since the 'imitation of art' factor that was endemic to early photography lurks persistently in the background, it was natural for early camera artists to measure from the very beginning the question of religious representations, primarily in Christianity, applying the new technique to a subject with an eighteen-century-long artistic tradition of creativity and visualization.

As a consequence, a new question arises concerning the character of photographic depiction and representation of religious subjects in Christianity (no such tradition exists in Judaism and Islam). It seems that such an artistic practice engenders or inspires a Promethean approach in the depiction of Christ and the saints, as opposed to the traditional approach. The photographic manoeuvre implies, to a large extent, not only the dismantling of the traditional mechanism of established rules and practices of depiction and representation but also a different reading of the final work. In interpreting and staging anew scenes from the Christian Bible – creating the tangible reality indispensable to the production of a photograph – the camera artists almost claim to have understood better than others the meaning of the Gospels. They seem to have stolen the fire of divine love, passion and suffering and bestowed it upon their models or, in the case of self-portraits, upon themselves. It is as if through suffering (or mimicking suffering!) they attain immortality by means of the photographic image. However, the claim to immortality, or at least to artistic fame, is often rudely castigated by critics, resulting in a symbolic fall, similar to that of Jesus, a Promethean figure too, who was apparently severely punished by his compatriots and God alike for his then revolutionary religious and social convictions.

In the beginning

During the formative era of photography many nineteenth-century intellectuals such as Charles Baudelaire condemned the new medium as a worthless, mechanical imaging practice, the last resort of uninspired and untalented would-be artists. Such an atmosphere was certainly not favourable to the creation of photographs with a certain degree of artistic pretence that would transcend mere documentation, and very few people showed real enthusiasm for the new tool. While this was the widespread attitude in continental

Europe, across the Channel John Ruskin was one of the fervent advocates of photography, calling the daguerreotype an antidote to "all the mechanical poison that this terrible nineteenth century has poured upon men".[8] However, the general lack of enthusiasm explains the very few examples of religion-orientated photographs from these years – and this at the height of studio work and the creation of genre scenes, a practice that was most propitious to the creation of religious scenes and biblical tableaux.

Between the affirmation in Genesis that God created man in his own image and John's claim that "No man hath seen God at any time" (John 1:18), for the last two millennia artistic licence has enabled many to imagine and create their own interpretation of Jesus Christ, who for Christians is God incarnate. Since during the early years of the medium there was no established photographic tradition and there were no examples to follow, it was only natural for photographers to rely on the canons and traditions of classic religious painting, just as they copied other principles of image-making such as those of portraiture and landscape. So, "Even sacred subjects suitable only for the artist with brush and pencil were attempted. Madonnas and saints more convincing than Mrs. Cameron's appeared."[9] Except for some individual cases, this practice has gone quite unnoticed (or been intentionally ignored?) by critics and historians. Many camera artists "… depicted Entombments and Crucifixions – extraordinary aberrations of taste when arranged for exhibition purposes, but neither public nor photographers realized that, however accomplished, such productions completely failed to further the art of photography".[10]

The Holy Bible offers nowhere a description of the physical appearance of Jesus. Although the tabloid *Weekly World News* (fig. 1) claims otherwise, there are no mechanically produced images of the face of Jesus prior to nineteenth-century photography, except for those divine imprints known as the *acheiropoieton* (that is, not made by human hand), supposedly created through direct contact with the body of Christ. The best known is the legendary 'true likeness' on St Veronica's Sudarium[11] depicted by such masters of painting as the seventeenth-century Spanish artist Francisco de Zurbarán and extensively reproduced over the centuries (fig. 2). Set chronologically earlier in the life of Jesus and lesser known, but more popular in the Eastern Orthodox Church, is the myth of the Mandylion of Edessa, a rival of the Veronica. According to Church history, it is believed that the likeness was created under equally miraculous circumstances, albeit in a deliberate manner, as Christ washed his face and dried it on the cloth, thus leaving an imprint on it that was also meant to be a message. No trace survives of the legendary Veronica or Mandylion, and what remains today are only imaginary depictions and artistic interpretations of the objects, based mostly on oral and partly on visual tradition.

Fig. 1
Weekly World News, 9 November 1999

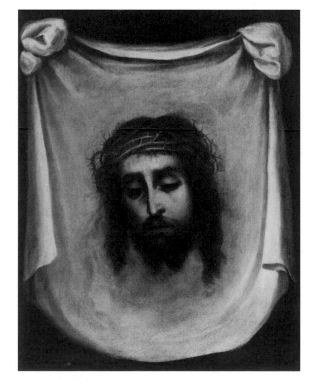

Fig. 2
Spanish School, 17th century, *The Veil of Veronica*, oil on canvas, The Israel Museum Collection, Jerusalem, gift of David Wapinsky, New York, to American Friends of The Israel Museum

Nowadays, the only relic believed to be of sacred origin and still in existence is the Holy Shroud of Turin (pp. 28–30). Although its roots and dates are contested and controversial,[12] it is the only visible chemical/mechanical graven image of a human figure that predates photography.[13] The likeness is believed to be that of Christ's body, created in some mysterious and divine manner during his brief entombment, and is due to an unknown chemical reaction and therefore the closest to an actual photograph. Furthermore, the shroud possesses undeniable photographic properties inasmuch as the image on the ancient fabric is a *negative* and could be seen as a positive only after a reversal of tones was applied. "Let us recall that the historic impetus that rendered the Shroud of Turin visible – or more precisely, figurative – is found in the history of photography."[14] Indeed, seeing and subsequently analysing the image of Christ on the relic became possible only after the invention of photography, when the first photographs of the shroud were taken by Secondo Pia (pp. 28–29) during the ostentation of 1898 and then again more than three decades later by Giuseppe Enrie in 1931 (p. 30). The parallel with photography was accentuated through a series of 'scientific' studies, as described in Dr Pierre Barbet's 1935 publication: "It is now proven, and no one can contest this any more, that the images on the fabric were created naturally, probably, according to the hypothesis of Professor Vignon, through the action of the ammoniacal emanations of a cadaver on a shroud impregnated with aloes: negative images whose existence was not even imaginable prior to Niépce and Daguerre, of which only the photographic cliché could reveal all their beauty, showing us the corresponding positive image."[15] Barbet did not hesitate to proclaim that "We are in possession … of the photograph of the cadaver of Jesus".[16]

No matter how one considers the Shroud of Turin and the Veronica, these early relics are no doubt the result of a natural need and yearning to have a glimpse of the divine, to receive a tangible proof of the stories of the Bible. As much as painting catered to a large extent to this demand, in the end photography, with its intrinsic fetishistic qualities, was best suited to fulfil this desire. Yet these early 'likenesses', and the fact that a face could be put on the persona of Jesus, had no effect on early photography, and Christ-related religious photographic imagery had to be invented, re-enacted and photographed for art's sake and for posterity, largely relying on the basic characteristics of the medium as well as its theatrical capabilities. The fundamental ambiguity of photography itself, its elusiveness, makes the resulting images at the same time unreliable and extremely real and moving. To some extent photography equals an epiphany, as the process involves an apparition, a quasi-magical manifestation of, in these cases, the image of a human/divine being, which is revealed through chemical reactions and manipulations, and therefore, as Father Marcel

Dubois[17] remarked, it becomes "an extension of the incarnation", and, through the process, transforms the photographers into exegetists of the sacred texts. In a similar spirit Edmund Teske's poem echoes the same idea, from a camera artist's point of view:

Photography!

Inmost
And ultimate
Light

From out of darkness
Ascending, once again,
God alone.[18]

From the very beginning photographers realized that images related to biblical and religious themes had to be constructed tableaux. The earliest preserved image in the history of photography to carry explicit Christian references is Hippolyte Bayard's iconic *Self-portrait as a Drowned Man* made in 1840 (fig. 3). The photographer's intention was to create an image of protest against what he considered an injustice, as Daguerre's photographic process was praised over Bayard's invention of a parallel technique. Daguerre was granted generous funds, and achieved recognition and fame, while poor Monsieur Bayard remained an obscure clerk for the rest of his life. At first glance the image appears to be devoid of religious connotations, and totally unrelated to any representation of Christ. However, the

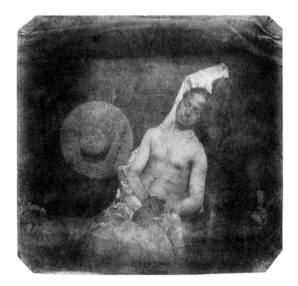

Fig. 3
Hippolyte Bayard (French, 1807–1887),
Self-portrait as a Drowned Man, 1840, salt print,
Collection Société Française de Photographie, Paris

pose of the 'dead' Bayard, with the limp body leaning to one side, wrapped in shrouds and with the hands crossed over the groin, is inspired by the traditional representations of Christ in painting, while the composition of the scene strongly resembles a classic Deposition from the Cross as depicted in Renaissance art. Furthermore, the choice of subject as well as the context in which the photograph was conceived and staged imply that the theme at the heart of the image is martyrdom: the photographer considers himself the medium's first 'political' martyr.[19]

The full-plate daguerreotype *The Infant Saviour Bearing the Cross* (*c*. 1850) by Gabriel Harrison (p. 33), in which the painter/photographer staged his young son as Christ, is a splendid early example of this genre of religious allegorical images in terms of both conception and execution. Besides being technically perfect, the image clearly reflects the religious penchant of the maker as well as strong painterly influences.

In contrast to Baudelaire, one of the admirers of the new art was his close friend Eugène Delacroix, who went as far as becoming a founding member of the earliest French photographic society, the Société Héliographique. His use of photographs as sketches for his paintings, especially those by the well-known Paris photographer Eugène Durieu, has been thoroughly documented. However, his appreciation of photography was not unconditional: photographic prints were acceptable provided that they did not record minute details but rather possessed certain imperfections such as blur and lack of detail (as typical of the calotype) that endowed them with *painterly* qualities.[20] This might explain the technically less-than-perfect prints of the Crucifixion studies by such an accomplished practitioner as Durieu (pp. 66–67). Used by Delacroix for his Crucifixion murals, the photographs were executed on commission, most probably under the painter's direct supervision.

Throughout the nineteenth century, photographic practice often involved the making of photographs with Christian content, as is obvious in the work of Julia Margaret Cameron (pp. 37–39), Oscar Gustav Rejlander (pp. 41, 130), Fred Holland Day (pp. 80, 82–83, 87, 96), Louis Bonnard (p. 93), Gaudenzio Marconi (pp. 70, 132) and many more. Besides these well-documented seminal works in photography, there are innumerable scenes with biblical content by unidentified makers catering to painters and sculptors and also to the wider public in search of explicit devout imagery. In addition there was an extensive market for photographs of questionable artistic merit, which included female crucifixions of lightly veiled models and similar equivocal subject matter: depicting a naked Mary Magdalene was the perfect means of both avoiding censorship and defying the Church.[21] It is noteworthy that photographic art resulting from deep religious belief flourished mostly in Britain, where the social and cultural atmosphere and the

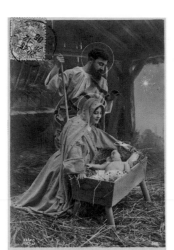

Fig. 4
Unidentified photographer,
La Naissance de Jésus, *c*. 1906,
hand-coloured gelatin silver print,
The Israel Museum Collection,
Jerusalem, gift of Gérard Lévy, Paris

Fig. 5
Unidentified photographer, *Untitled*,
c. 1900, gelatin silver print,
The Israel Museum Collection,
Jerusalem, gift of Gérard Lévy, Paris

pictorialist tradition combined to form a favourable setting for such a practice. Henry Peach Robinson's much reprinted and translated *Pictorial Effect in Photography* (1869) was the ultimate guide, as it stressed the effects and possibilities open to photographers by the skilful mixture of real and artificial elements in one photograph, a technique well suited to the creation of devout images. However, Robinson was more interested in form than in emotion and content, and therefore severely criticized the untidy look of Rejlander's and Cameron's photographs.

Although it would have been most appropriate, Robinson's pictorialism did not have a lasting influence on, or foster the creation of, religious imagery. Indeed, it failed even to answer what the mid-nineteenth-century French journalist Ernest Lacan identified as the "… [nineteenth] century's need which is vulgarization",[22] which implied an inflation of popular and populist pictures of pseudo-classic scenes and images made available to everyone. Typical of this sort of devout imagery catering to the public at large are the anonymous photographs from the 1860s staged and taken in Jerusalem, for the sake of the tourists and pilgrims visiting the Holy City (p. 32), a precursor of the widespread postcard industry. In fact, the postcard market found in religious imagery one of its

steadiest and most lucrative outlets, one not bound to change at the whim of fads or fashions. It flourished initially in relatively expensive photographic prints (fig. 4), and a few decades later reached an apogee with the improvement of the printing press (fig. 5). To be commercially successful the 'images for all' ideology produced popular stereotyped representations that conformed to the conventional, accepted perception of Christ and the saints.

The new century and the crisis of belief

The passage into the twentieth century saw the continuation of the crisis of belief that had begun in the 1850s, and the decline of the influence of religion. By the mid-twentieth century, as a result of the influence of earlier masters of doubt such as Friedrich Nietzsche, Karl Marx and Sigmund Freud, as well as of contemporary thought, philosophy, sociology and psychiatry, everything converged towards the implantation and growth of the idea that 'God is dead', which garnered a certain popularity in Western countries. A dramatic development in Europe at the political level took place in 1904 when Catholic France decided to make the final division between Church and State, followed by the historically significant move of breaking off diplomatic relations with the Vatican. Among many steps taken, a decree ordered the removal of all religious symbols from courtrooms. This provoked a deep discontent on the part of the Church, and caused a series of protests, epitomized in the famous postcard *France!!! Quo Vadis?* (p. 182). This beginning of de-Christianization announced the advent of the materialist ideologies, the anti-establishment ideas of Dada, and Surrealism, with its interest in automatism and the beauty of accidence, which themselves would lead later, in the 1950s and 1960s, to the experimentation of Fluxus and of the composer John Cage, and to all the artistic movements believing in the beauty and the creative possibilities of a chance happening.

From the beginning of the twentieth century until World War I, hardly any religious imagery is discernible in photography, except perhaps for a sporadic sequel to nineteenth-century pictorialism, as in Gertrude Käsebier's much-praised photograph *The Manger* (1899; p. 34). The photograph unmistakably draws inspiration from Renaissance art. However, despite the fact that both title and subject suggest a religious content, Käsebier did not positively sustain a religious interpretation of the image, and claimed that the work should rather be considered as an artistic exercise in light effects and composition. Just as rare is the appearance of similar subjects in other art forms. An overview of the photographic work between the two wars clearly shows an absolute lack of concern and preoccupation with religion: photographers such as Eugène Atget, Brassaï and André Kertész in France, and groups such as Neue Sachlichkeit in Germany and the Photo League and f/64 in the United States, are just a few examples.

Dada and Surrealism: ignoring religion

In the course of the evolution of art in the twentieth century the Dada and Surrealist movements, in their call for the eradication of all organized religion, might have been expected to yield a significant number of works of art critical of religion, and especially of Catholicism. It is a fact (or almost a prerequisite) that both Dadaists and Surrealists were avowed and resolute atheists by definition (except for Paul Eluard, who was a Roman Catholic, and perhaps Rimbaud, who embraced Christianity on his deathbed). Yet, surprisingly, close scrutiny of the period beginning with the end of World War I establishes that during these decades very few works of art touched upon religious subjects in general and Christ-related images in particular. Furthermore, it appears that, with some exceptions, the topic was deliberately ignored altogether and excluded from the artistic discourse of the time.[23] It is important to note that the atheism of the Dadaists and the Surrealists was neither rationalist or scientific, nor romantic in the Nietzschean fashion, but rather *natural*. It was the result of an unquestionable knowledge and conviction that simply excluded the possibility of the existence of a transcendent being. They provoked many scandals in every possible sphere of life but produced very few visual works of art criticizing or expressing hostility towards religion and religious belief – this despite the fact that atheism and anti-clericalism were at the basis of the beliefs of most of these artists, and that they all wanted to stick by the rather vague formula that one of Surrealism's purposes was to defy Christianity and replace it as a new valid contemporary religion.

The Surrealists' preoccupation with ancient myths, psychoanalysis, mysticism and the occult, including the Jewish mystic tradition of Kabbalah and the Zohar (the book of enlightenment in Jewish Hasidic tradition) and Eastern religions such as Buddhism and Shintoism, still does not explain the reason for their conscious avoidance of Christian religious issues. The staging of impossible settings and the creation of nonexistent realities are at the core of Surrealist art, and an Ascension scene, for instance, is unquestionably surrealistic in character since it is an imaginary creation, a figment of mystic/religious/artistic fantasy. Perhaps because voluntary ambiguity in the use of objects in the works of art as well as in thought was one of the main instruments of expression of the movement, and because religious art usually had to be precise and explicit, no such works were created even during the height of Surrealism. One of the key works of iconoclastic proportions was Max Ernst's painting *The Virgin Spanking the Christ Child Before Three Witnesses: André Breton, Paul Eluard, and the Painter* (1926; fig. 6), which is in unquestionable conflict with established canons of religious representation. Besides the description of a prosaic scene unfit for religious art, in the painting the mythical Three Wise Men are replaced by the 'three popes' of

Surrealism who preach the eradication of religion. In a sense, this painting is reminiscent in approach to, and seems to have adopted the form and content of, Rejlander's allegorical 'spiritistical' photograph, *Hard Times* (1858; p. 41). In this quasi-Surrealist multiple exposure, while also depicting an everyday moment, the artist becomes once again creator and actor, participant and witness, as he positions himself, as Ernst did, simultaneously inside and outside the work.

And yet this did not become a sweeping trend, and very few works with religious references were produced by the Surrealists during their period of activity in all the creative fields, including literature. "One of Surrealism's best-known works, *The Immaculate Conception*, lies midway between poetry and manifesto. On one level the book is a series of prose texts describing mankind's various creative impulses. But as the title suggests, its aims are not only literary but ideological and philosophical as well: at once an implied attack on Catholic dogma and the moral strictures it entails, and a practical attempt at rectification, at defining a creative process (in one critic's words) 'devoid of literary original sin' – sins that include social conformity and concessions to literary success."[24] The criticism of religion still remains mitigated, and every statement seems to be reversible as the Surrealists recommend: "Perform miracles in order to deny them."[25]

Even the movement's publication *La Révolution surréaliste*, which was the principal channel of expression, had relatively few issues dealing with religion, often just limiting itself to the use of an illustrative photograph. The most blatant was Issue Number 3. Its cover featured a double-exposure photograph by an unidentified maker, representing a typical Parisian building façade with religious sculptures superimposed on it (fig. 7). The photograph bears the same title as the main article: "1925: End of the Christian Era." In any case, it seems that both Dadaists and Surrealists even when attacking Christianity dealt mainly with its symbols rather than with the image and personality of Christ.

No matter how rare works dealing with religious subject matter were, once they appeared they were powerful and often blasphemous. On 15 January 1930 a group of dissident Surrealists, among them G. Ribemont-Dessaignes, Jacques Prévert, A.J. Boiffard and Georges Bataille, published a four-page pamphlet titled *Un cadavre*[26] in reaction to André Breton's second Surrealist Manifesto. Besides virulent articles attacking Breton personally, the pamphlet featured on its cover page the famous photograph of the poet with closed eyes taken from the anonymous photomontage *Je ne vois pas* … (1929) but adorned with a crown of thorns added probably by Boiffard (fig. 8). The presenting of Breton as a Christlike personage, while calling him a false prophet (as Jesus was called by some), was a blatant transgression of all conventions, just "like the mystics, like Sade or Artaud calling themselves Jesus Christ in an

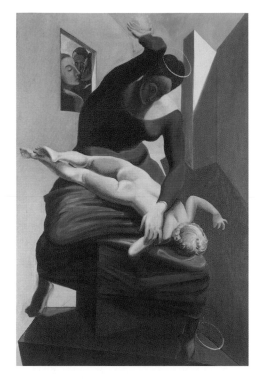

Fig. 6
Max Ernst (German, active Germany and France, 1891–1976), *The Virgin Spanking the Christ Child Before Three Witnesses: André Breton, Paul Eluard and the Painter*, 1926, oil on canvas, Museen der Stadt Collection, Cologne

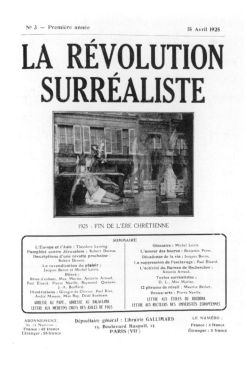

Fig. 7
La Révolution surréaliste, No. 3, 15 April 1925, The Israel Museum Collection, Jerusalem, The Vera and Arturo Schwarz Collection of Dada and Surrealist Art

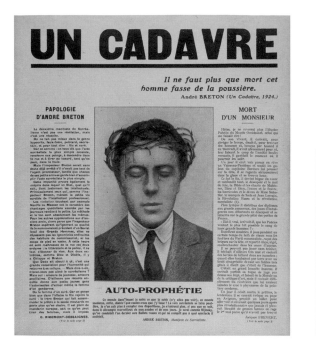

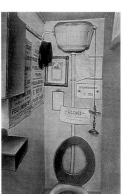

Fig. 8
Un cadavre, Paris, 1930, The Israel Museum Collection, Jerusalem, The Vera and Arturo Schwarz Collection of Dada and Surrealist Art

Fig. 9
Man Ray (American, active France, 1890–1976), *Untitled (Georges Sadoul's house)*, 1920s, The Israel Museum Collection, Jerusalem, The Vera and Arturo Schwarz Collection of Dada and Surrealist Art

amorous and equally destructive rage".[27] Among the many other verbal attacks, Prévert stated that Breton had "… confounded everything … the Bible and the Chants de Maldoror, God and God" and then called him an "occult Christ",[28] while Bataille accused him of being a "Christ-headed false revolutionary".[29]

When discussing the scarcity of religion-related plastic creations during this period, Arturo Schwarz affirms that although the Dadaists were by definition nihilists and were against all values, the Surrealists basically despised Christianity and therefore were totally uninterested in it. It is owing to their indifference that they created very few plastic works dealing with religion, even in order to attack it.[30] In fact, their opposition to Christianity and Christian civilization was amply expressed in writing in a long series of violent attacks, mostly by Breton.

Earlier on, the Dadaists, who besides being atheists actively wanted to crush all institutions, established values and conventions, had practised a militant iconoclasm, and aggressively attacked all religious dogmas, beliefs and attitudes and especially Christian conventions. However, when it came to confronting the Christian establishment directly, they too became somewhat shy. Among the few notable images of the period is Georges Hugnet's provocative and even sacrilegious photo-collage *The Last Supper* (1934; p. 141), which speaks for itself. Man Ray's photograph *Monument à Sade* (1933; p. 142) expresses a deep contempt for religion and for Christian symbols, as the figure is framed by the hand-drawn inverted cross, which could also be interpreted as the symbol of the Antichrist. In this image the beauty of the form clashes with the content and the idea of the work. This conflict between the

temptation of the beautiful forms and the anti-religious idea and message could almost be an illustration to Christ's words in Norman Mailer's fiction: "The Devil is the most beautiful creature God ever made."[31] Even more provocative and scandalous in its ostentatious expression of the typical anti-clerical attitude is a photograph by Man Ray, taken in Georges Sadoul's house (fig. 9), where, as well as the fact that the handle at the end of the lavatory chain is an ornate cross, a sign above the seat reads: "Silence in respect of the Very Holy Sacrament continuously displayed." Finally, another image attributed to Man Ray is a photograph of the poet Jacques Rigaut in a crucifixion pose, probably taken shortly before his suicide in 1929.[32]

During the same period, the field of cinematography produced several important creations, especially the joint works of Luis Buñuel and Salvador Dalí, that were replete with Christian and especially Catholic symbolism, and subversive scenes dealing with religion. Besides the well-known *Un chien andalou* (1929), *L'Age d'or* (1930), with its many shocking references to the marquis de Sade, was also conceived by Buñuel and Dalí, although it was produced only by the former as their opinions diverged: Dalí began shifting towards religiosity and became weary of criticizing the Church. As a result, Buñuel dissolved the partnership, declaring that he had no interest whatsoever in filming "the splendour of Catholic myths".[33]

Images for the masses

Together with other creative techniques such as collage, multiple exposure, combination printing and similar manipulations, photomontage, which Barbara Morgan called the "photographic

shorthand of the imagination",[34] was among the essential tools in the creative arsenal of the Dadaists and Surrealists. In a different practice, it has been adapted for use for religious subjects as it is a convenient means of creating imaginary and fantastic scenes circumventing the necessity of meticulous staging. The earliest manipulated print on record is probably Johann Carl Enslen's 1839 photogenic drawing showing Christ's face superimposed over a skeleton oak leaf (fig. 10). This creates a startling effect, which must have been considered almost as magic. Another early image assembled with photographs of different origin is Julia Margaret Cameron's *Adoration* (c. 1865; p. 37). Although the crude pasting of a strip at the bottom of the print is a relatively primitive approach, it is the result of a creative instinct in search of unconventional means to illustrate an unusual subject, and manifests both artistic beauty and pious exaltation. Rejlander's allegorical 'spiritistical' photograph, *Hard Times*, is also a multiple-image manipulation and illustrates the search for artistic effects.

This practice has occurred in almost all areas of photographic creation. Volume III of Keystone's series *Palestine Through the Stereoscope* is a set of twenty-four images depicting scenes from the Passion. In search of authenticity the maker could not resist the temptation of adding 'real' faces to some of the images through tipped-in tiny portraits. The subterfuge is more than obvious for Joseph in *The Flight into Egypt* (fig. 11) and Jesus and the executioner in *Jesus Attached to the Cross* (fig. 12), where faces are crudely pasted on for the sake of truthfulness, and oblivious of aesthetic principles such as angle of view, lighting and proportion.

The art of photomontage continued an autonomous life well into the twentieth century in the work of such artists as John Heartfield (p. 184), Marinus (p. 183), Kurt Schwitters, Hannah Höch, George Grosz and Raoul Hausmann, and was mainly used in the context of political protest or class struggle. Still a valid mode of expression, under different guises it has extended into the creative work of such contemporary artists as John O'Reilly (pp. 94, 104), Dinh Q. Le (p. 86), Luis Gonzales Palma (p. 103), the Starn Twins and many more. Besides creative work, in a more popular approach, an astounding image is the contemporary postcard of an anonymous giant photo-collage (p. 139). A giant mosaic of faces, among them those of many famous people (actors, politicians and other celebrities), forms a likeness of Jesus, suggesting the universality of Christ and that a part of him exists inside every individual.

It is interesting to note that, with the exception of these manipulations, photographs with religious essence are usually devoid of artifice, adhering to the 'straight' frontal approach, deliberately omitting the possibilities offered by the camera for the sake of content and subject-matter. It is as if the photographers in question were acting in accordance with Ruskin's recommendation that in works of art "the primal object is to place the spectator, as far as art can do, in the scene represented, and to give him the perfect sensation of its reality, wholly unmodified by the artist's execution".[35]

A truthful image?

"… [T]hroughout history, humankind has told two stories: the story of a lost ship sailing the Mediterranean seas in quest of a beloved

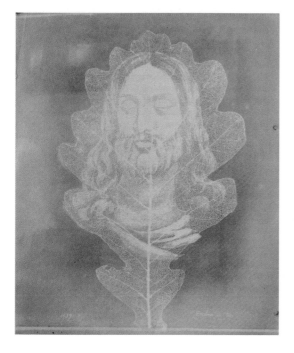

Fig. 10
Johann Carl Enslen, *Christuskopf*, 1839, photogenic drawing, Tübingen Universitätsbibliothek Collection, Germany

Figs. 11 and 12
Keystone View Company (American), *The Flight into Egypt* and *Jesus Attached to the Cross*, c. 1900, albumen prints, private collection, Israel

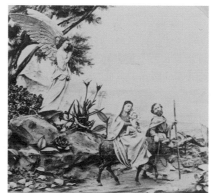 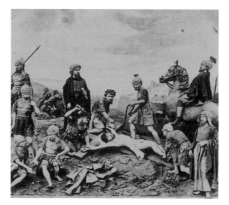

isle, and the story of a god who allows himself to be crucified on Golgotha."[36] In the visual arena this very god has become one of the most sought-after and depicted characters, hero of the all-time bestseller. On the photographic surface, as opposed to the canvas, the persona of Jesus takes on a somewhat different identity, as the silver image documents and transcribes a certain reality, carrying as it does the trace of a real person with specific features and personality. Therefore the photographic Christ remains less symbolic, and less representative of an idea. Photographic practice rather becomes a matter of finding 'doubles' to the image and idea of the Saviour. Nevertheless, the image of Christ in photography still often conforms to the consensus and to the established artistic canon: fair complexion, long hair and beard, light-coloured eyes. Every other representation (black or dark, bold, female) is considered unacceptable, shocking and even blasphemous. Furthermore, even a dress code is often respected, since a totally naked Jesus is inadmissible. Because photography is an 'exact' reproduction of reality and is much more explicit than other means of representation, it is capable of generating greater opposition or causing violent reactions and even outrage at things shown or suggested. If in Renaissance and classical painting Christ's genitalia were often shown or hinted at, this becomes unthinkable in photography as it would verge on the sacrilegious, even in contemporary artistic creation where personal and at times iconoclastic interpretations are not unusual. When it comes to the vision of the person of Jesus, the meaning is always in the eye of the beholder. "Everywhere the body appears no inscription is possible. These apparitions – or epiphanies – remain unseizable, and cannot be fulfilled but in the close and fragile encounter between gaze and matter."[37]

One of the characteristics of religious photography in general, and a trait that differentiates it greatly from other art forms, especially painting, is the unconditional focus on the person acting as Christ while the background generally suffers from an obvious lack of attention. In this respect, photography is closer to the New Testament: the sacred texts "… contain hardly any detailed descriptions of outward appearances, either of people or landscape",[38] so in photography at least the landscape does not have to be invented. In painting, and especially from the Renaissance onwards, the elaborate backgrounds painstakingly depicting in minute detail a biblical landscape were as important as the representation of scenes from the Passion. Whether real or a figment of the artist's fertile imagination, nature, as a representation of the incarnation of the divine order, remains inexorably part of Christian religious art, especially as its symbolic value is a necessary complementary element. Christian religious imagery (and as a matter of fact all other religious art) is the product of hearsay. In photography too the narrative of the staged scenes relies on

the Gospels, which evidently are not historically accurate documents. This, of course, does not imply that the events described did not happen, but the Scriptures, written decades later, do not provide absolute evidence as to the nature of all the minute details necessary to the reconstruction of these scenes. Recognizing this, Norman Mailer has his fictional Jesus confess: "While I would not say that Mark's gospel is false, it has much exaggeration. And I would offer less for Matthew, and for Luke and John, who gave me words I never uttered and described as gentle when I was pale with rage. Their words were written many years after I was gone and only repeat what old men told them. Very old men."[39] In this perspective, photography becomes the result of religious knowledge and imagination, and a representation of what Walter Benjamin calls "things as they have been". However, such photographs carry no historical truth and no historical reality, since they are not photographs of actual historical events. Paradoxically, they are genuine images of actual scenes, depicting a reality but not the reality. These images encapsulate a certain memory, but not the actual remembrance of things past: this is a memory tainted by generations of artistic licence and religious and mystical interpretation, a transfiguration and transliteration of words into images. The seemingly overt and explicit qualities of the photograph, its apparent immediacy and accessibility, have made it the perfect vehicle for the transmission of messages and ideas of every possible character: direct, positive, subdued or subversive. It is the deviation of photography from the point of view "… in which the perceptual world is accepted only as a means of illustrating ideas to the senses".[40]

Interpretations, uses and abuses

One of the most frequently used themes in the social/political context has been that of the Madonna and Child. It is one of the most effective images, powerful enough to arouse love, human compassion or religious sentiments and to achieve the desired impact to convey a specific message. Even in secular societies, "The reality, whatever it may be, palpable or invisible, goes into the eye or the mind's eye and comes out as work of art".[41] This is true throughout the history of photography. John Thomson's *The Crawlers* (1877), Jacob Riis's *Home of an Italian Ragpicker* (c. 1890), Lewis Hine's *Tenement Madonna* (1908; p. 158), the many FSA (Farm Security Administration) images by Dorothea Lange, and W. Eugene Smith's *Tomoko in her Bath* (1972; p. 155) are but a few examples.

In the social/political arena the image of Christ has been exploited at many levels, often in conformity with specific cultural and national needs or in contexts not directly related to Christianity. Such is the case of Manuel Alvarez Bravo's iconic photograph *Striking Worker, Murdered* (1934; p. 181). This photograph

epitomizes such an adaptation, providing a Christlike image capable of touching all viewers. The detail of the body of the dead striker seems as natural as a Crucifixion in a church, and he is neither hero nor martyr, but just like Jesus a sacrificial lamb offered to God for the salvation of the community he belongs to; and, as Christ on his cross, he is alone and abandoned. An image of similar significance is John Filo's equally iconic photograph (1970) of the shooting at Kent State University. However, in this case the dead student is not alone, and like the murdered worker he is no hero, but simply a victim of social/political violence. Their deaths transform them into anonymous martyrs who may herald the coming of a new order.

Still in a social context, Duane Michals is one of the few artists who has excelled in the depiction of Christ as an ordinary person. However, in his series *Christ in New York* (1981; pp. 160–65) Michals did not omit one of Christ's conventional divine attributes, a carefully dodged luminous halo around his head, to ensure that the viewer would not be mistaken. The seemingly humorous series is in fact a rather sad meditation on the contemporary human condition. Cruelty, injustice, violence and indifference are at the core of the work, which depicts a helpless Christ. Profoundly religious, it is also replete with doubts, and hints at the possible failure of the Saviour in his mission once again, on his second coming.

Among the innumerable uses of religious imagery, Christian symbols have often been the inspiration in fashion, commercial and editorial photography. A recent example is Annie Leibovitz's "Last Supper" advertisement for the television series *The Sopranos* (p.147), which employs such a strategy, relying on an internal paradox between image and meaning. The depiction of the United States frisbee champion by Kurt Markus (p. 149) is another noteworthy example. Finally, in fashion, the photograph of one of Jean-Paul Gaultier's creations expands the genre to this discipline (fig. 13).

In the field of cinematography, which is discussed on pages 186–89, the image of Christ has been shaped and interpreted *ad infinitum*, not only in movies dealing directly with the New Testament and the Gospels but also in those that often have no relation to religion or Christianity, involving mere hints or allegorical characters or situations. The inventiveness of such interpretations has yielded a multitude of images of extraordinary beauty, often a fleeting moment in a long movie but one that is capable of becoming a powerful still image, such as the scenes from Sidney Olcott's 1912 film *From the Manger to the Cross*, the first ever to be shot completely on location in Palestine and Egypt (pp. 136–37). Still photography remains the basis of the movies, as for instance Raymond Voinquel's photographs (pp. 31, 88 and 138) taken in preparation for a film planned by Abel Gance, who wrote that "… all legends, all mythologies and all myths, all founders of religion, and the very religions … await their exposed resurrection, and the heroes crowd each other at the gate".[42]

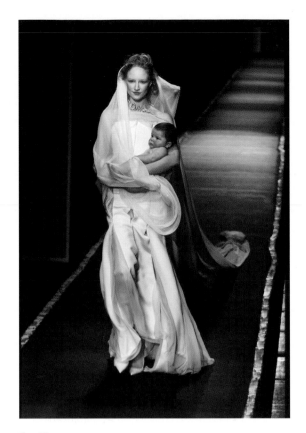

Fig. 13
Daniel Simon (French), Jean-Paul Gaultier fashion show, 2001, chromogenic print, Gamma, Paris

The image of Jesus, or of Jesus-like individuals, is used often, either in a straightforward fashion or in a subtle form, in all domains of photographic practice. Usually this practice is no different from the use of such subjects as Elvis Presley, Marilyn Monroe or other cult heroes who have become mythical figures, as best recognized in Andy Warhol's art, which made use of a wide range of idols in Western culture.

Jesus-like or I the Saviour: staging the self

In his treatise *Della Pittura* (1435) Leon Battista Alberti bluntly proclaims that "The esteem that surrounds painting is such … that the master will see himself considered almost as another God".[43] This declaration opens a long tradition of artists' self-portraits as saints or Christ, mostly in painting, and subsequently in photography after the 1840s.[44] In staging and depicting themselves in their medium, photographers joined the ranks of such masters of the canvas as Fra Filippo Lippi, Albrecht Dürer, Jean-François Millet, James Ensor, Vincent van Gogh and Paul Gauguin.

In Christian faith it is a convention that anyone can become Christ's messenger provided that he or she conveys Christ's ideas, ideals and messages in the accepted manner and within the religious consensus. However, in art anyone can impersonate him

if endowed with the physical traits accepted by the generations-old visual and artistic traditions: hence the quest for people with very specific looks, not only for photographic purposes but also for such scenic adaptations of the Passion as the traditional annual Easter parades in Jerusalem, the renowned Oberammergau Passion Play in Germany held every ten years (pp. 42–43), or the various scenes and processions recorded by José Ortiz Echagüe in different religious communities, along with numerous other popular manifestations of religious cult. Part journalism and part staged studio photography, Ortiz Echagüe's photographs carry strong pictorial references to Zurbarán and El Greco (p. 89). Such dramatizations also require the use of traditional symbols and attributes based on the Gospels, as they cannot reflect an established visual truth but only a historical interpretation. The search for veracity is reflected by Joel-Peter Witkin's plea in the afterword to his 1985 monograph *Forty photographs*, in which he solicits models with all sorts of deformities and ailments and ends the long list with the item "Anyone bearing the wounds of Christ". A purist, Witkin would look for 'authentic' stigmata, in the same way that he looked for genuine physical disabilities, rather than theatrically create them in his studio through the artifice of makeup. Another example of a similar photographic search for Christ's multifaceted likeness is Nancy Burson's *Guys Who Look Like Jesus*, a series she planned and executed for the millennium and for which she solicited models through advertisments in the paper. The variety of faces she decided to picture ranges from the traditionally accepted image of Jesus to black or Oriental ones, and reflects the impossibility of knowing what he looked like. In the artist's own words, the project was an investigation of the "… assumptions about what one of the most powerful figures in the history of the world looks like". [45]

A rather infrequent mental affliction, yet one well known in psychiatric circles, bears the name "Jerusalem Syndrome". Diagnosed in the 1930s, it is a site-specific temporary psychotic episode, occurring only in the Holy City and almost exclusively among Christian tourists and pilgrims.[46] Apparently Jerusalem Syndrome either is generated by the special aura of the city as absorbed by pious visitors or results from very high religious hopes and expectations, such as the much-awaited return of Jesus Christ, the Second Coming of the Messiah. Sufferers believe they are biblical characters, such as Jesus, Moses or Mary, start to act and dress differently, and eventually begin preaching. This relatively unusual illness and the resulting changes of conduct are reminiscent of the behaviour of many photographers who staged themselves for the sake of a series of photographs related to the life of Jesus or other biblical characters.

The long tradition of self-staging as Christ or one of the saints in the history of photography is often linked to, and considered part of, the self-portraiture trend, but a closer look at such images suggests a different reading. The beginning of the tradition, which could be attributed to Bayard, was followed throughout the decades by many of the prominent practitioners of the art. The list is long and includes photographers from different periods and a variety of approaches, such as Fred Holland Day, O.G. Rejlander, Frantisek Drtikol, John O'Reilly, Orlan, Cindy Sherman, Yasumasa Morimura, Jan van Leeuwen, John Dugdale and Dieter Appelt. In many instances such a practice might also contain elements of exhibitionism, and the question arises whether a self-portrait as Christ (or any other acceptable biblical figure such as the Virgin Mary, John the Baptist or Mary Magdalene) is not a cynical use of religion to legitimize such ostentation.

The most striking case in point is the similarity between Jerusalem Syndrome and the behaviour of Day while he prepared and created the series of images of the Passion in 1898. Apart from its artistic content and its success as a conceptual and technical *tour de force*, the work also involved an inner mystical experience. The artist's fasting for weeks in order to achieve an emaciated Christlike appearance, and even the fact that he imported artefacts for the sake of the authenticity of the scene, were in the same line of logic. In addition, the manifest expressions of ecstasy while playing the crucified are more than strong hints of the described ailment and the particular mental condition.[47] In Day's case, dealing with photography and thence the necessity of self-staging concretized the religious experience: imagination comes before the work of art, and the execution demands direct personal involvement. As the medieval mystics maintained, understanding only follows experience. In the end, besides many favourable reactions to his photographs, the criticism Day endured was an additional Via Dolorosa. The *British Journal of Photography* called his photographs repulsive: not an artist's reverent and mental conception of a suffering Christ, but rather the image of a man made up to be photographed as the Christian redeemer.

The self-portrayal tradition encompasses also the genres of body art and self-mutilation in their many different manifestations. Castigation of the flesh is in more than one sense part of the Christian tradition, and therefore carries religious overtones, even if unconscious, and links directly to the Passion of Christ and to symbolic significations such as expiation. Vito Acconci's biting of his naked body, Orlan's physical transformations through repeated painful plastic surgery, Dieter Appelt's life-endangering situations, and even John Coplans's photographs of body details contain allusions to the chastised and mutilated body of Christ. One of the most interesting cases is without doubt Chris Burden's 1974 performance *Trans-Fixed*, as a result of which his hands, nailed to the roof of a Volkswagen car, bear real stigmata.

Whether they stem from deep religious belief and sentiments or have ulterior motives, the photographic self-portraits as Christ (and eventually as saints) are to a large extent ostentatious. They

seem to be the result of the artist's seemingly pretentious declaration: "I the Saviour". Strangely enough, a photograph of a 'dead Christ' becomes also a *memento mori* of the living model, almost a projection into the future through which the artist envisions his own death.

Corpus Christi: gender, sexuality and sensualism

Few subjects in Christian art allow for nudity, and most of these relate directly to Jesus, because "… in spite of the Christian horror of nakedness, it was the undraped figure of Christ that was finally accepted as canonical in representations of the Crucifixion".[48] The other instances still take their source in the Passion and are the Flagellation, the Deposition from the Cross, the Pietà and the Entombment.

The study of the depiction of Christ's earthly appearance in human form and consequently the description of his earthly body present problems that have been debated thoroughly and attacked and defended from all possible angles. Flesh and blood, it is the human body that occupies centre stage in Christian religious art. Martyrdom, suffering, sacrifice and death are at the roots of a delicately balanced impossible coexistence of the sacred and the profane in what Georges Bataille calls "the unreality of the divine world"[49] of which the *amor carnalis Christi* is an indivisible part, especially when the boundaries between *caritas* and *cupiditas* become blurred. The ecstatic religious images often oscillate on the edge of the exceptionally thin line between the voluptuousness of spiritual love, and sensuality and sexual lust, and their reading is open to interpretation. Most of the works of art, including photographs, unfold the extremes of desire and passion, carnal versus divine love, and draw a line between the paradoxical worlds of Eros (the urge for self-preservation and sexual pleasure) and Thanatos (the urge for destruction or self-destruction) constantly present in them. The ambiguity of expression in Drtikol's self-portrait as crucified (p. 81) tends to make one think in terms more of sexual agony/ecstasy than of mystical exaltation, as the photograph is part of a series depicting crucifixions of beautifully posed nude women (pp. 74–75).

The characteristics of Christ's body and its features have gone through infinite transformations and interpretations. Innumerable texts deal with the manhood of Christ and his male attributes. Yet apart from the clearly masculine images, at the height of Renaissance art one cannot avoid noticing the use of excessively feminine traits in depictions of Jesus. Not only the musculature or the shape of the limbs but also, and especially, the poses and gestures suggest the presence of the female body behind the painting. The best examples of effeminate renderings of the body of Christ are in Titian's *Noli me Tangere* (c. 1515), Bernardo Strozzi's *The Incredulity of Saint Thomas* (c. 1620) and Velásquez's *Christ*

After the Flagellation Contemplated by the Christian Soul (c. 1630). In Correggio's *Christ Presented to the People (Ecce Homo)* (1525–30) the figure of Christ stands next to a virile Roman soldier, who makes a contrast to Christ's delicate features and the way his crossed arms seem to float lightly. In many instances when the images involve the ostentation of the wound on Christ's chest, the gesture is typically feminine and reminiscent of holding up or offering the breast, as in *The Blood of the Redeemer* (1460–65) by Giovanni Bellini.

These facts strongly suggest that, although this might appear a sacrilegious approach, many painters must have resorted to female models when painting the image of Christ. The roots of such a preference can be found in earlier times, in medieval mysticism and theology where "women were identified with Christ's physical body and men with his soul … such identification meshes nicely with the idea of the body as a source of knowledge".[50] Quite naturally, many of the Renaissance artists took up the idea and made use of "the ambiguous nature of female sexuality and the tension between purity and sensuality"[51] in the depiction of the dual nature of the Saviour. Consequently, a certain sexual tension would often have been present in the studio situation where artists were painting their lightly draped models, and this naturally transpires in the final works of art. Even when the artists were masters such as Leonardo or Michelangelo, whose preferences were different, sexual tension was probably no less present while they painted male models.

In scenes depicting the life of Jesus, divinity, mysticism and eroticism often become one, in images carrying heavy sexual connotations. In many instances, physical contact and male and female touching appear particularly problematic: after the Resurrection, for instance, Jesus would not let Mary Magdalene touch him but encouraged Thomas to touch his hands with his finger. Notably, parts of the gay community have fully embraced the image of Christ. This masculine promiscuity is described by Kristeva who bluntly states: "Christianity is the religion which has best unfolded the symbolic *and* corporal impact of the paternal function on mankind … Christianity leads to the preconscious formulation of the essential fantasies that mark out the desires of men. Thence, the substantial, corporal, incestuous fusion of the father unveils and sublimates homosexuality. The killing of the God-man reveals … that the representation of the Christic Passion signifies a guilt that is projected like a boomerang on the Son who delivers himself to death."[52]

Many of the photographic interpretations of Christ's image and personality carry homoerotic overtones and are clearly about physical contact. They offer a vision of communion and possible salvation through direct touch totally opposed to the famous *Noli me Tangere*. This approach is best exemplified in John Dugdale's images, in which sexually explicit physical contact becomes the true

path to redemption. The minimalist yet very symbolic photograph *Christ, Our Liberator* (p. 106) is an image not only suggesting a moment of redemption but also pointing to a helping hand that frees from homosexual terrors. Equally charged is the photograph in which Lazarus is brought back to life by a male kiss, where Dugdale himself is Christ, saviour and redeemer, and through physical contact raises his friend from the dead (p. 85). In the much broader context, it is also salvation from the realm of guilt so strongly present in Roman Catholicism. "The message of the son was the message of liberation: the overthrow of the Law (which is domination) by Agape (which is Eros). This would fit in with the heretical image of Jesus as the Redeemer in the flesh, the messiah who came to save men here on earth."[53]

The tradition of imaging Christ is also closely related to the will to envision and describe perfect and absolute beauty, as he is to be the ultimate perfection embodied in human form. Added to what are perceived as the tragic elements of Christ's life and death, this almost directly connects to Yokio Mishima's aesthetic perception, according to which "absolute beauty can be attained only through violent death, and this only if the dead is a young and handsome man".[54] Physical punishment in many disguises (for example, Aids) is only a stage in the process of redemption, and not the conventional idea of sacrifice. "Not only what is being sacrificed is only temporary (the body of Christ will be resuscitated intact), but … it is just a body of lust, the erotic body",[55] which in its resurrection will become the ideal body.

The image of Christ as a symbol of suffering has also been espoused by many women artists and parts of the lesbian community, as if in proof of Freud's concept of the "return of the repressed".[56] Many women artists have assumed the role of Christ or used female models in their works, and these have often created clamorous scandals. The existence of so many photographs of female crucifixions could most probably signify the way in which artists pointed to the fact that it was God's bodily (therefore feminine) manifestation that was tortured on the cross and that his spirit was intact.[57] In different contexts, and from a variety of viewpoints, the issue of gender and the sexuality of Christ, and especially his male attributes, has been discussed at length by many authors and researchers, from Leo Steinberg's classic *The Sexuality of Christ in Renaissance Art and in Modern Oblivion* (1996) to Alexandre Leupin's *Phallohanies* (2001), in which the author finds the image of a phallic symbol on Jesus' abdomen in each and every depiction of the Crucifixion that he examines.

As a philosophy that also embraced and took into account all possible discourses that Modernism ignored or suppressed, Post-modernism adopted diversity and plurality and advocated acceptance. Such open-mindedness made it appealing to groups such as the gay community, which, pushed to the fringes of society, finds a voice and an expression through artistic creation far from the angry eye of the Church. Many declared homosexual artists such as Robert Mapplethorpe, John Dugdale and Pierre et Gilles, along with numerous others, were raised and lived in the Catholic tradition. One of the obvious examples of this genre is the work of the renegade painter/photographer Pierre Molinier who, at first promoted by André Breton, was later 'excommunicated' by him because he painted his blasphemous *Oh! Marie Mère de Dieu* (1965), considered offensive even by Breton; in 1970 he made the series of photographs *Hanel Crucifiée*.

The more the Christian establishment banned and disparaged homosexuality, the more violently parts of the gay community embraced this theme in artistic discourse, using the very symbols of Christianity in order to make it acceptable, if not to the Church, then to themselves, thus creating a parallel community with its own religious/aesthetic values and symbolic conventions. The stigmata of Christ become the moral and psychological wounds of the ostracized who bear the cross of their sexual preferences. Christ then becomes their saviour, and galvanizes them in their Via Dolorosa amidst the puritan straight culture.

The image of Christ as universal symbol

Through their extensive use during the last two centuries the themes of martyrdom and salvation that are central to Christianity have become universally recognized symbols, and not necessarily in a religious context. Such symbols are often absent in other religions, and especially in the Jewish faith and cultural tradition. Christian imagery such as crucifixes, together with the name of Jesus, is taboo among Orthodox and devout Jews, and in fact the word *Christ* does not exist in Hebrew, and *Yeshu* (Jesus) or *Yeshua* are the only designations. However, secular Judaism and the art world are exposed to the Christian aesthetic and tradition through art history and Western culture. As a result, in many instances, Jewish and Israeli artists have embraced Christian imagery and symbols to express ideas with absolutely no relation to the Church. A classic example in contemporary literature is Chaim Potok's novel *My Name is Asher Lev*, which describes the tribulations of a Hasidic youth from Brooklyn whose vocation is painting. In his creative journey he is first brought to admire Christian religious artworks, until he is as "… an observant Jew working on a crucifixion because there was no aesthetic mold in his own religious tradition into which he could pour a painting of ultimate anguish and torment".[58] This is an almost exact description of Marc Chagall's Crucifixion paintings done in the early 1940s in which the painter laments the suffering of European Jewry during the Holocaust. This was not the first time Chagall had used Christian symbolism: he also wrote in a letter to his wife that he felt as if he were nailed to his easel like a crucified Christ. These canvases are all quasi-blasphemous in Jewish

Fig. 14
Marc Chagall (Russian, active Russia, France and USA, 1887–1985), *The Crucified*, 1944, gouache on paper, The Israel Museum Collection, Jerusalem, permanent loan of the America–Israel Cultural Foundation

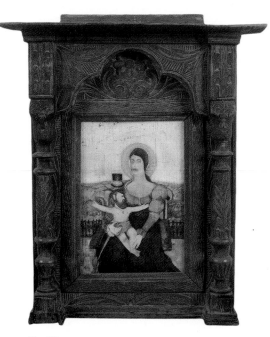

Fig. 15
Batya Apollo (Israeli), *The Birth of the Zionist Dream*, 1966, mixed media, collection of the artist

religious terms as they depict the crucifixion of Jews in their traditional Eastern European attire (fig. 14). In another painting, titled *White Crucifixion*, Chagall goes as far as painting a half-naked religious Jew with his abdomen draped in a Tallith – the traditional prayer shawl – and crucified against a background of pogroms and violence. Because his ethnic and religious background does not offer him the visual and cultural tools to express his pain and sorrow, the artist conceives a situation in which two alien religious concepts and their associated symbols paradoxically coexist in an imaginary scene. Jesus' Jewish origins might be the only historical thread linking him to such unrelated themes. Another instance of such a use of Christian symbolism is found in the Israeli artist Batya Apollo's allegorical painting *The Birth of the Zionist Dream* (1966; fig. 15). In a typically Renaissance frame and background a Mary-like figure holds a child who is none other than the bearded figure of Theodor Herzl, the father of Zionism, depicted as the infant Saviour and the (secular) Messiah of the Jewish people.

In the work of contemporary Israeli photographers, and especially in the field of photojournalism and images with political content, artists such as Micha Kirshner (p. 156), Miki Kratzman (p. 178) and Pavel Wolberg (p. 180) make use of explicit Christian themes, such as a Madonna and Child, a Deposition from the Cross or a Lamentation, yet not as Christian symbols or from a Christian point of view, but rather as visual conventions imported directly

from art history. Such are Efrat Natan's installation shot (p. 121) and Adi Nes's Last Supper (pp. 62–63) and wounded soldier (p. 168), while Deganit Berest (p. 109) finds in Christ's wound the best vehicle to express a personal emotional ordeal.

A photograph is a relic. Like a fossil or an archaeological artefact, it is a shred of evidence, a lasting trace of something that existed but has disappeared. However, when it comes to photographs with religious content – scenes from the Passion or re-enactments of biblical events – this principle ceases to exist altogether, and the evidential dimension of the medium is destroyed. In the end what we are left with is just a product of the artist's imagination.

Over the centuries and generations, cultures, nations, ethnic groups and denominations adopted temporary standards for the likeness of Christ particularly adjusted to specific needs of time and place. Nevertheless, the variation is such that Jesus' interrogation of his disciples on the shores of Caesarea, "Who do you say I am?" (Matthew 16:15),[59] can and should be directed to all those artists who, over the last two thousand years, and across cultures and generations, have imagined, interpreted and depicted him in a variety of modes and styles. Consequently, the image and the concept of Christ transcend attributes and symbols, dogmas and religious beliefs. They have become universal motifs that not only lie at the core of Western art, culture and civilization but also hold

Fig. 16
Jack Pierson (American, b. 1960), *Jesus*, 1998,
The Israel Museum Collection, Jerusalem,
gift of Robert Saligman Charitable Foundation, New York,
to American Friends of The Israel Museum

Fig. 17
Mark Wallinger (British, b. 1959), *Ecce Homo*, 1999,
The Israel Museum Collection, Jerusalem, gift of Roslyn and
Lesley Goldstein, New York, Peter and Shawn Leibowitz, New
York, Joan and Alan Safir, New York, and The Stanley H. Picker
Trust, London; and the West Coast Contemporary Art
Acquisitions Committee of American Friends of The Israel
Museum

a dominant grip on visual literacy that transcends countries and cultures. The representation and uses of images of Christ are so widespread and varied that all we can say of him is that – according to the artists – Christ is what one makes of him: he is who one says, believes or imagines he is.

Looking at the image of Christ through the interpretations of photographers during the last century and a half almost leads the viewer to discover a new photographic Gospel, in which each artist adds something personal, and renders Christ more human, more real, at eye level with the spectator, even if at times the image on the surface is not to the liking of all. Yes, photography is the medium capable of providing a means of producing 'the perfect likeness' – but of whom? On a more earthly plane, in producing such visions of biblical allegories, scenes from the Passion and 'portraits' of Jesus, photography deliberately undermines its own credibility and the permanent aura of truthfulness attributed to the medium, disclosing the secret of the artifices behind a seemingly documentary or realistic picture.

The question arises whether, in contemporary creation, controversial photographs, such as the ones by Andres Serrano, Sam Taylor-Wood, Renée Cox, Gilbert and George, or in other media the pop singer Madonna's 1980 album *Immaculate Collection,* Yoko Ono's 1965 performance *Sky Piece for Jesus Christ*, Jack Pierson's *Jesus* (1998; fig. 16) or Mark Wallinger's *Ecce Homo* (1999; fig.17), could still be catalogued under the rubric of sacred art. No matter how one looks at them, and notwithstanding the issues of context and intention, these are still the result of a two-thousand-year-old visual tradition, and they are informed by an immense reservoir of imagery assimilated and refined by generations of artists. These are no more the fruit of what Paul Valéry called "the ancient craft of the Beautiful".[60] It is obvious that photographs, especially today, even if mass-produced and marketed as modern icons, do not carry a "cult value"[61] any more. Therefore, in accordance with Freud's principle, the "work of art is regarded not as a simply visible thing to be enjoyed, but as a many-leveled vehicle for hidden meanings".[62]

The investigation of the image of Christ in art as well as its photographic interpretation are bound to continue as long as faith and dogma exist, and at least as long as part of humankind believes in the existence of some kind of Supreme Being.

This is an unending pursuit comparable to the eternal quest for the Holy Grail: a concept and an ideal, and beyond all else, a mythical object of yearning and of lasting belief. The search for the image as such, and as an act of faith, are more important than the subject itself.

What is divine is the process of creation.

NOTES

1 Medieval Sourcebook: The Second Council of Nicaea, 787.

2 *Ibid.*

3 Kenneth Clark, *The Nude: A Study in Ideal Form*, Princeton NJ (Princeton University Press) 1972, p. 233.

4 Quoted in E.H. Gombrich, *The Story of Art*, Oxford (Phaidon Press) 1977, p. 95.

5 Jaroslav Pelikan, *Jesus Through the Centuries: His Place in the History of Culture*, New Haven CT and London (Yale University Press) 1999, p. 87.

6 Giorgio Vasari, *Lives of the Most Eminent Painters, Sculptors and Architects*, London (G. Bell and Sons) 1914, II, p. 376.

7 In the framework of a comprehensive exhibition held at The Israel Museum in 2000, the religious painting of the nineteenth century is discussed in Yigal Zalmona's article 'Sacred Scenes in Nineteenth-Century Landscape Painting' in Gill Pessach (ed.), *Landscape of the Bible: Sacred Scenes in European Master Paintings*, Jerusalem (The Israel Museum) 2000, pp. 37–44.

8 Aaron Scharf, *Art and Photography*, New York (Pelican Books) 1975, p. 97.

9 Helmut Gernsheim, *Creative Photography: Aesthetic Trends 1839–1960*, New York (Dover Publications) 1962, p. 133.

10 *Ibid.*, p. 134.

11 The name Veronica lends itself to a play on the word and has often been interpreted as *vera icon*, which means 'true image', and therefore the cloth itself is called the Veronica, and is one of the most replicated images in Christendom.

12 Carbon-dating test has helped in setting the origins of the shroud to approximately 1260–1390.

13 Arguments concerning the 'true nature' of the image on the shroud have been developed *ad infinitum*, with special insistence on its photographic origin, including actual experiments. In this context, the Web has become the most convenient channel to disseminate such ideas. See for example the two articles by Nicholas P.L. Allen, claiming that the image is definitely photographic and that it was created by photographic procedures already known and used in the middle ages, at: http://www.unisa.ac.za/dept/press/dearte/51/dearturn.html and http://www.petech.ac.za/shroud/isthe.htm.

14 Georges Didi-Huberman, 'The Index of the Absent Wound (Monograph on a Stain)', *October*, no. 29, Summer 1994, p. 65.

15 Pierre Barbet, *Les Cinq Plaies du Christ*, Paris (Editions Dillen & Cie) 1935, p. 6.

16 *Ibid.*

17 Father Marcel Dubois, a Dominican priest and professor of philosophy at the Hebrew University of Jerusalem, whom I consulted several times while working on the exhibition, remarked after having seen the photographs that for him "photography is an extension of the incarnation".

18 Edmund Teske, *Images from Within*, Carmel CA (Friends of Photography) 1980.

19 Michal Sapir, 'The Impossible Photograph: Hippolyte Bayard's Self-portrait as a Drowned Man', *Modern Fiction Studies*, XL, no. 3, 1994, pp. 619–29. In her article Sapir discusses at length the significance of this early photograph, and yet, following the idea originally put forward by André Jammes and Eugenia Parry Janis (*The Art of French Calotype*, Princeton NJ [Princeton University Press] 1983), she maintains that the scene is primarily a parody of Jacques-Louis David's *Death of Marat*.

20 In her article 'Les Photographies d'Eugène Delacroix' (*Revue de l'art*, no. 127/ 2000–2001, pp. 62–69) Sylvie Aubenas suggests that Durieu, who was an accomplished photographer but was still using the calotype in the mid-1850s, deliberately threw out of focus or added motion blur to many of the photographic studies he executed for Delacroix.

21 In painting, female crucifixions were much less common and could be seen mostly in the work of the Symbolist painters.

22 Ernest Lacan, *Esquisses photographiques*, Paris 1856, p. 20.

23 This is true for circles outside Dada and Surrealism and for all artistic disciplines, including cinema. The fact that, with a few exceptions, religious imagery was almost nonexistent between the world wars, and from then until the 1950s, should become the subject of more extensive research.

24 Mark Polizzotti, *Revolution of the Mind: The Life of André Breton*, New York (Farrar, Straus and Giroux) 1995, p. 352.

25 André Breton and Paul Eluard, *L'Immaculée Conception*, Paris (Editions Surréalistes) 1930, p. 120.

26 *Un cadavre*, Paris (Imprimerie du Cadavre) 1930.

27 Julia Kristeva, *Histoires d'amour*, Paris (Editions Denoël) 1983, p. 182.

28 *Un Cadavre, op. cit.* note 26, p.1.

29 *Ibid.*, p. 4

30 In a private conversation, Arturo Schwarz explained that the Surrealists constantly accused Catholicism and denounced its social attitude, and especially the relationship to women, while they treated other religions with much respect, especially Judaism,

because of their interest in the Kabbalah. See Arturo Schwarz, *Dreaming With Open Eyes*, Jerusalem (The Israel Museum) 2000. However, on the same subject Gérard Lévy argues that although they wrote acerbically against religion and the Church, the Surrealists did not dare to create explicit images, either because they did not want to alienate their believer friends, or because they realized that this would be going 'one scandal too far' and feared the inevitable, violent reaction that would have been detrimental to their already controversial image.

31 Norman Mailer, *The Gospel According to the Son*, New York (Ballantine Books) 1997, p. 45.

32 It was almost natural for Man Ray to portray Rigaut in a Christlike pose because the poet considered himself to be a martyr; since untimely and painful death is the fate of most martyrs, his suicide was most predictable.

33 Polizzotti, *op. cit.* note 24, p. 354.

34 Diana Emery Hulik (ed.), *Photography: 1900 to the Present*, Upper Saddle River NJ (Prentice Hall) 1998, p. 84.

35 Michael Bartram, *The Pre-Raphaelite Camera*, Boston (New York Graphic Society) 1985, p. 102.

36 Jorge Luis Borges, 'The Gospel According to Mark', *Selected Fictions*, New York (Penguin Books) 1998, p. 400.

37 Arièle Bonzon, *Ecrits dans le noir: Chère absente: Fondations/Epiphanie*, Lyon (Environ Infini) 1994.

38 C.M. Kauffman, 'Biblical Imagery in European Landscape Painting', in Pessach, *op. cit.* note 7, p. 16.

39 Mailer, *op. cit.* note 31, p. 3.

40 Rudolf Arnheim, *Towards a Psychology of Art*, Berkeley CA and Los Angeles (University of California Press) 1966, p. 44.

41 Jacques Barzun, *The Use and Abuse of Art*, Princeton NJ and London (Princeton University Press), 1974, p. 126.

42 Walter Benjamin, *Illuminations*, New York (Schocken Books) 1969, p. 222.

43 Leon Battista Alberti, *Della Pittura*, ed. L. Mallé, Florence, 1950, p. 77, quoted in Philippe Junod, '(Auto)portrait de l'artiste en Christ', in Erika Billeter (ed.), *L'Autoportrait à l'âge de la photographie: Peintres et photographes en dialogue avec leur propre image,* Lausanne (Musée Cantonal des Beaux-Arts) 1985.

44 *Ibid.*, pp. 59–79. Philippe Junod's article discusses at length the phenomenon of painters' self-portraits as Christ, and the historic and artistic traditions and relationships between classical and contemporary artists.

45 Nancy Burson, *Seeing and Believing: The Art of Nancy Burson*, Santa Fe NM (Twin Palms Publishers) 2002, p. 150. Burson's 'Healing' series also carries a deeply mystical dimension, and many images, such as *Starr* (1998), are directly linked to religious scenes.

46 The affliction was first identified in the 1930s by Dr Heinz Herman, the father of Israeli psychiatry, and later researched in depth by Dr Yair Bar-El, director of the Kfar Shaul Mental Health Center in Jerusalem, where most such patients are hospitalized for the duration of the episode.

47 These facts were validated by the clinical psychologist Professor Yoel Elizur of the Hebrew University of Jerusalem, who is also an active photographer. Professor Elizur believes that F. Holland Day experienced a similar phase of mystical ecstasy as he planned and executed the series.

48 Clark, *op. cit.* note 2, p. 231.

49 Georges Bataille, *Théorie de la religion*, Paris (Gallimard) 1973, p. 60.

50 Eleanor Heartney, 'Blood, Sex, and Blasphemy: The Catholic Imagination in Contemporary Art', *New Art Examiner*, XXVI, no. 6.

51 *Ibid.*

52 Julia Kristeva, *Au commencement était l'amour: Psychanalyse et foi*, Paris (Hachette) 1985, pp. 62–63.

53 Herbert Marcuse, *Eros and Civilization*, London (Sphere Books) 1969.

54 Shlomit Steinberg, 'Mishima and the St Sebastian Syndrome', *Muza Art Quarterly*, January 2001, p. 28 (Hebrew).

55 Kristeva, *op. cit.* note 27, p. 179.

56 *Ibid.*

57 This is certainly not the case for such works as Félicien Rops's *La Tentation de Saint Antoine* (1878), which was, in the artist's own words, just a good excuse to paint from nature a beautiful woman.

58 Chaim Potok, *My Name is Asher Lev*, New York (Alfred A. Knopf) 1972, p. 330.

59 The episode where Jesus questions his disciples is also described in the Gospels by Mark (8:29) and Luke (9:20).

60 Paul Valéry, *Aesthetics*, New York (Pantheon Books) 1964, p. 225.

61 Benjamin, *op. cit.* note 42, p. 224.

62 Jack J. Spector, *The Aesthetics of Freud: A Study in Psychoanalysis and Art*, New York (McGraw-Hill) 1972, p. 166.

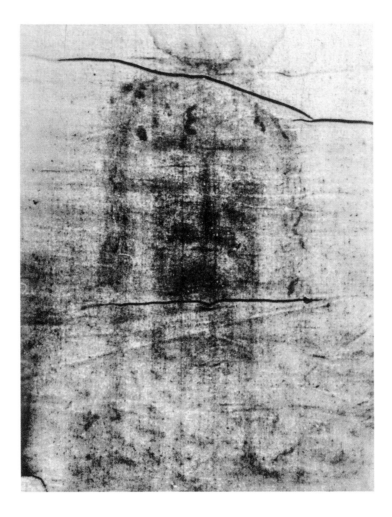

Secondo Pia (Italian), *The Shroud of Turin, Head*, 1898
photogravure, The Israel Museum Collection, Jerusalem, gift of Michael S. Sachs, Westport CT

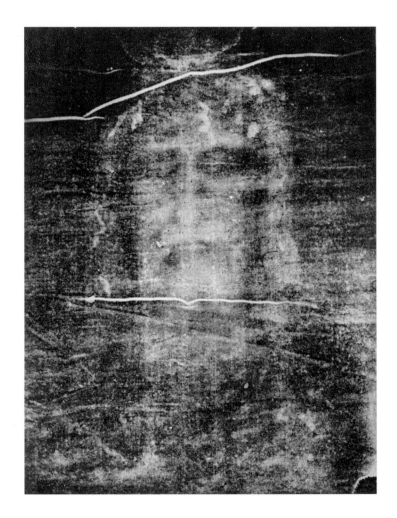

Secondo Pia (Italian), *The Shroud of Turin, Head*, 1898
gelatin silver print, The Israel Museum Collection, Jerusalem, gift of Michael S. Sachs, Westport CT

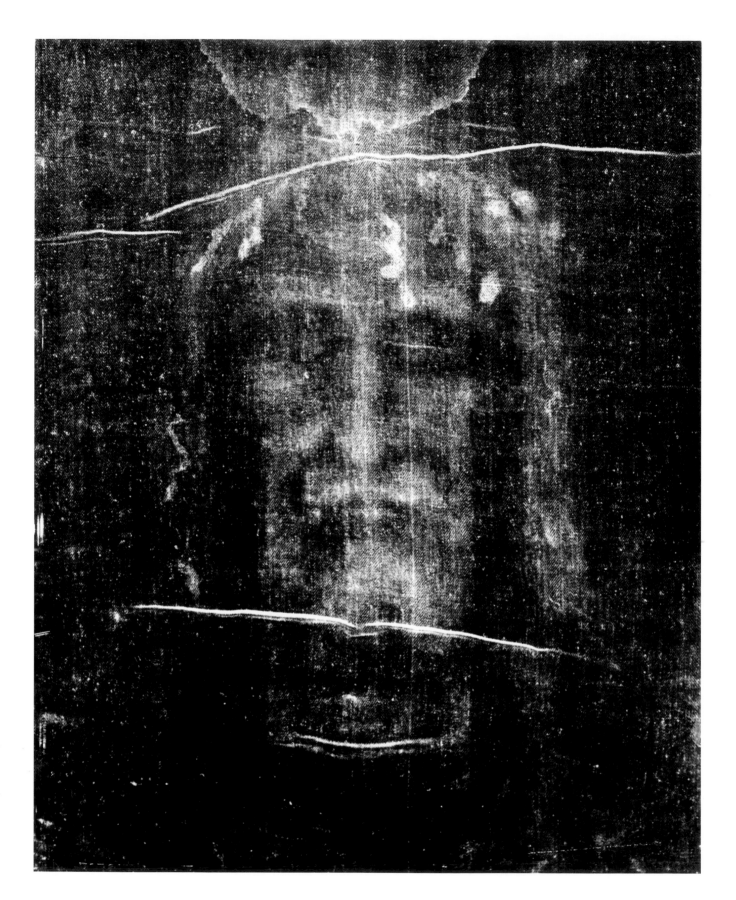

Giuseppe Enrie (Italian), *The Shroud of Turin*, 1931
gelatin silver print, The Israel Museum Collection, Jerusalem, gift of Michael S. Sachs, Westport CT

Raymond Voinquel (French, 1912–1994), *Sketch for La Divine Tragédie by Abel Gance*, 1949
gelatin silver print, Ministère de la Culture, Paris

Unidentified, *Jerusalem*, 1860s
albumen print, private collection

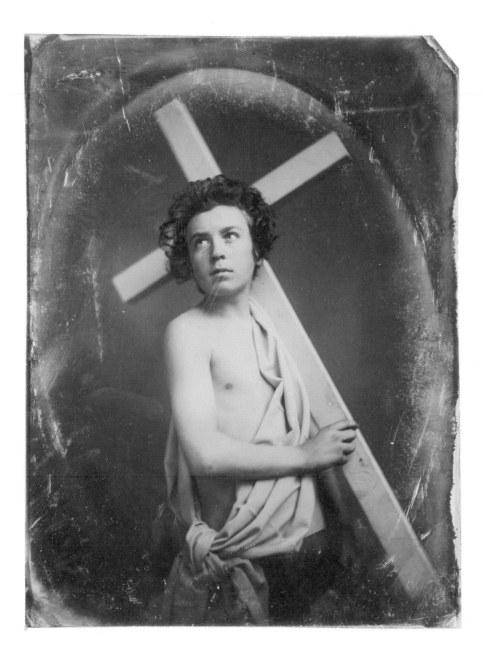

Gabriel Harrison (American, 1818–1902), *The Infant Saviour Bearing the Cross*, c. 1850
daguerreotype, courtesy of George Eastman House, New York

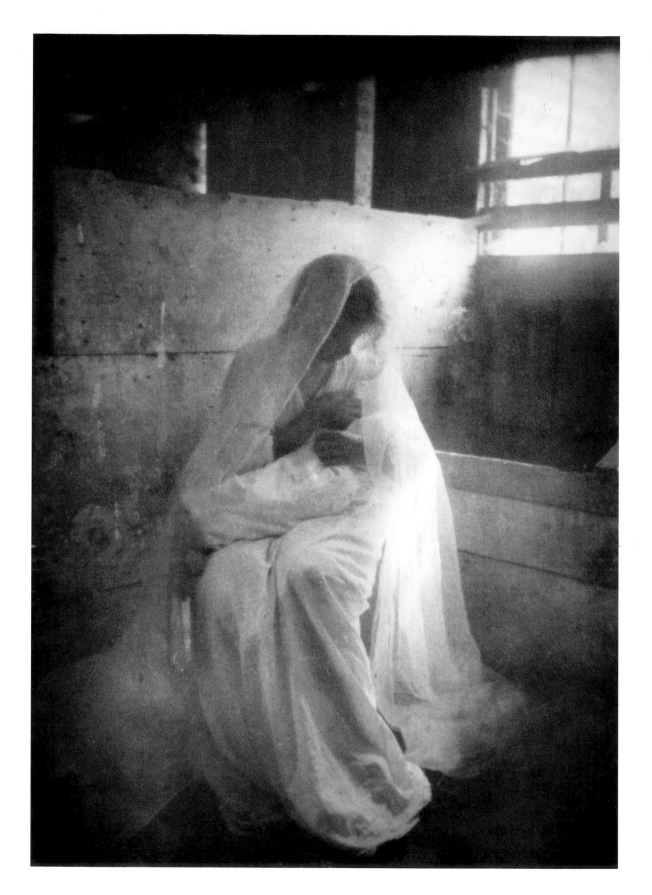

Gertrude Käsebier (American, 1852–1934), *The Manger*, 1899
photogravure, Prints & Photographs Division, Library of Congress, Washington, D.C.

Rudolf F. Lehnert (Austrian, 1878–1948) and Ernst H. Landrock (German 1878–1966) (Lehnert et Landrock active 1904–1930), *Maternité, c.* 1910
albumen print, Gérard Lévy Collection, Paris

John Demos (Greek, b. 1944), *Messolonghi*, 1986
gelatin silver print, lent by the artist, Thessaloniki, Greece

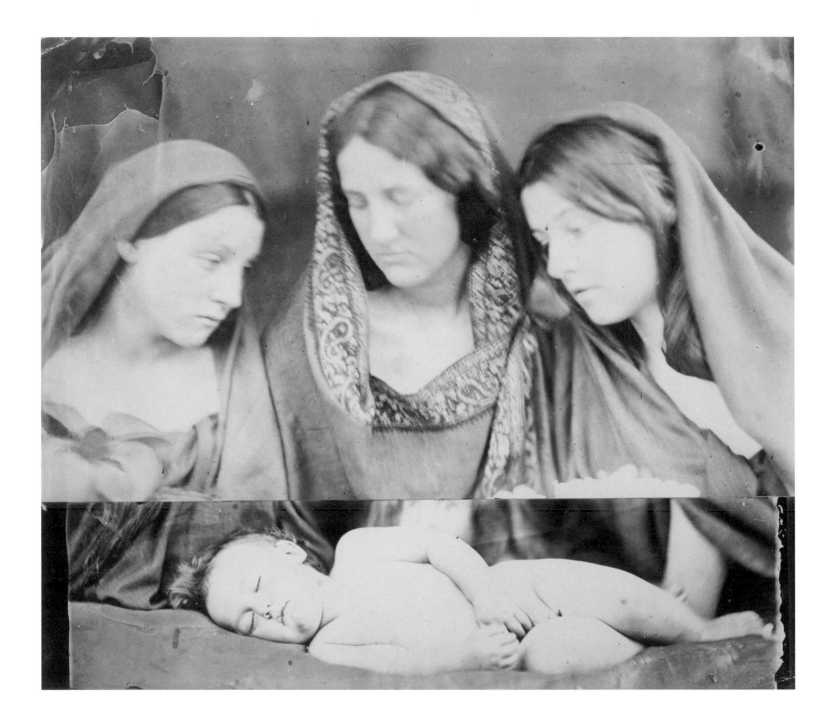

Julia Margaret Cameron (British, b. India, 1815–1879), *Adoration*, c. 1865
albumen print, courtesy of George Eastman House, New York

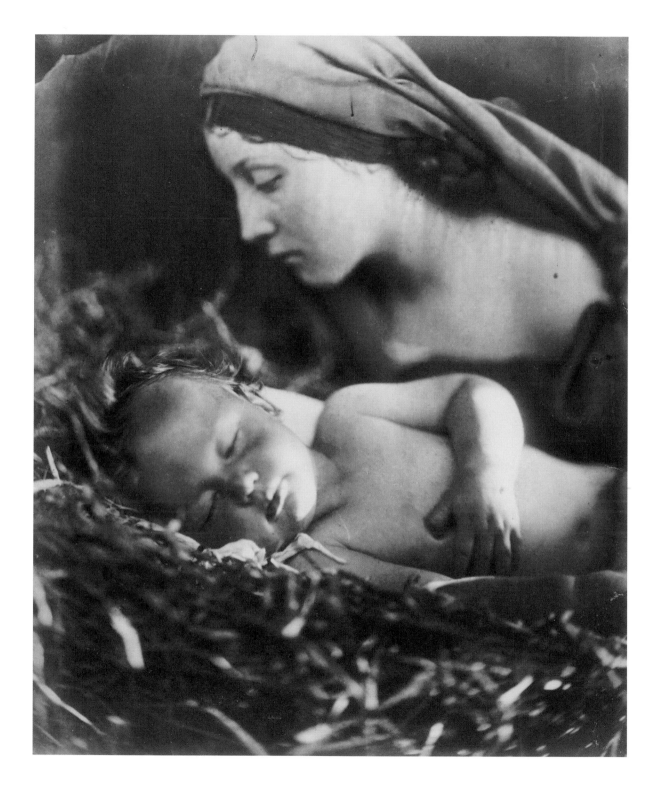

Julia Margaret Cameron (British, b. India, 1815–1879), *Light and Love*, 1865
albumen print, lent by The J. Paul Getty Museum, Los Angeles

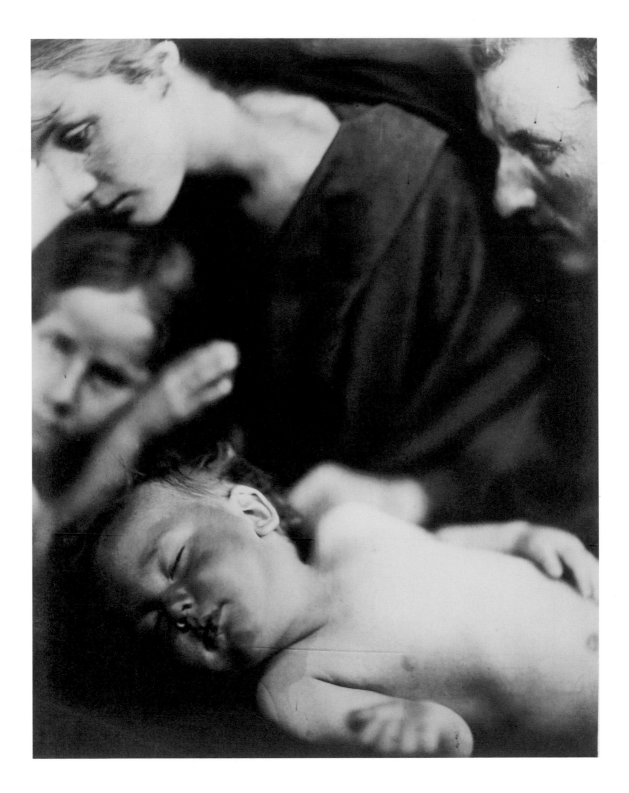

Julia Margaret Cameron (British, b. India, 1815–1879), *Prayer and Praise*, 1865
albumen print, lent by The J. Paul Getty Museum, Los Angeles

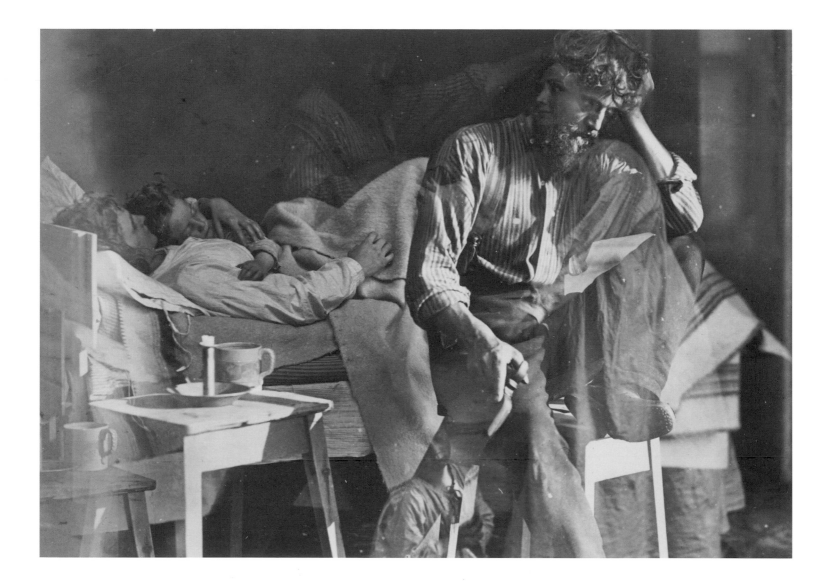

Oscar Gustav Rejlander (British, b. Sweden, 1813–1875), *Hard Times*, 1858
albumen print, courtesy of George Eastman House, New York

H. Korff (German), *Untitled (Oberammergau),* 1890
albumen prints, lent by Stephen Wirtz Gallery, San Francisco

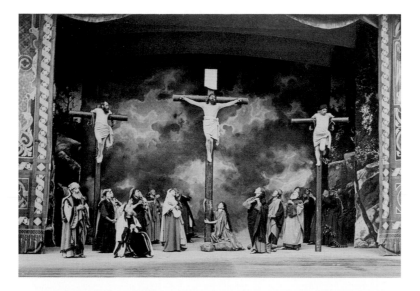

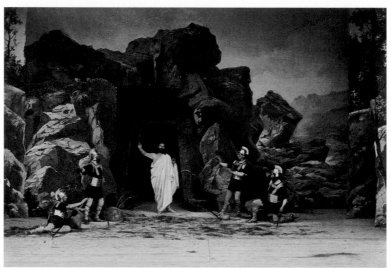

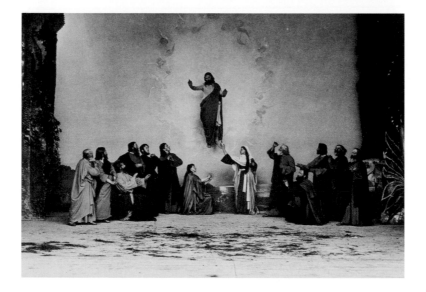

H. Korff (German), *Untitled (Oberammergau),* 1890
albumen prints, lent by Stephen Wirtz Gallery, San Francisco

43

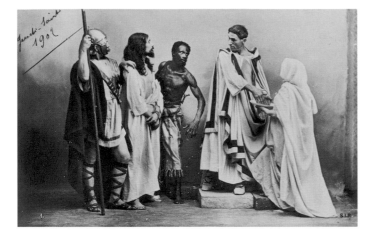
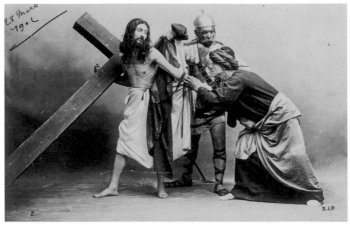
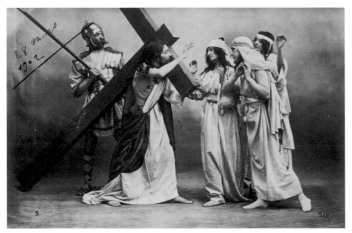
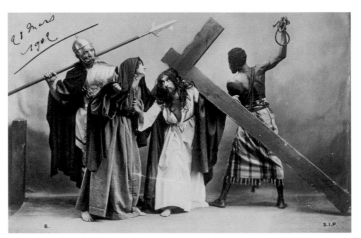
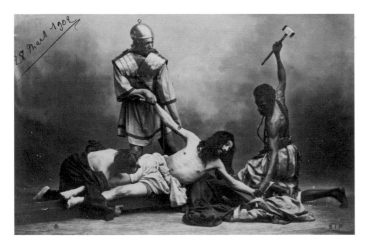
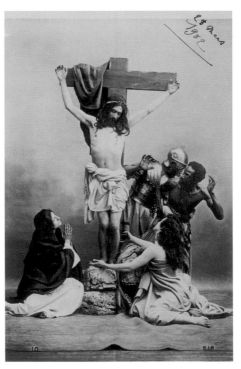

Unidentified, *Twelve Scenes from the Life of Jesus*, 1902
gelatin silver prints, The Israel Museum Collection, Jerusalem, gift of Gérard Lévy, Paris

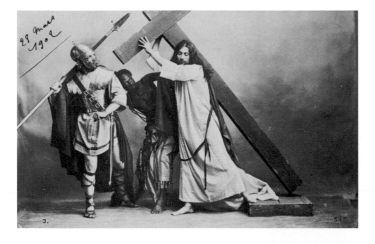
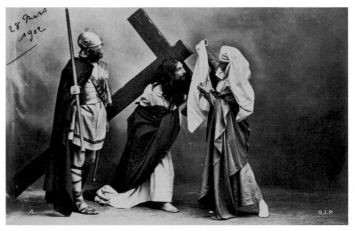
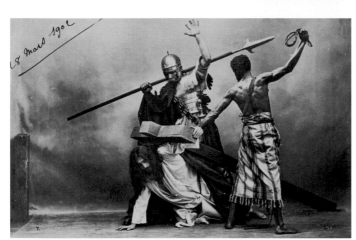
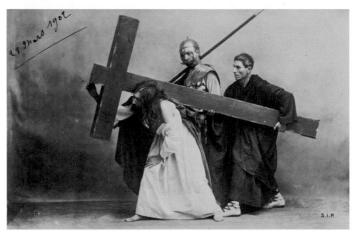
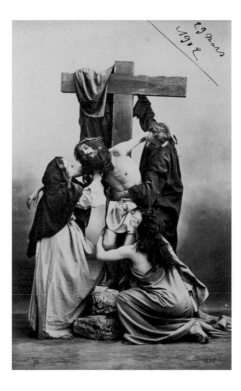
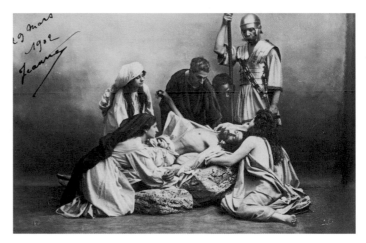

Unidentified, *Twelve Scenes from the Life of Jesus*, 1902
gelatin silver prints, The Israel Museum Collection, Jerusalem, gift of Gérard Lévy, Paris

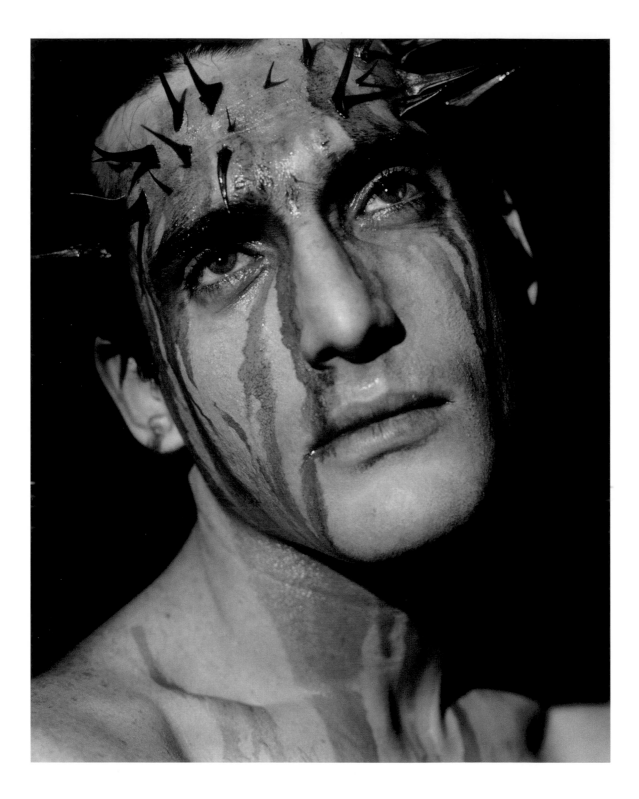

Bettina Rheims (French, b. 1952) and Serge Bramly (French, b. Tunisia, 1949), *Crown of Thorns*, 1997
chromogenic print, Collection Maison Européenne de la Photographie, Paris

Toni Catany (Spanish, b. 1942), *El Christ d'Esperreguera*, 1997
chromogenic print, lent by the artist, Barcelona

Unidentified, *INRI*, n.d.
lenticular photograph, private collection

Unidentified, *INRI*, n.d.
lenticular photograph, private collection

Unidentified, *INRI*, n.d.
lenticular photograph, The Israel Museum Collection, Jerusalem, gift of Michael S. Sachs, Westport CT

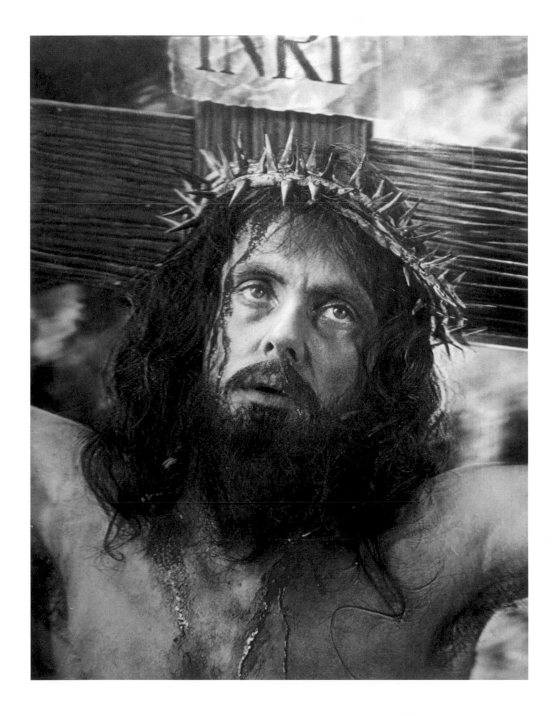

Unidentified, *INRI*, n.d.
lenticular photograph, The Israel Museum Collection, Jerusalem, gift of Michael S. Sachs, Westport CT

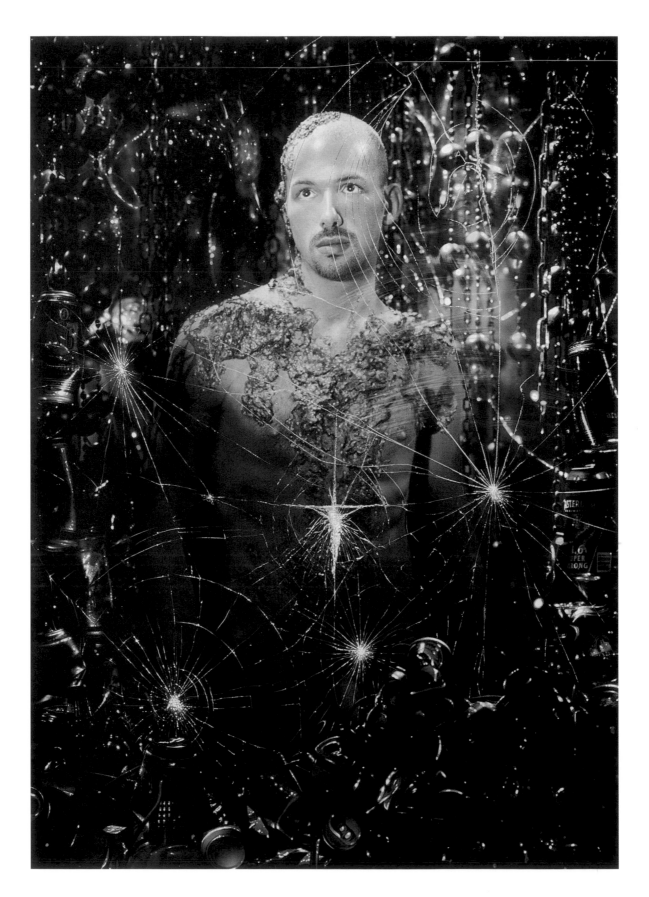

Pierre et Gilles (French, active together since 1976), *Jesus, Model Raphael*, 2000
hand-coloured photograph, courtesy of Pierre et Gilles and Galerie Jérôme de Noirmont, Paris

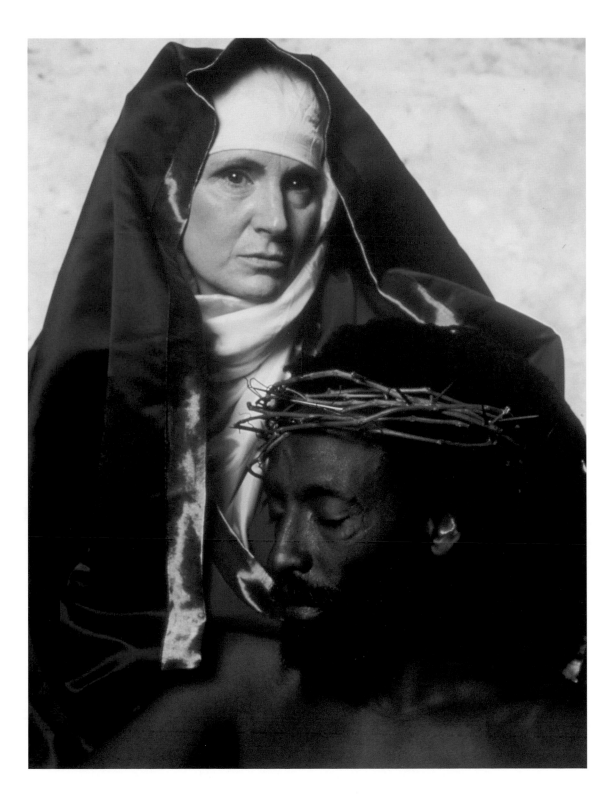

Andres Serrano (American, b. 1950), *The Interpretation of Dreams (The Other Christ)*, 2001
Cibachrome print, courtesy of the artist and Paula Cooper Gallery, New York

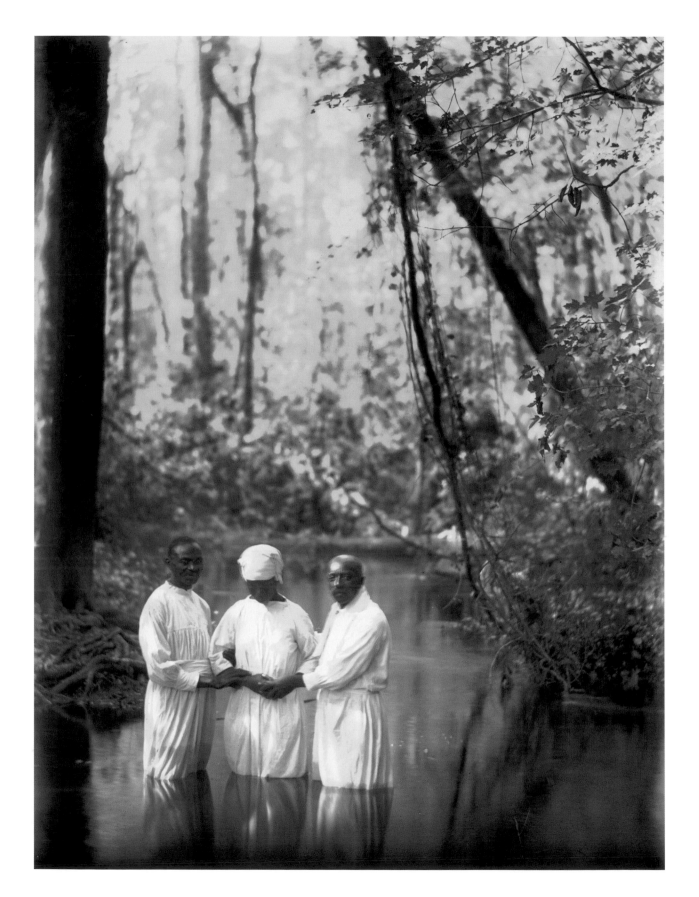

Doris Ulmann (American, 1882–1934), *Untitled*, c. 1928–34
Special Collections & University Archives, Doris Ulmann, Ph. 38, University of Oregon, Eugene

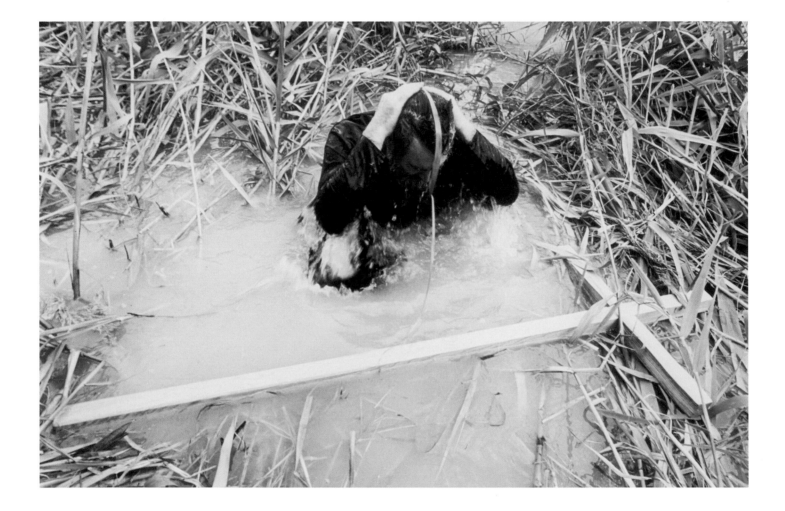

Noel Jabbour (Israeli, b. 1970), *Epiphany, Jordan River*, 18 January 2000
chromogenic print, The Israel Museum Collection, Jerusalem, gift of Loushy Art & Editions, Tel Aviv

Herlinde Koelbl (German, b. 1939), *Sacrificial Lamb*, 1998
chromogenic print, lent by the artist, Munich

Geno Rodriguez (American, b. 1940), *Untitled*, 1980
inkjet print, The Israel Museum Collection, Jerusalem, gift of the artist

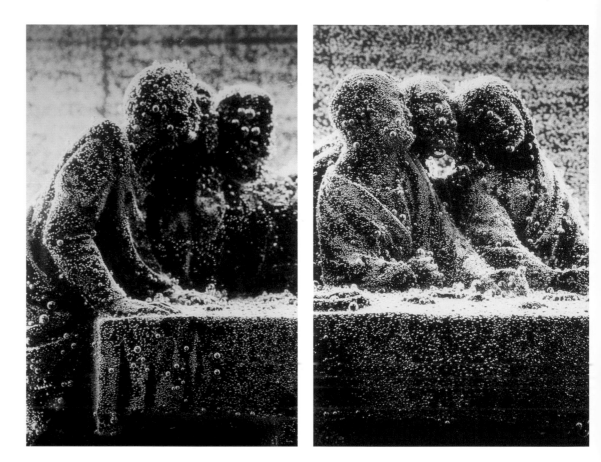

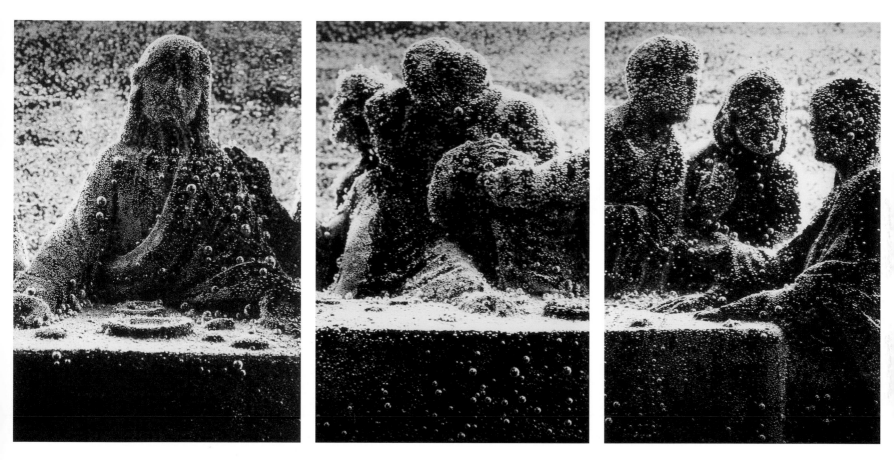

Andres Serrano (American, b. 1950), *Black Supper*, 1990
Cibachrome print, The Israel Museum Collection, Jerusalem, gift of Peter and Shawn Leibowitz, New York

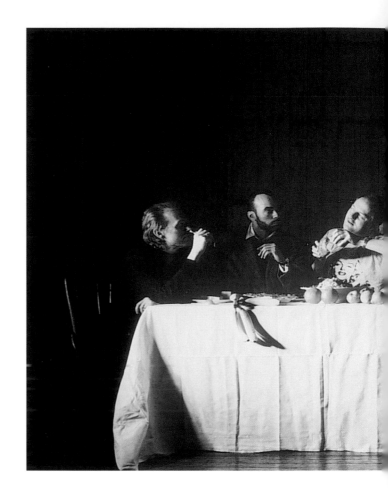

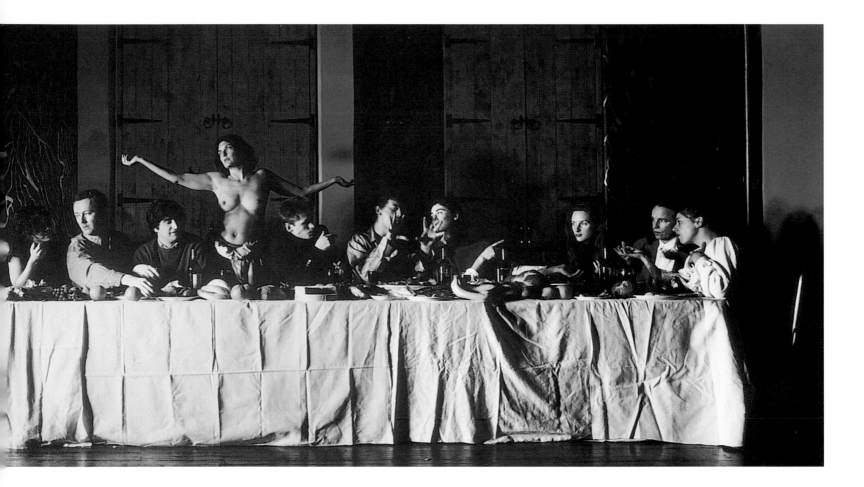

Sam Taylor-Wood (English, b. 1967), *Wrecked*, 1996
chromogenic print, from the collection of Sir Elton John

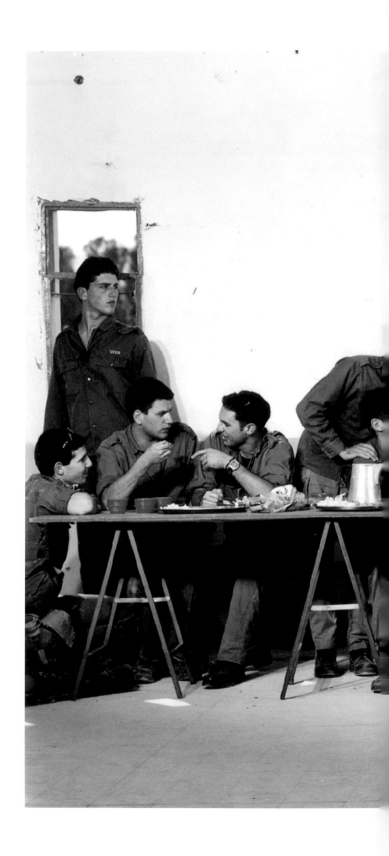

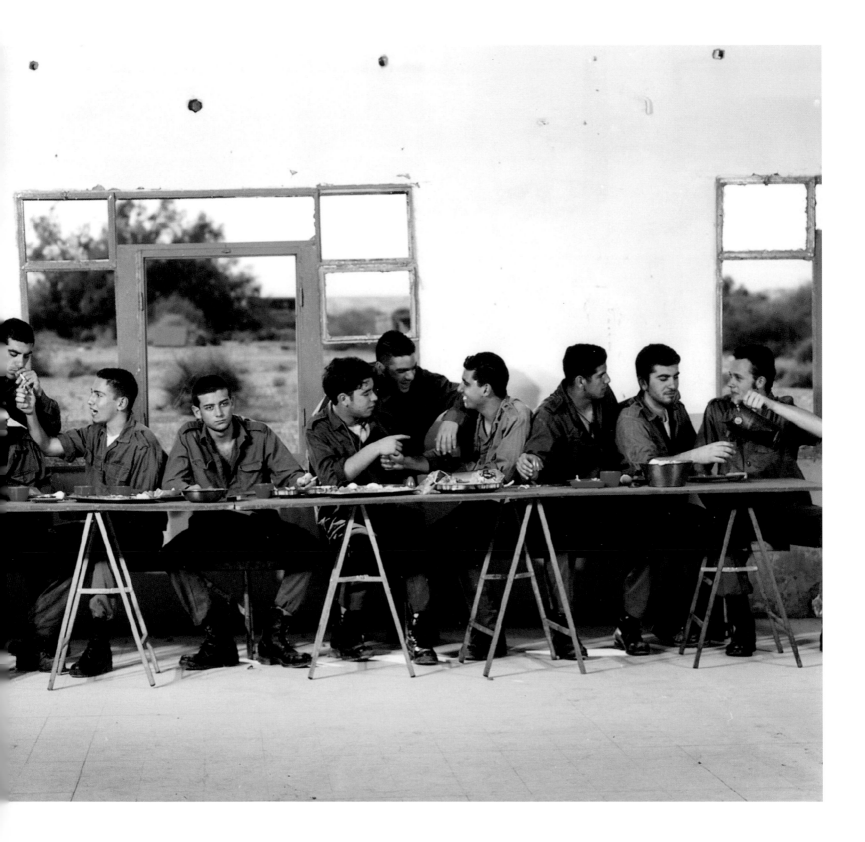

Adi Nes (Israeli, b. 1966), *Untitled*, 1999
chromogenic print, The Israel Museum Collection, Jerusalem, gift of Gary Sokol, San Francisco

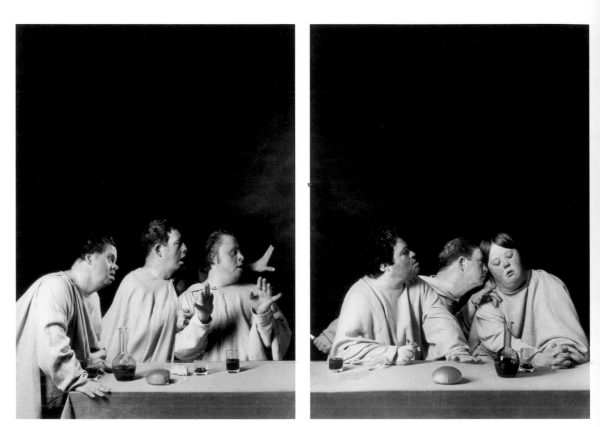

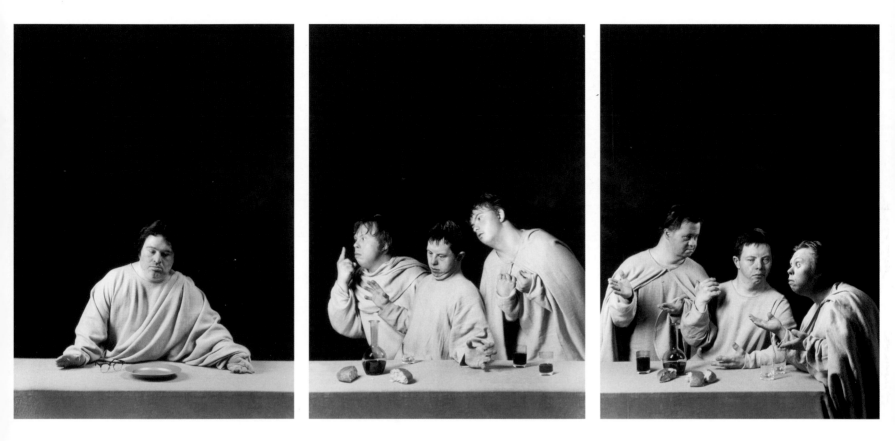

Rauf Mamedov (Azerbaijani, b. 1956), *The Last Supper*, 1998
chromogenic print, The Israel Museum Collection, Jerusalem, gift of Gary Sokol, San Francisco, and Loushy Art & Editions, Tel Aviv

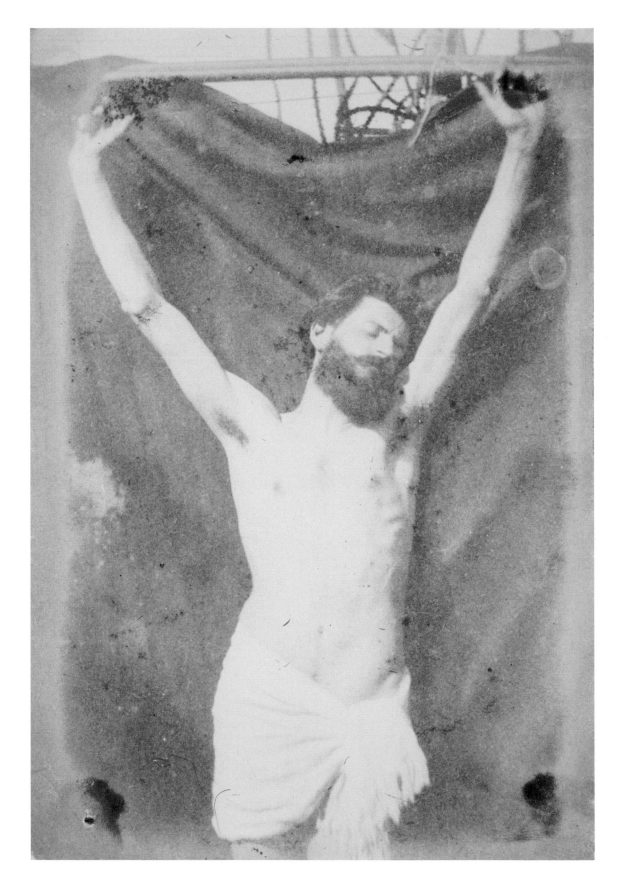

Eugène Durieu (French, 1800–1874), *Study of Crucifixion*, 1853–56
salt print, Gérard Lévy Collection, Paris

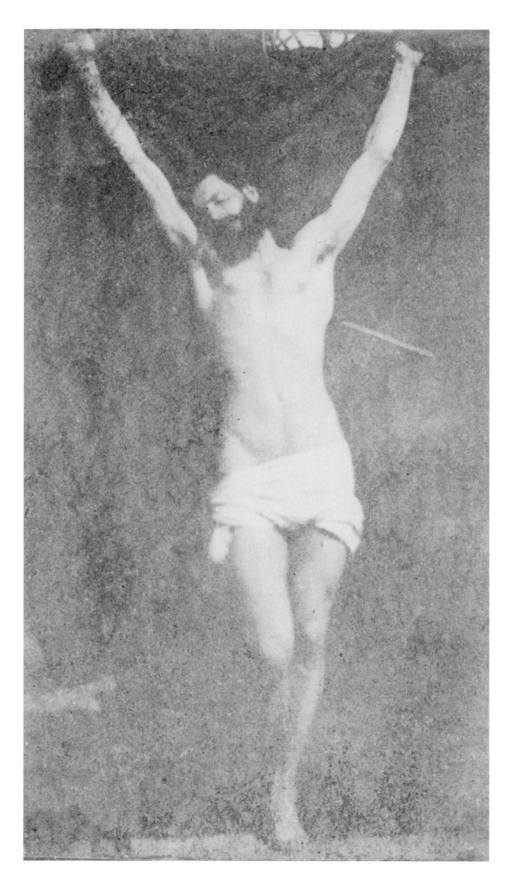

Eugène Durieu (French, 1800–1874), *Study of Crucifixion*, 1853–56
salt print, Gérard Lévy Collection, Paris

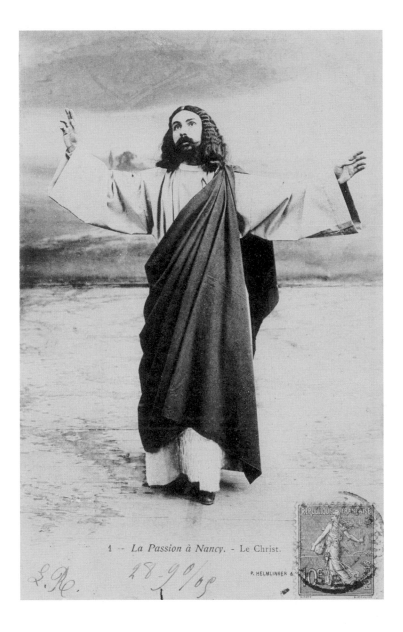

Unidentified, *La Passion à Nancy*, 1905
gelatin silver print, The Israel Museum Collection, Jerusalem, gift of Gérard Lévy, Paris

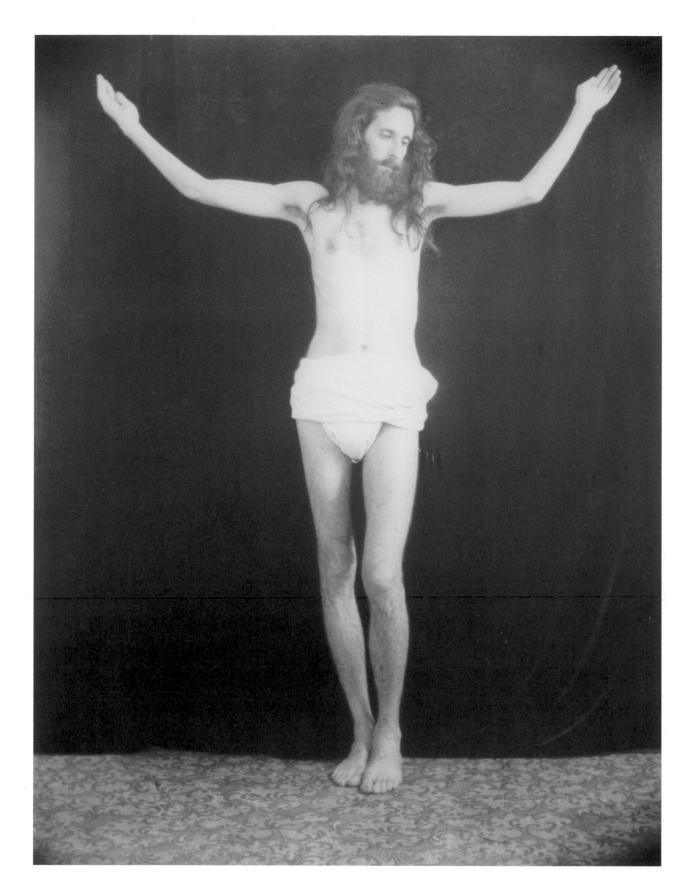

David McDermott (American, b. 1952) and Peter McGough (American, b. 1958), *Study of a Crucifixion 1904*, 1989
cyanotype, The Israel Museum Collection, Jerusalem, gift of Gorovoy Foundation, New York, to American Friends of The Israel Museum

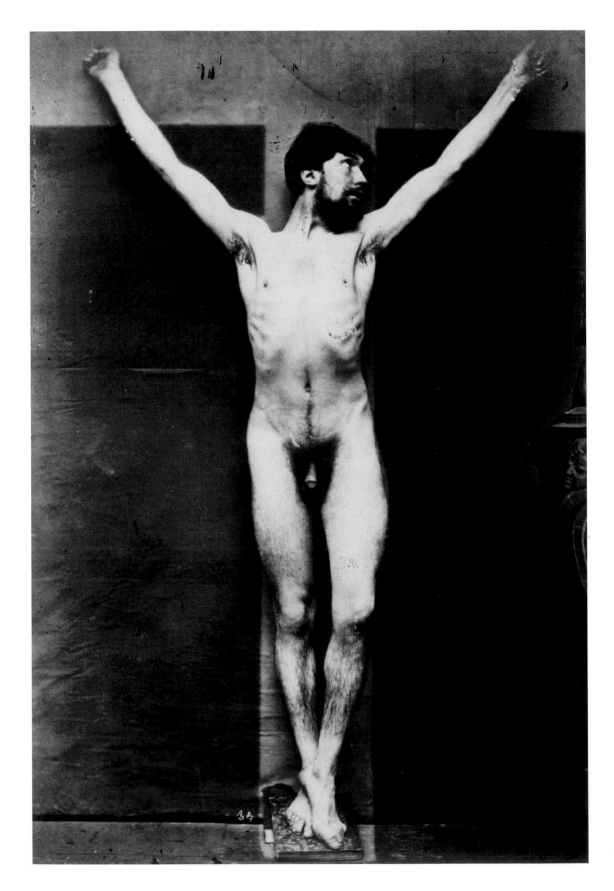

Gaudenzio Marconi, (French, active 1865–1875), *Untitled, c.* 1870
albumen print, Ecole Nationale Supérieure des Beaux-Arts, Paris

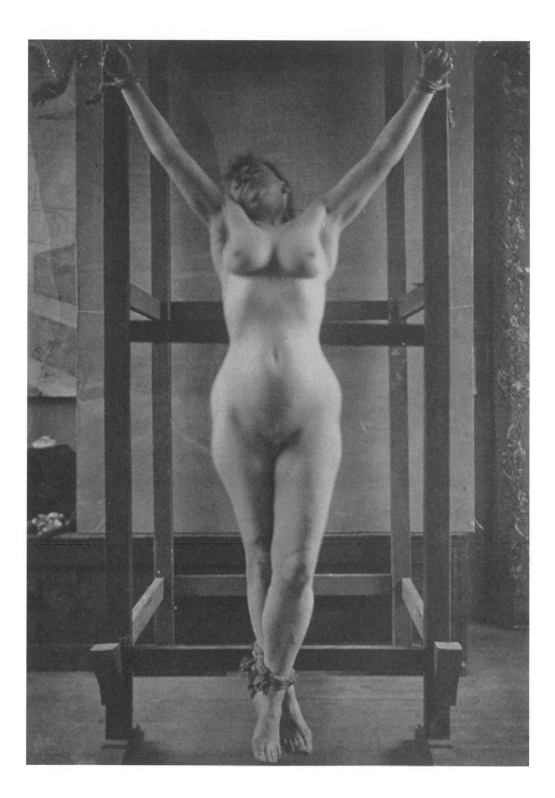

Charles-François Jeandel (French, 1859–1942), *Study, c.* 1890
cyanotype, lent by Musée d'Orsay, Paris

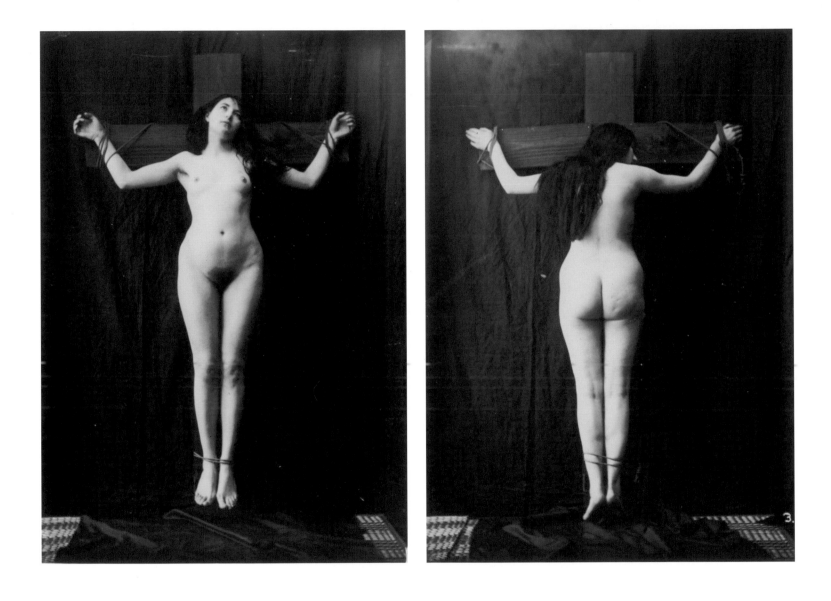

Unidentified, *Deux femmes en croix*, c. 1900
albumen prints, courtesy of Galerie 1900–2000, Paris

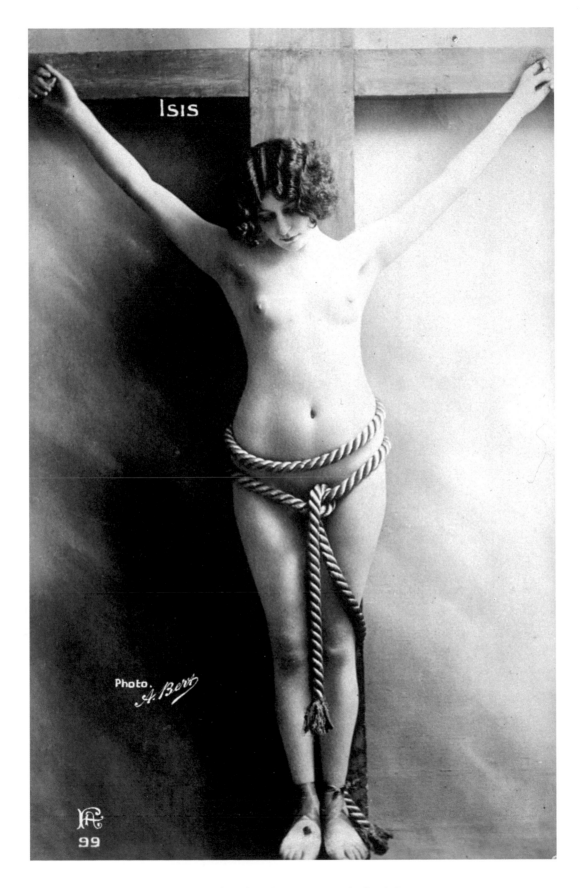

A. Bert (French, active 1880s–1910s), *Isis*, 1917
gelatin silver print, Gérard Lévy Collection, Paris

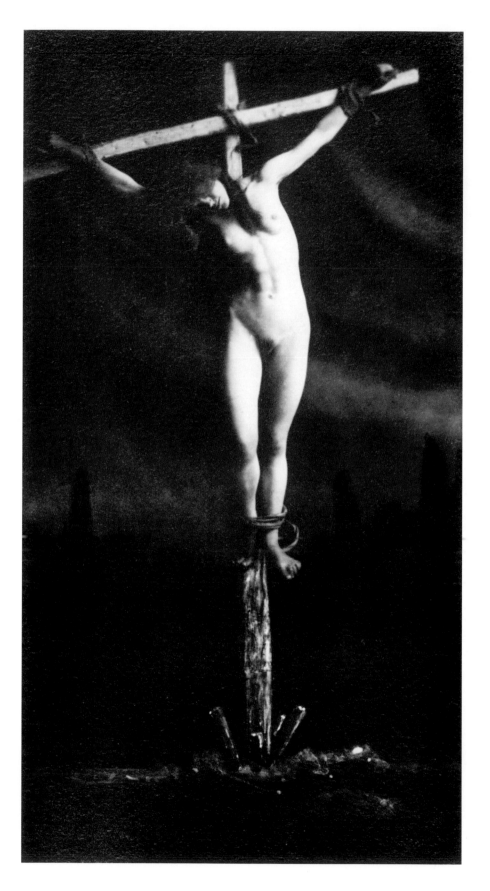

Frantisek Drtikol (Czech, b. Bohemia, 1883–1961), *Crucified Woman*, 1913
gelatin silver print, Gérard Lévy Collection, Paris

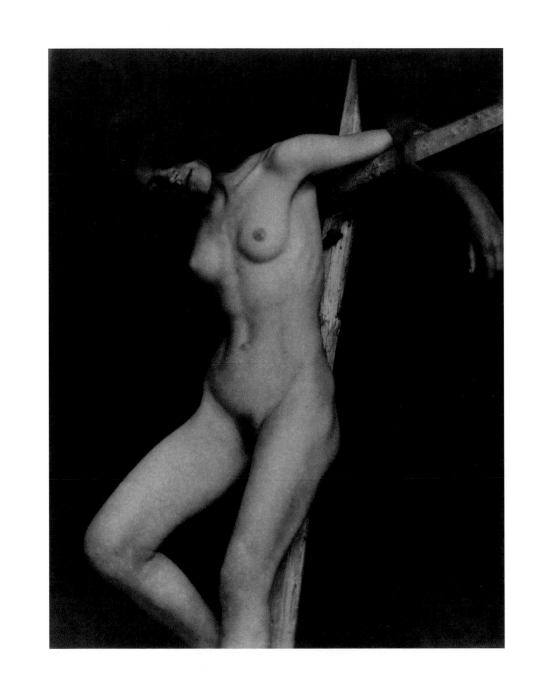

Frantisek Drtikol (Czech, b. Bohemia, 1883–1961), *Female Crucifixion*, 1913
gelatin silver print, The Israel Museum Collection, Jerusalem, gift of Robert Koch, San Francisco

Humberto Rivas (Argentinian, b. 1937), *J.C.*, 1992
gelatin silver prints, lent by the artist, Barcelona

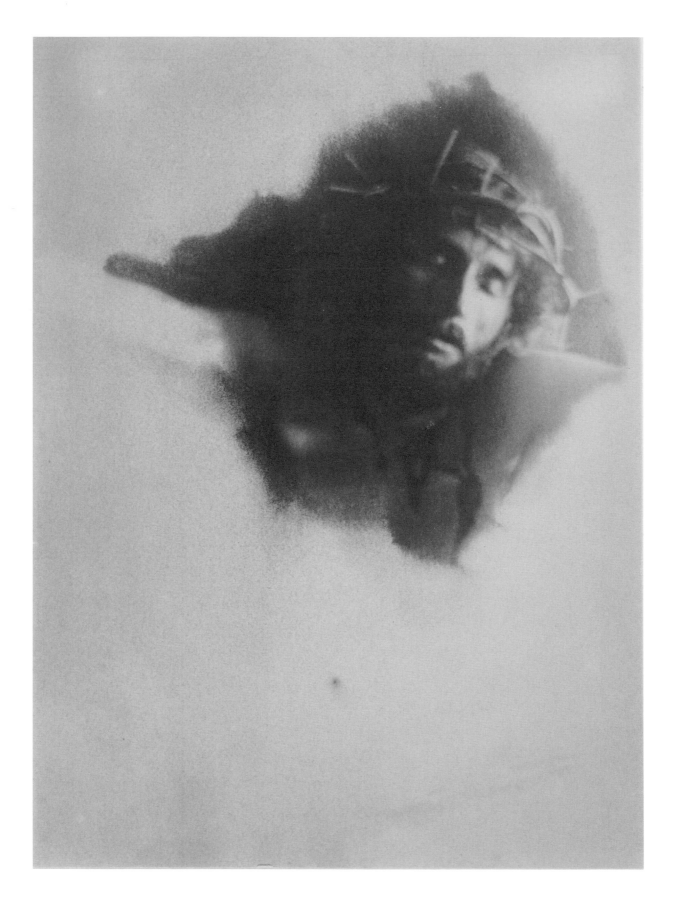

Fred Holland Day (American, 1864–1933), *It's Finished*, 1898
platinum print, Prints & Photographs Division, Library of Congress, Washington, D.C., lent by the Louise Imogen Guine Collection

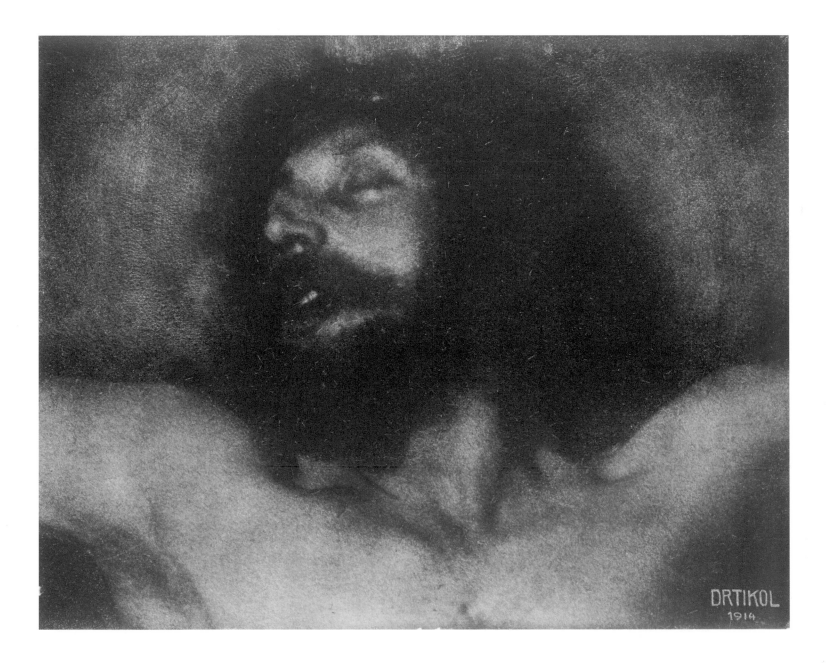

Frantisek Drtikol (Czech, b. Bohemia, 1883–1961), *Jesus*, 1914
oil print, lent by Jane Levy Reed, San Francisco

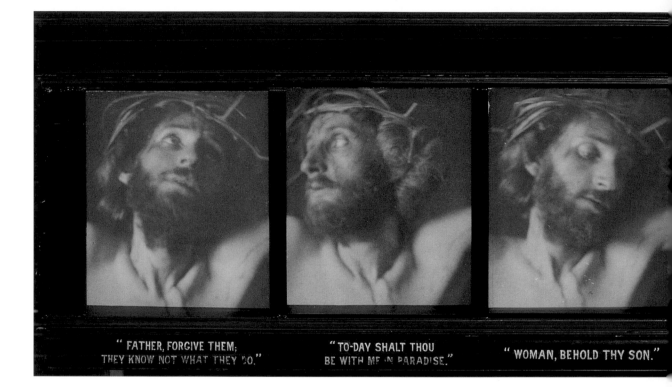

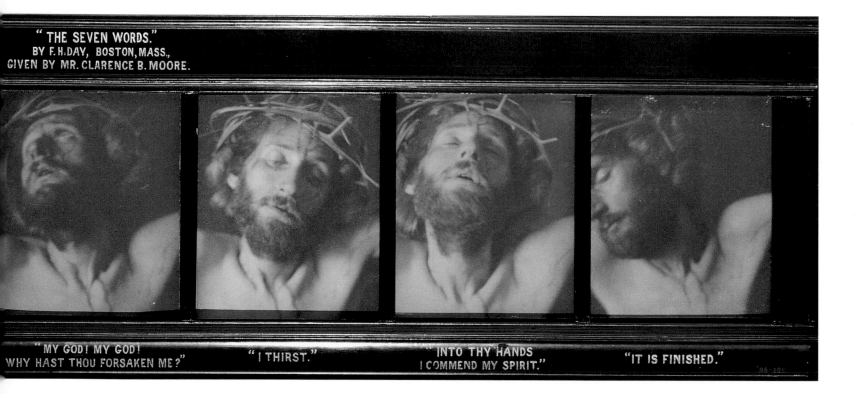

Fred Holland Day (American, 1864–1933), *The Seven Last Words of Jesus*, 1898
platinum prints, Bruce Silverstein Gallery, New York, Collection of Bruce Silverstein

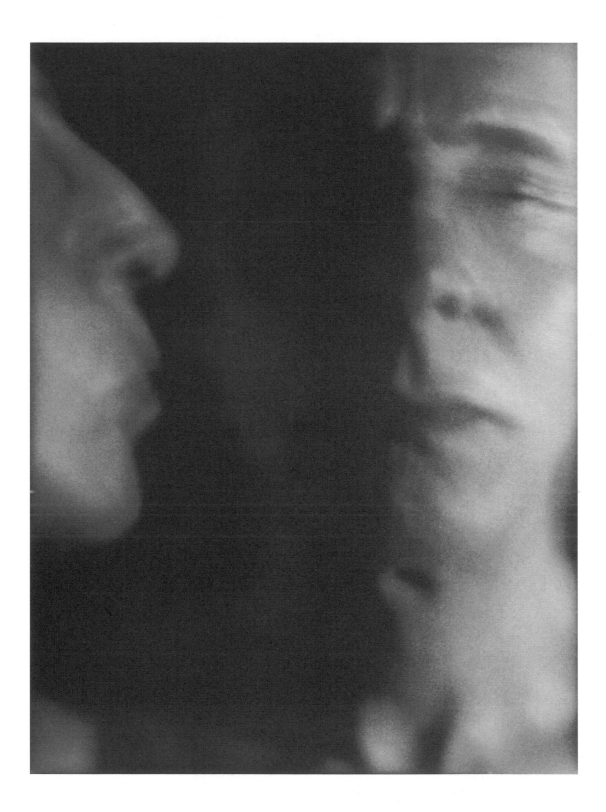

Jan van Leeuwen (Dutch, b. 1932), *Kiss of Judas*, 1992
vandyke kallitype, The Israel Museum Collection, Jerusalem, gift of the artist, Bennekom, The Netherlands

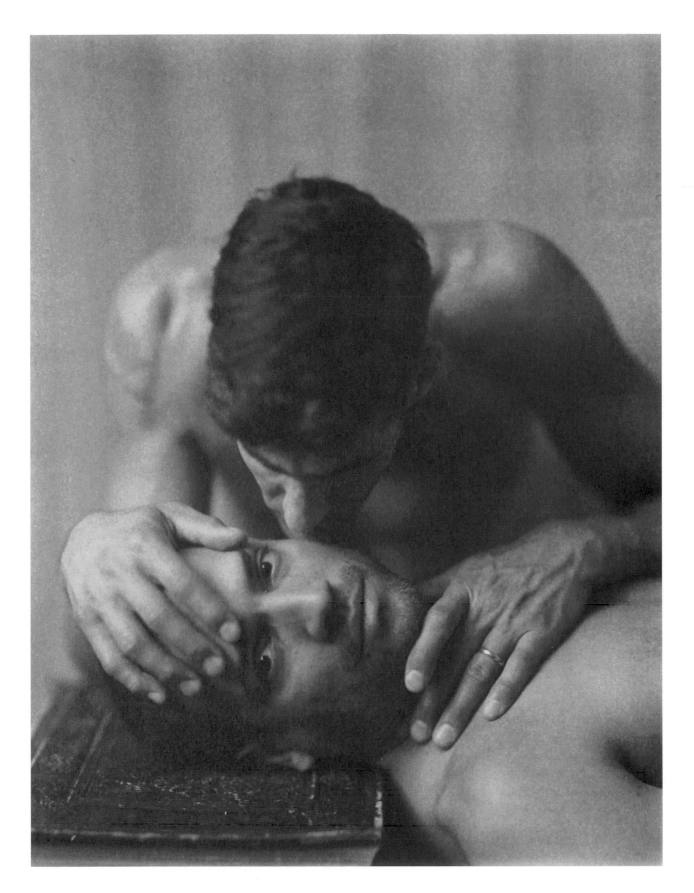

John Dugdale (American, b. 1960), *Lazarus, Brother of Mary and Martha*, 1999
cyanotype, lent by the artist, New York

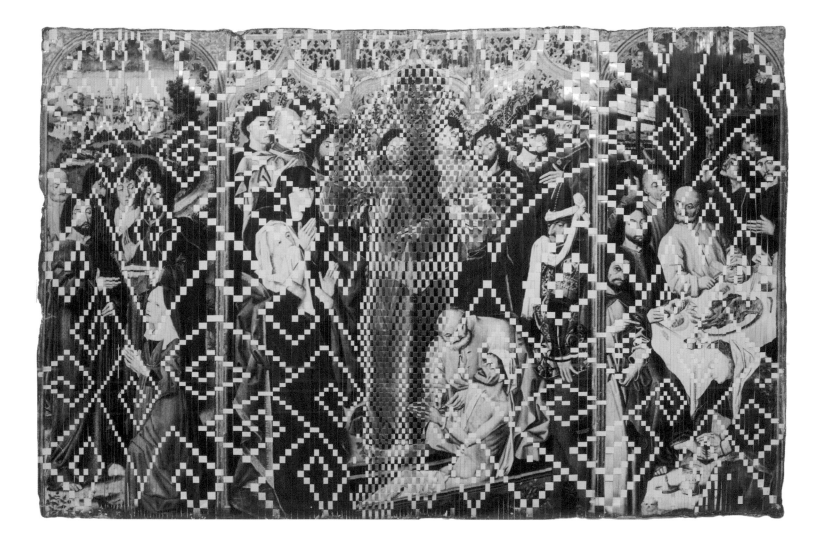

Dinh Q. Le (American, b. Vietnam, 1968), *The Raising of Lazarus*, 1991
chromogenic print and linen tape, lent by the artist and Shoshana Wayne Gallery, Santa Monica CA

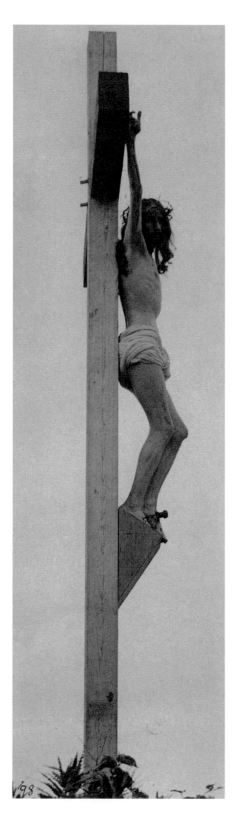

Fred Holland Day (American, 1864–1933), *Crucifixion*, 1898
platinum print, Prints & Photographs Division, Library of Congress, Washington, D.C., lent by the Louise Imogen Guine Collection

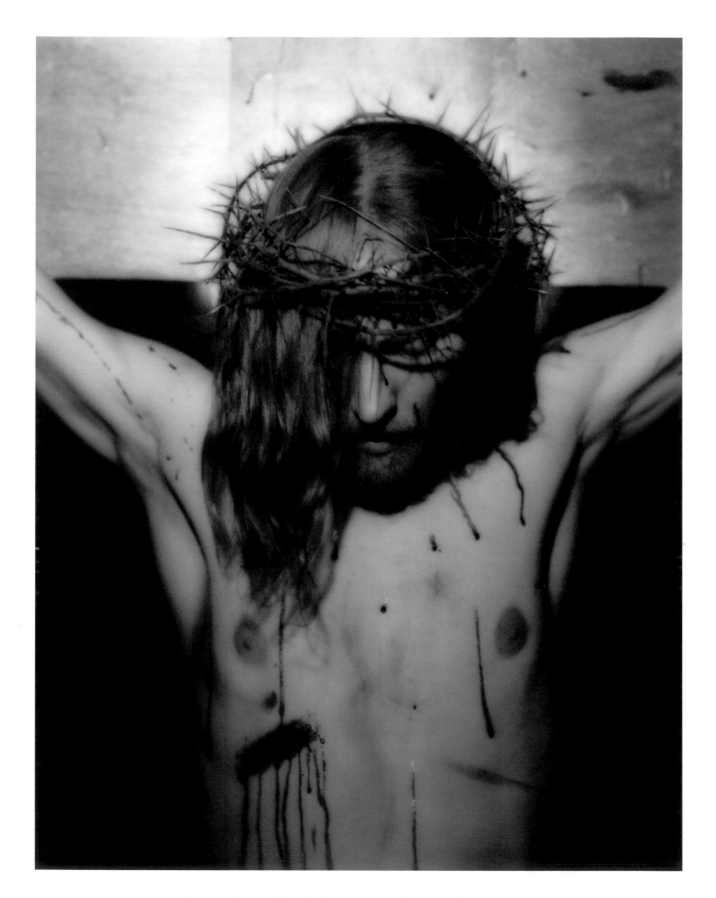

Raymond Voinquel (French, 1912–1994), *Sketch for La Divine Tragédie by Abel Gance*, 1949
gelatin silver print, Ministère de la Culture, Paris

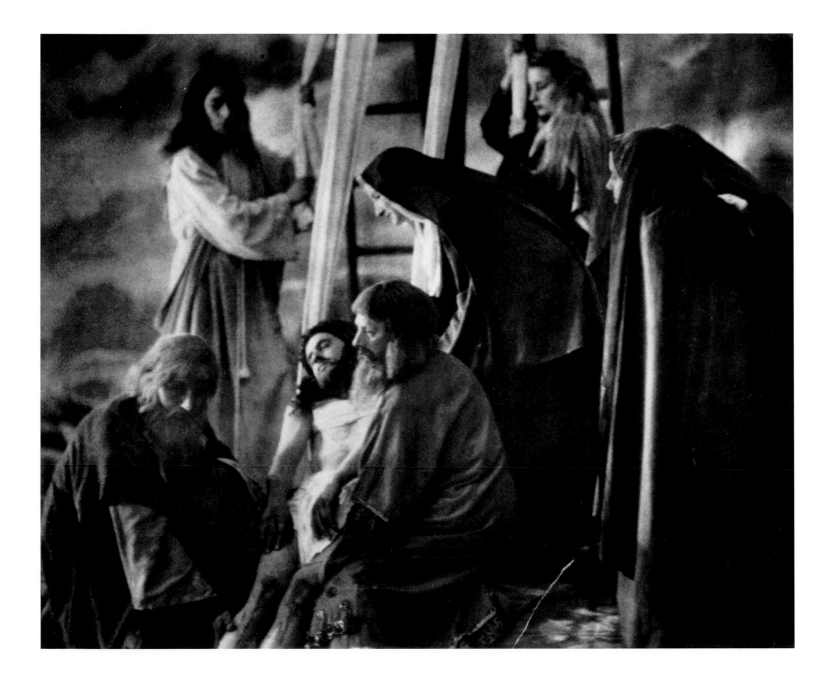

José Ortiz Echagüe (Spanish, 1886–1980), *Descendimiento de Cristo*, 1950
carbon print, Universidad de Navarra, Pamplona, Spain, lent by the Legado Ortiz Echagüe, Fundación Universitaria de Navarra

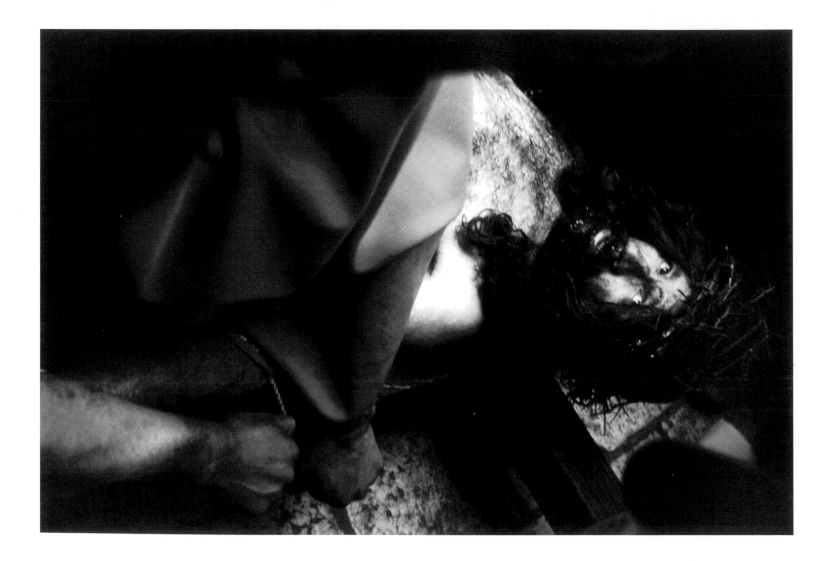

Joel Kantor (Israeli, b. Canada, 1948), *Untitled*, 1999
gelatin silver print, lent by the artist, Jerusalem

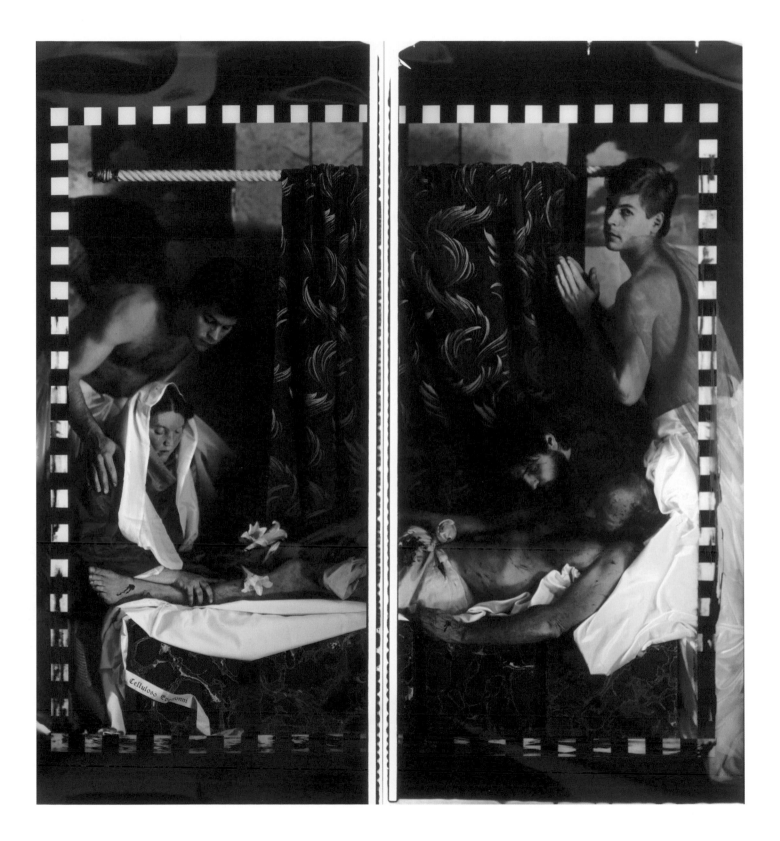

Evergon (Al Lunt) (Canadian, b. 1946), *The Deposition from the Cross*, 1985
Polaroid prints, courtesy of the Canadian Museum of Contemporary Photography, Ottawa

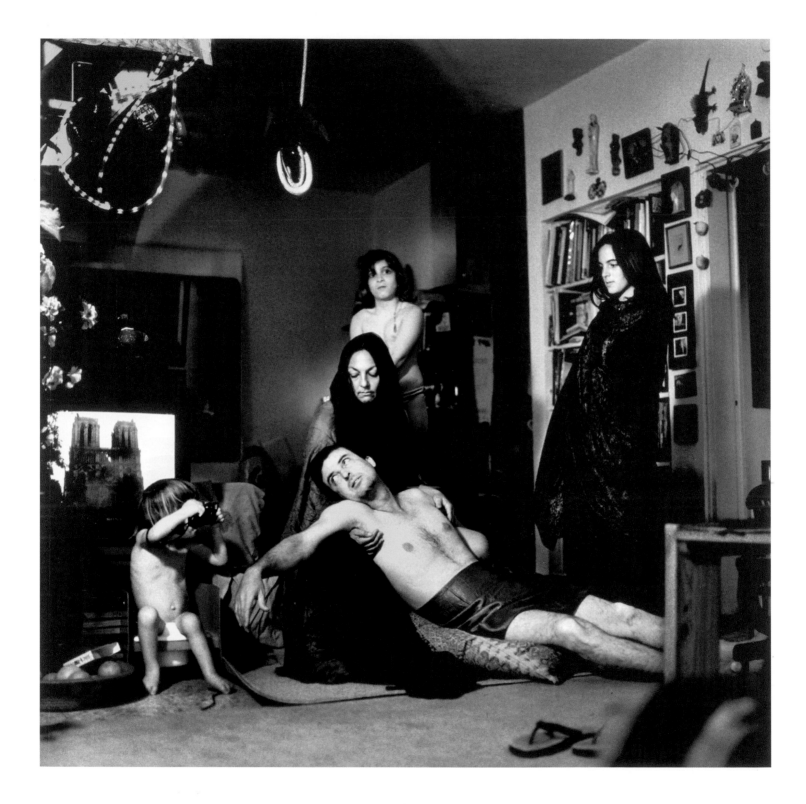

Boaz Tal (Israeli, b. 1952), *Self-portrait with my Family, Pietà with Notre Dame*, 1992
gelatin silver print, lent by the artist, Tel Aviv

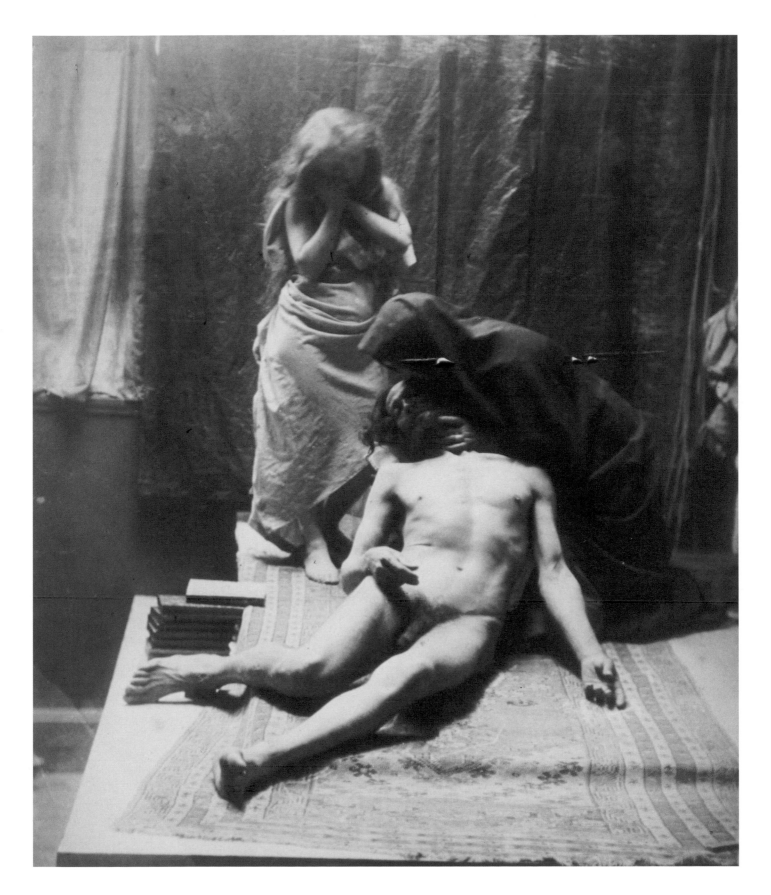

Louis Bonnard (French, active 1880–84), *Déploration du Christ*, 1880s
albumen print, Serge Kakou Collection, Paris

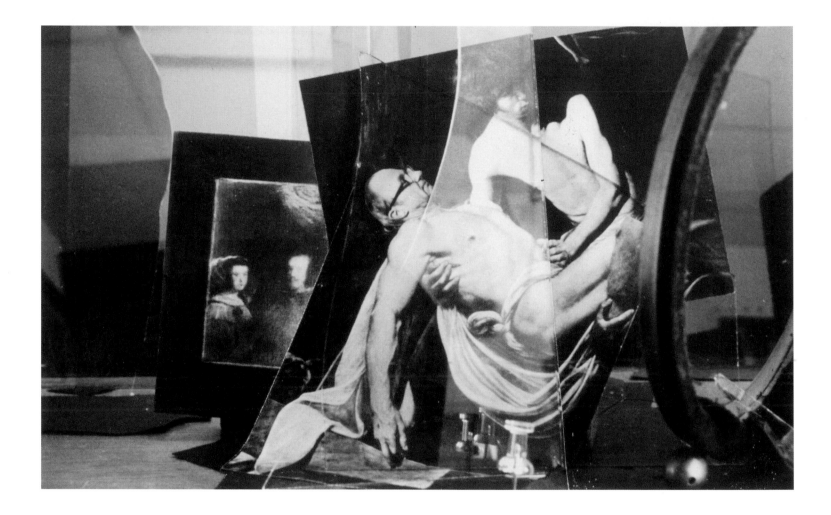

John O'Reilly (American, b. 1930), *Held by John*, 1988
Polaroid montage, lent by Julie Saul Gallery, New York

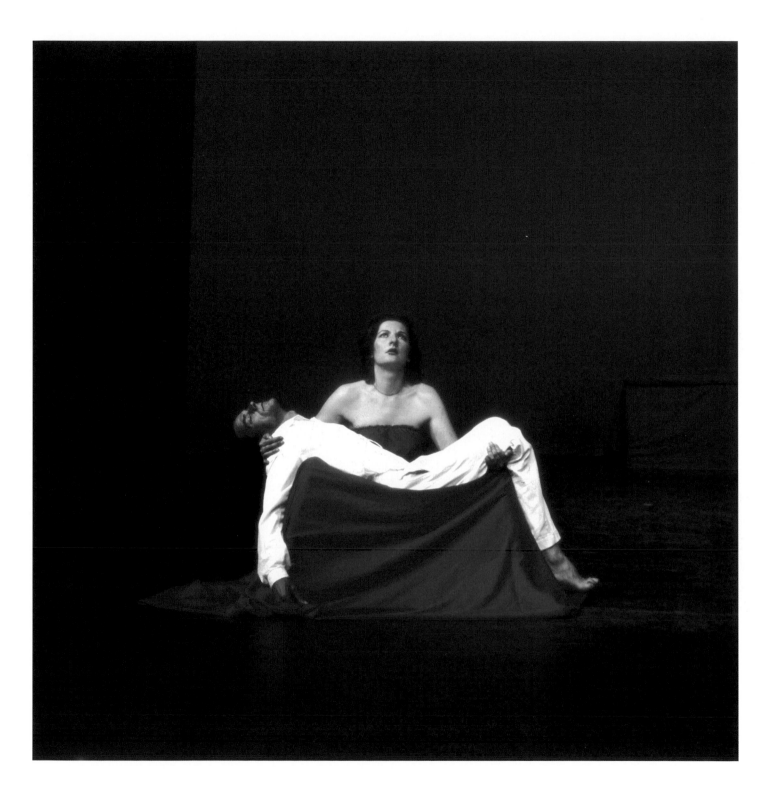

Marina Abramovic (Yugoslavian, b. 1946) and Ulay Abramovic (German, b. 1943), *Anima Mundi (Pietà)*, 1983
chromogenic print, lent by the artists, Amsterdam

Fred Holland Day (American, 1864–1933), *Jesus at the Tomb*, 1898
platinum print, Prints & Photographs Division, Library of Congress, Washington, D.C., lent by the Louise Imogen Guine Collection

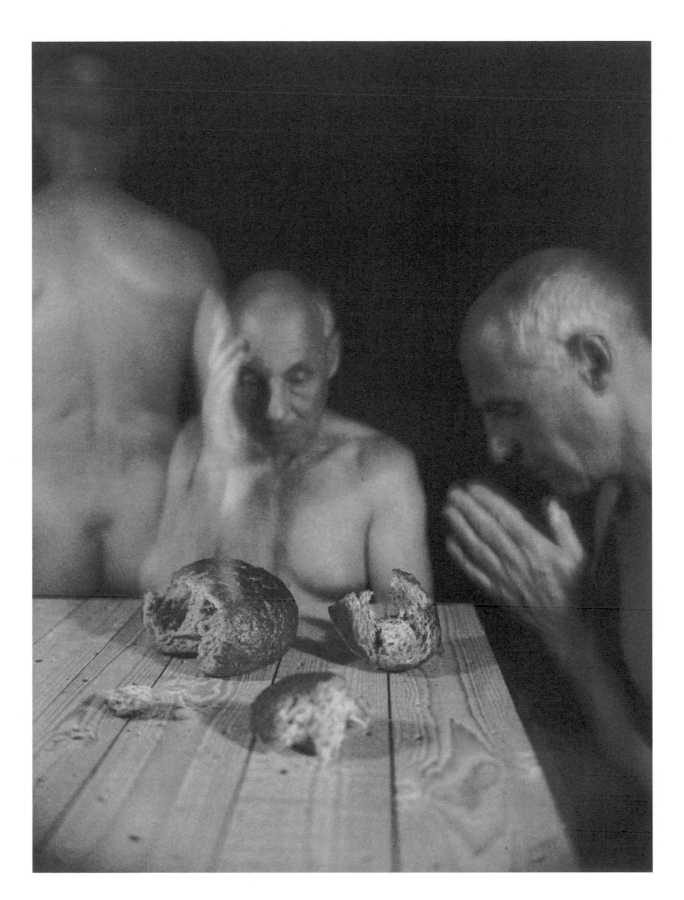

Jan van Leeuwen (Dutch, b. 1932), *Meal at Emmaus*, 1996
vandyke kallitype, The Israel Museum Collection, Jerusalem, gift of the artist, Bennekom, The Netherlands

Robert Mapplethorpe (American, 1946–1989), *Christ*, 1988
gelatin silver print, lent by the Estate of Robert Mapplethorpe, New York

David Wojnarowicz (American, 1954–1992), *Untitled (Christ)* from the 'Ant' series, 1988
gelatin silver print, courtesy of the Estate of David Wojnarowicz and PPOW Gallery, New York

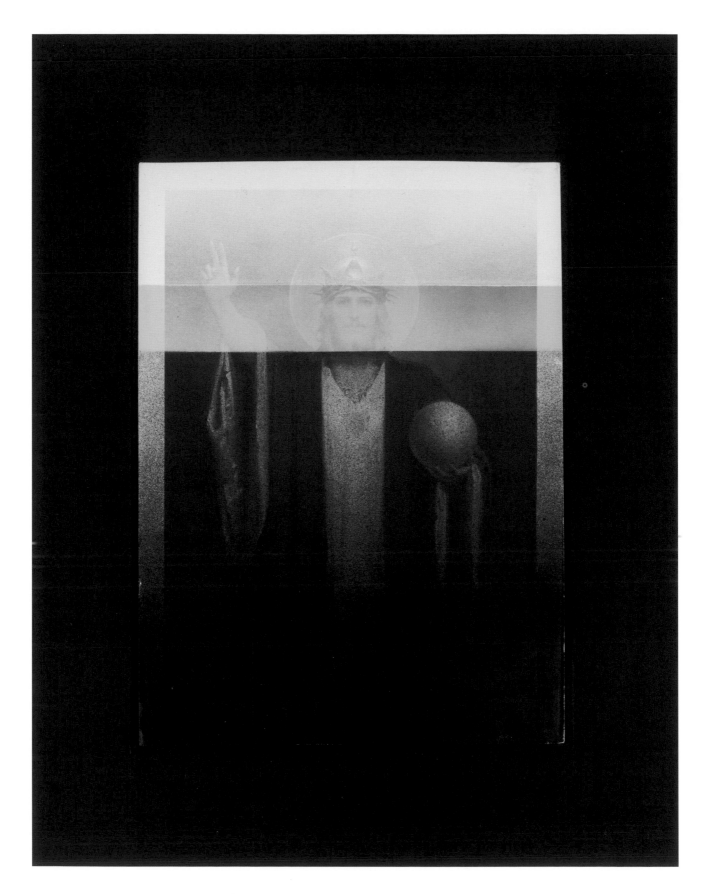

Robert Mapplethorpe (American, 1946–1989), *Jesus*, 1971
mixed media, lent by the Estate of Robert Mapplethorpe, New York

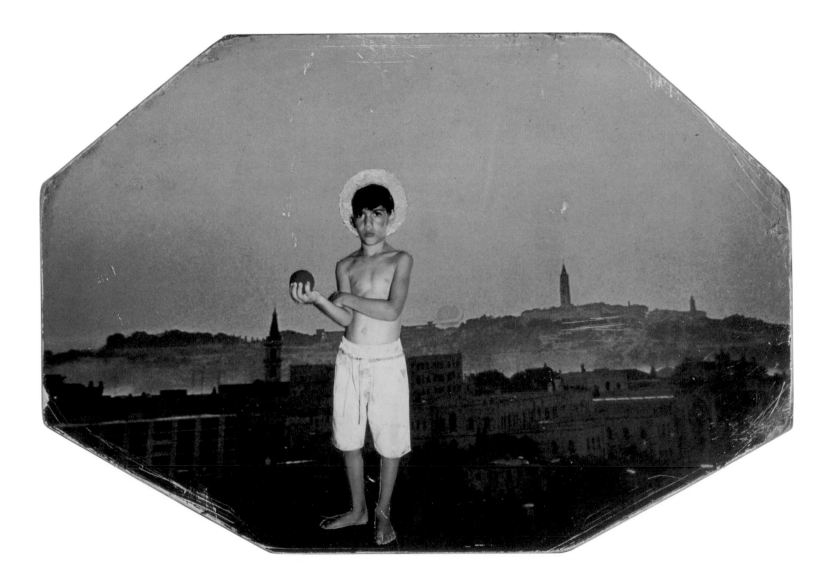

Ayelet Hashachar Cohen (Israeli, b. 1965), *Jerusalem*, 1995
chromogenic print, The Israel Museum Collection, Jerusalem, gift of the America–Israel Cultural Foundation

Luis Gonzalez Palma (Guatemalan, b. 1957), *Retrato de Niño*, 1990
gelatin silver print with bitumen, courtesy of Throckmorton Fine Art, Inc., New York

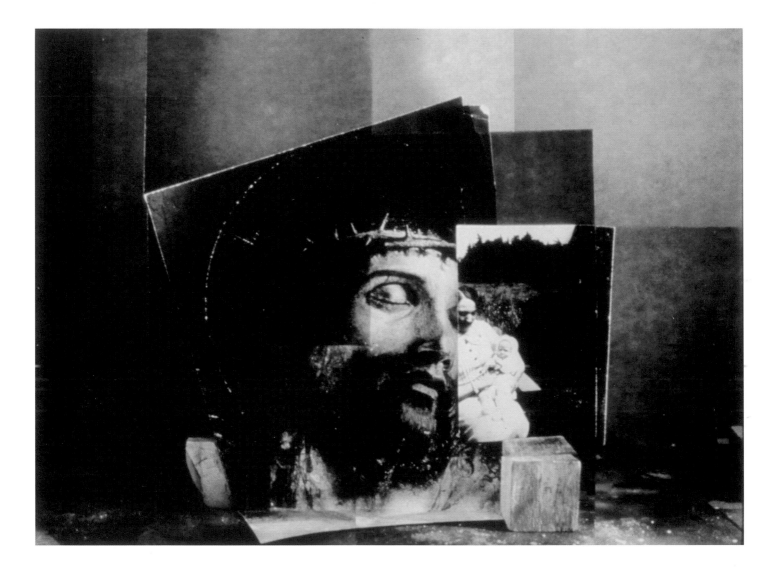

John O'Reilly (American, b. 1930), *Holding*, 1997
Polaroid montage, lent by Julie Saul Gallery, New York

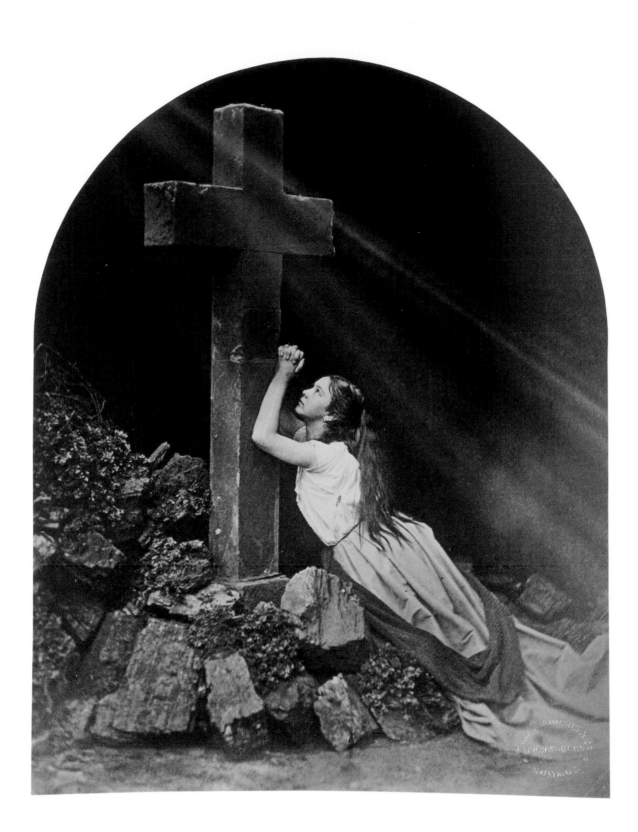

C. Tune (British), *Be Thou Faithful Until Death ...*, c. 1865
albumen print, The Israel Museum Collection, Jerusalem, gift of Gérard Lévy, Paris

John Dugdale (American, b. 1960), *Christ, Our Liberator*, 1999
cyanotype, lent by the artist, New York

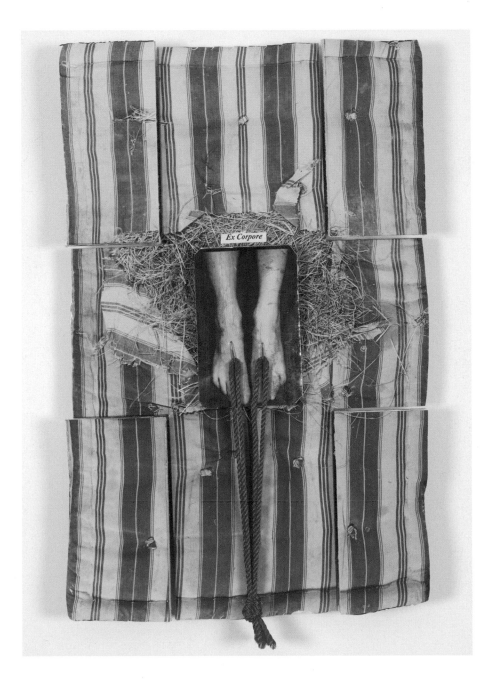

Natale Zoppis (Italian, b. 1952), from the 'Ex Corpore' series, 1999
chromogenic print, cardboard and metal staples, courtesy of Fondazione Sandretto Re Rebaudengo per l'Arte, Italy

Edmund Teske (American, 1911–1996), *Untitled (George Herms)*, c. 1960
gelatin silver print, duotone solarization, Leland Rice and Susan Ehrens Collection, Oakland

Deganit Berest (Israeli, b. 1949), *Dream #32B*, 2000
chromogenic print, The Israel Museum Collection, Jerusalem, purchase, Photography Acquisition Fund

Natale Zoppis (Italian, b. 1952), from the 'Ex Corpore' series, 1999
chromogenic print, cardboard and metal staples, courtesy of Fondazione Sandretto Re Rebaudengo per l'Arte, Italy

Dr P. (French), *Tattoo, Lyon*, 1934
chromogenic print from original autochrome, Gérard Lévy Collection, Paris

Simcha Shirman (Israeli, b. Germany, 1947), *Surgery*, 1997
chromogenic print, lent by the artist, Tel Aviv

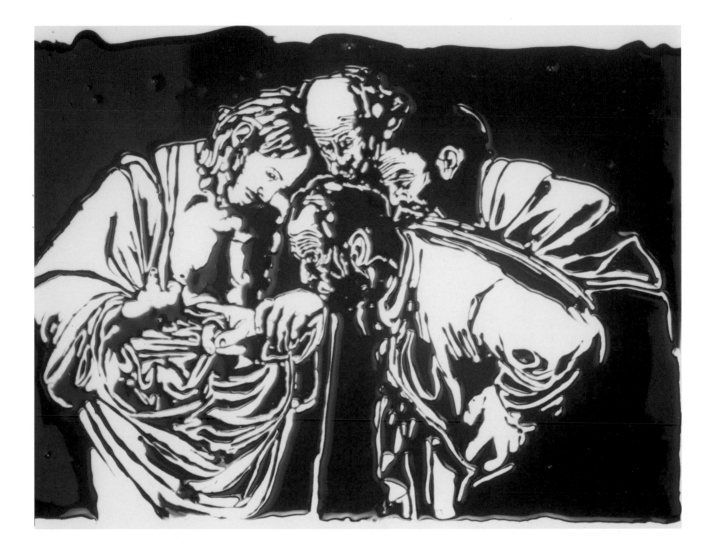

Vik Muniz (Brazilian, b. 1961, works in New York), *The Doubting of Thomas*, 2000
Cibachrome print, courtesy Brent Sikkema, New York

Manuel Alvarez Bravo (Mexican, 1902–2002), *A Fish Called Saw*, 1934
gelatin silver print, The Israel Museum Collection, Jerusalem, gift of Martin Pomp, New York, to American Friends of The Israel Museum

Bettina Rheims (French, b. 1952), *Ave Maris Stella*, 1999
chromogenic print, collection of the artist, Paris

Andres Serrano (American, b. 1950), *Pietà*, 1985
Cibachrome print, courtesy of the artist and Paula Cooper Gallery, New York

Kimiko Yoshida (Japanese, b. 1963, works in France), *Who is Afraid of the Image of Christ?*, 2000–01
digital print, courtesy of Galerie Rabouan-Moussion, Paris

Frederick Sommer (American, b. Italy, 1905–1999), *Virgin and Child with St Anne and the Infant St John*, 1966
gelatin silver print, lent by The J. Paul Getty Museum, Los Angeles, and the Frederick and Frances Sommer Foundation, Prescott AZ

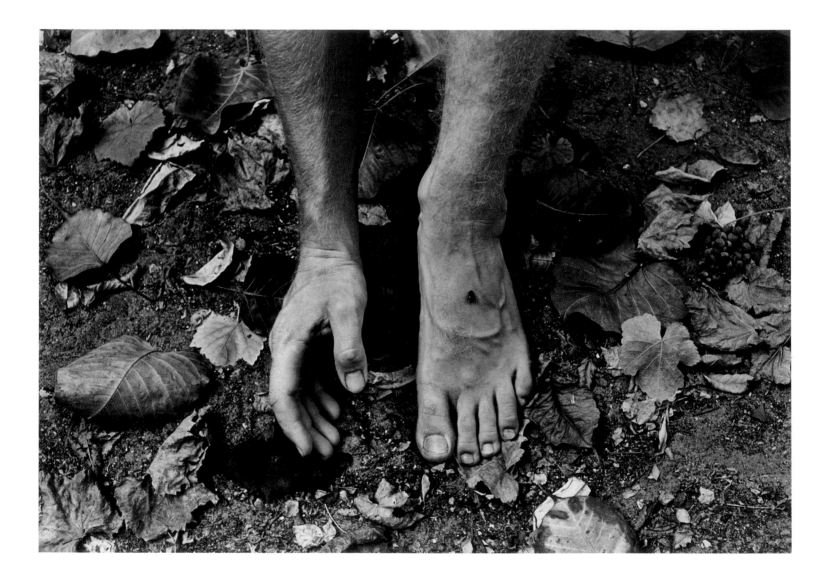

Pesi Girsch (Israeli, b. Germany, 1954), *Untitled*, 1991
gelatin silver print, The Israel Museum Collection, Jerusalem, gift of Israel Discount Bank Fund

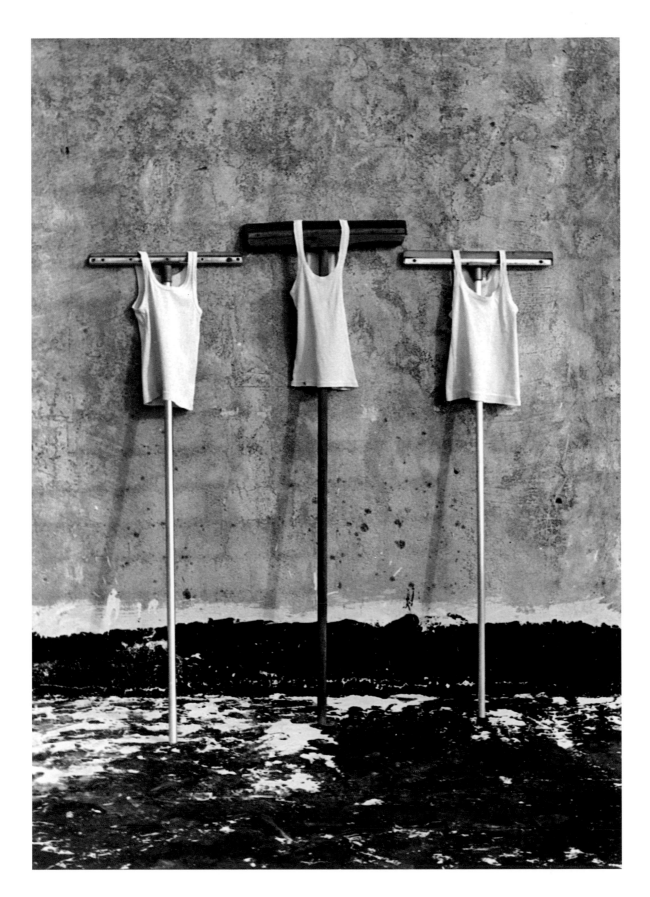

Efrat Natan (Israeli, b. 1947), *Roof Work (installation photograph: Judith Itach)*, 1979
gelatin silver print, lent by the artist, Tel Aviv

Arièle Bonzon (French, b. 1955), *Chère absente: Epiphanies ('chère absente'/'chair absente')*, 1992/94
gelatin silver print, marble, glass and lead, courtesy of Arièle Bonzon and Galerie Le Réverbère, Lyon, France

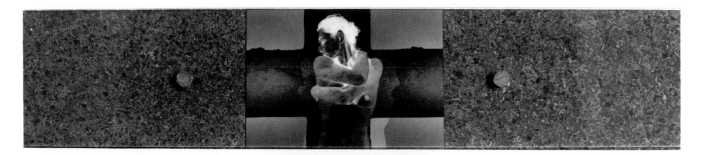

Arièle Bonzon (French, b. 1955), *Chère absente: Epiphanies ('chère absente'/'chair absente')* (details), 1992/94
gelatin silver prints, marble, glass and lead, courtesy of Arièle Bonzon and Galerie Le Réverbère, Lyon, France

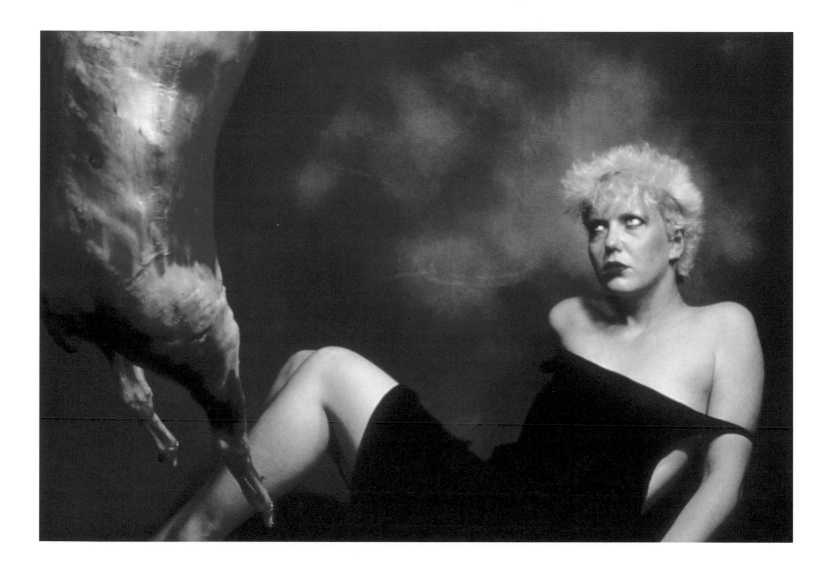

Andres Serrano (American, b. 1950), *The Unknown Christ*, 1984
Cibachrome print, courtesy of the artist and Paula Cooper Gallery, New York

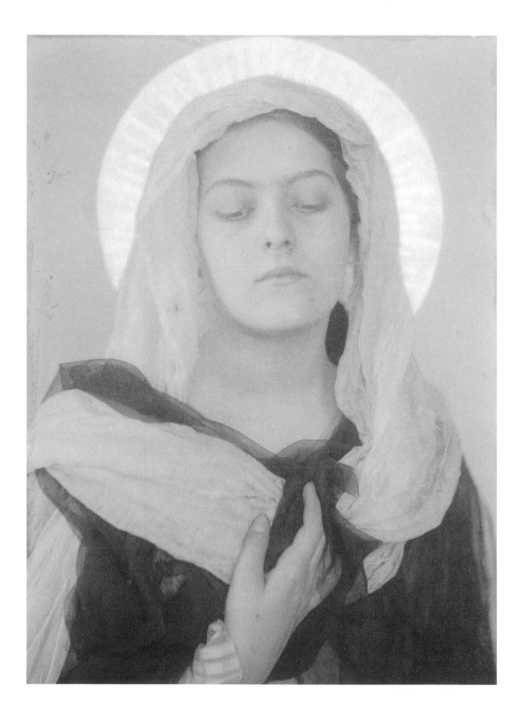

Charles I. Berg (American, 1856–1926), *Mary*, 1900–10
platinum print, Prints & Photographs Division, Library of Congress, Washington, D.C.

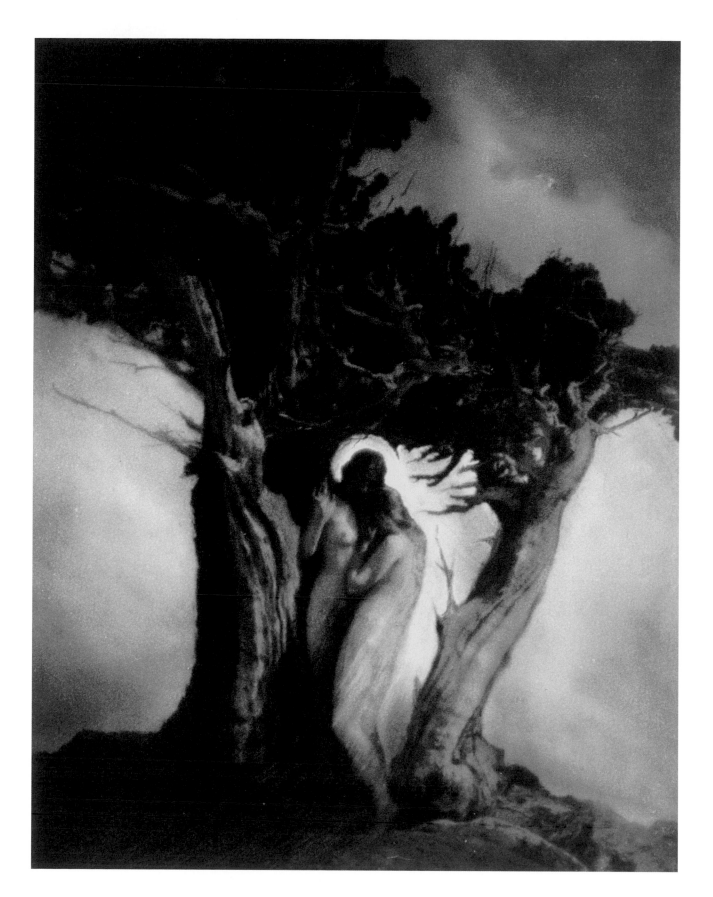

Anne W. Brigman (American, 1869–1950), *The Heart of the Storm*, c. 1912
gelatin silver print, Leland Rice and Susan Ehrens Collection, Oakland

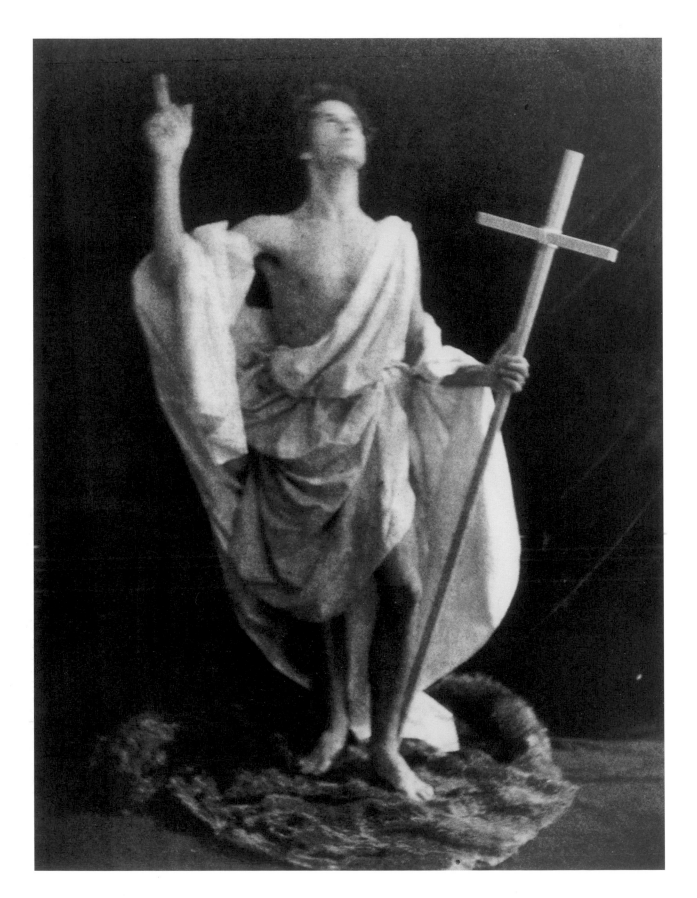

David McDermott (American, b. 1952) and Peter McGough (American, b. 1958), *The Ascension of St John the Baptist 1907*, 1989
cyanotype, The Israel Museum Collection, Jerusalem, gift of Gorovoy Foundation, New York, to American Friends of The Israel Museum

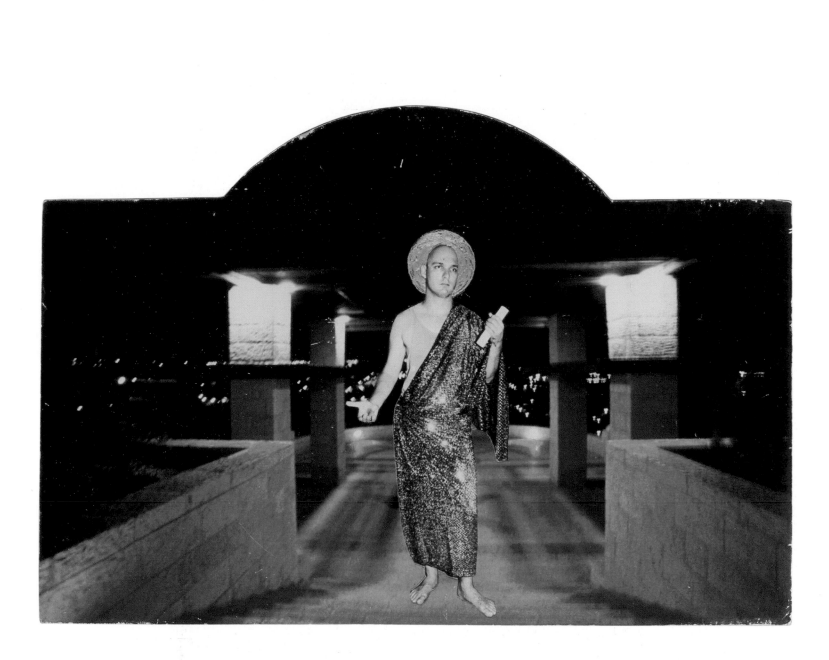

Ayelet Hashachar Cohen (Israeli, b. 1965), *Jerusalem*, 1995
chromogenic print, The Israel Museum Collection, Jerusalem, gift of America–Israel Cultural Foundation

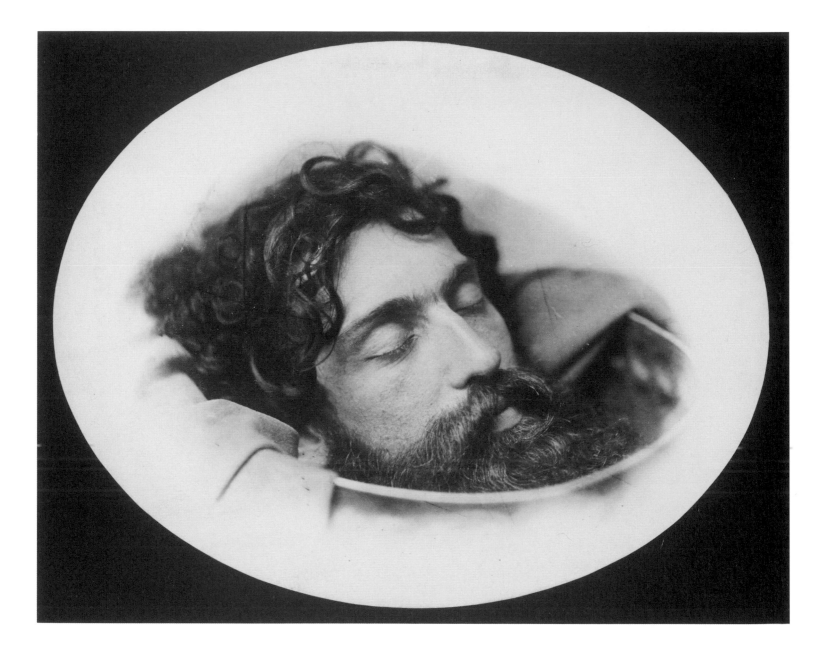

Oscar Gustav Rejlander (British, b. Sweden, 1813–1875), *Head of St John the Baptist on a Charger*, c. 1858
albumen print, courtesy of George Eastman House, New York

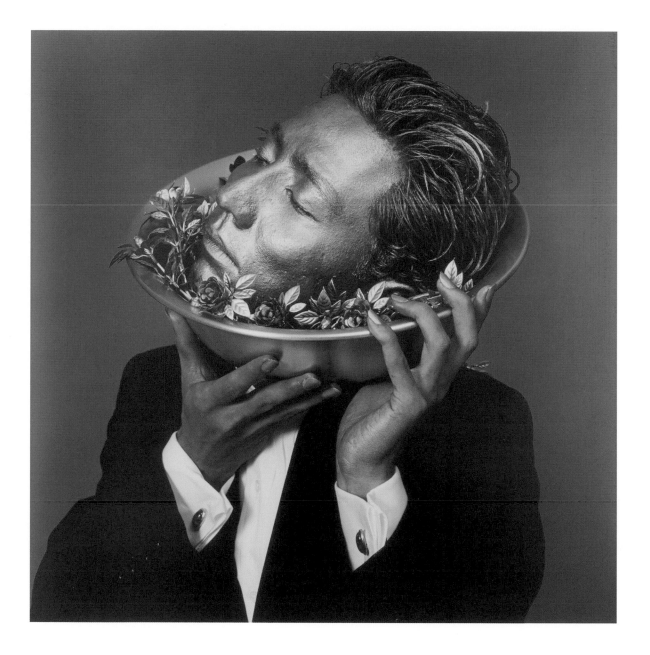

Yasumasa Morimura (Japanese, b. 1951), *Doublonnage Portrait D*, 1988
colour print, The Israel Museum Collection, Jerusalem, gift of Patti and Frank Kolodny, New Jersey, to American Friends of The Israel Museum

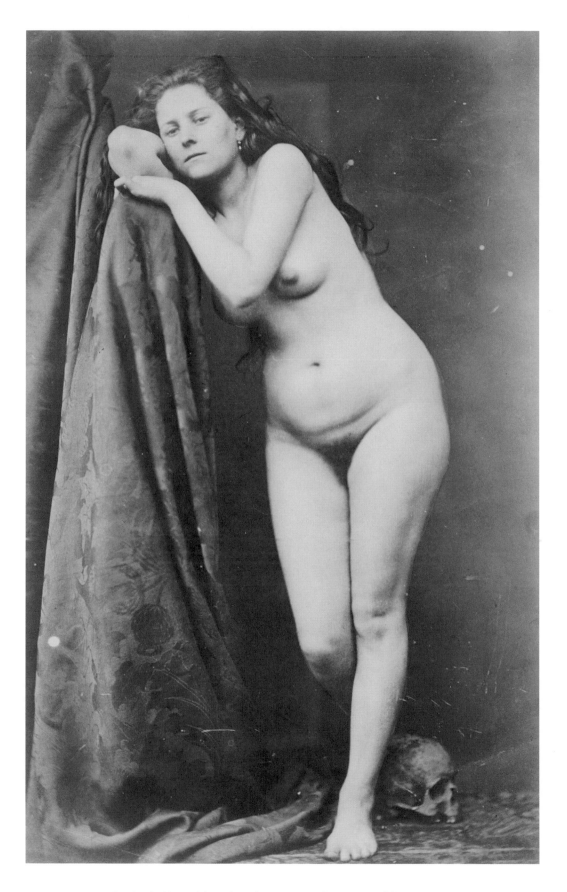

Gaudenzio Marconi (French, active 1865–1875), *Mary Magdalene*, c. 1870
albumen print, The Israel Museum Collection, Jerusalem, gift of Michael S. Sachs, Westport CT

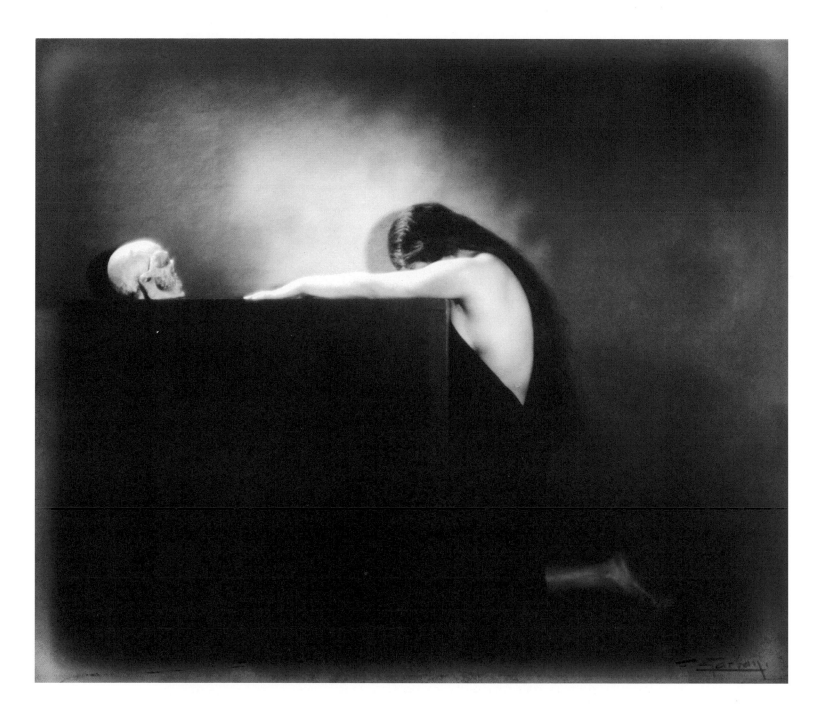

André Garban (French, d. 1858), *Mary Magdalene*, 1930
gelatin silver print, Gérard Lévy Collection, Paris

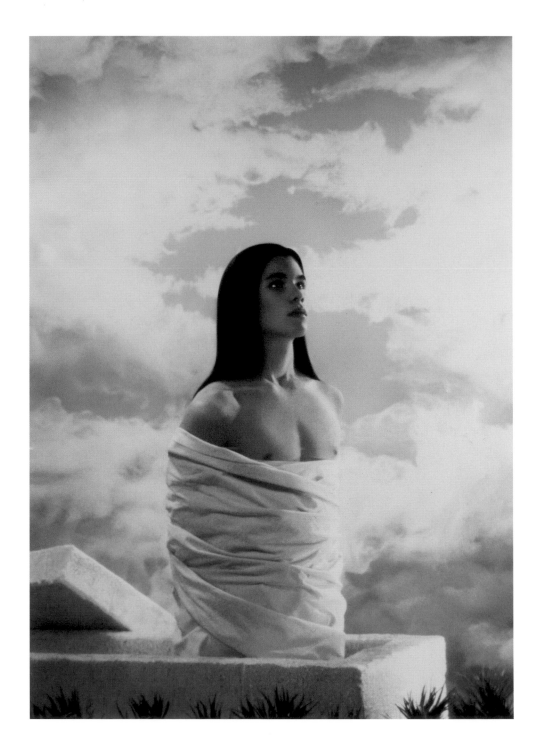

Pierre et Gilles (French, active together since 1976), *Saint Lazare – Alexis Lemoine*, 1988
hand-coloured photograph, courtesy of Pierre et Gilles and Galerie Jérôme de Noirmont, Paris

Pat York (American, b. Jamaica), *Jesus Christ and St John the Baptist*, n.d.
digital print, lent by Pat York with Ace Gallery, Los Angeles and New York

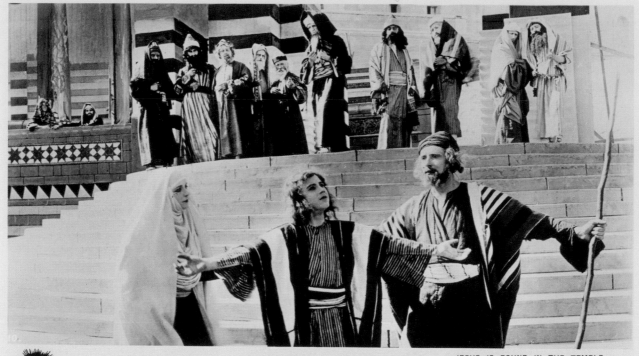

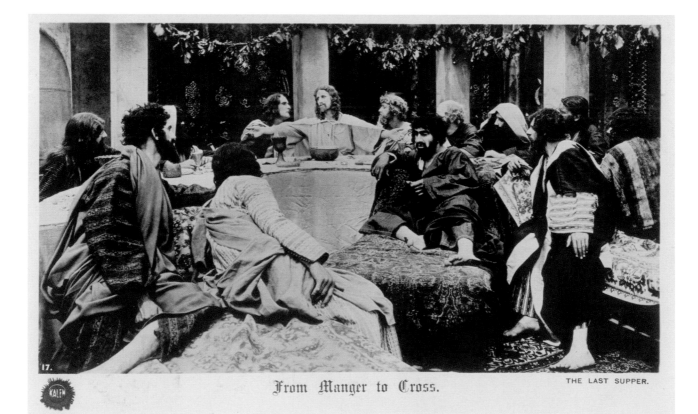

Unidentified, *From Manger to Cross*, 1912
gelatin silver prints, private collection

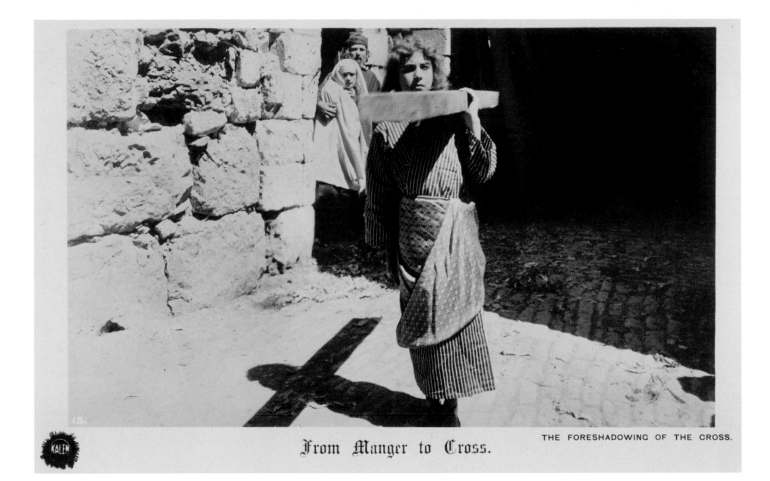

From Manger to Cross. THE FORESHADOWING OF THE CROSS.

Unidentified, *From Manger to Cross*, 1912
gelatin silver print, private collection

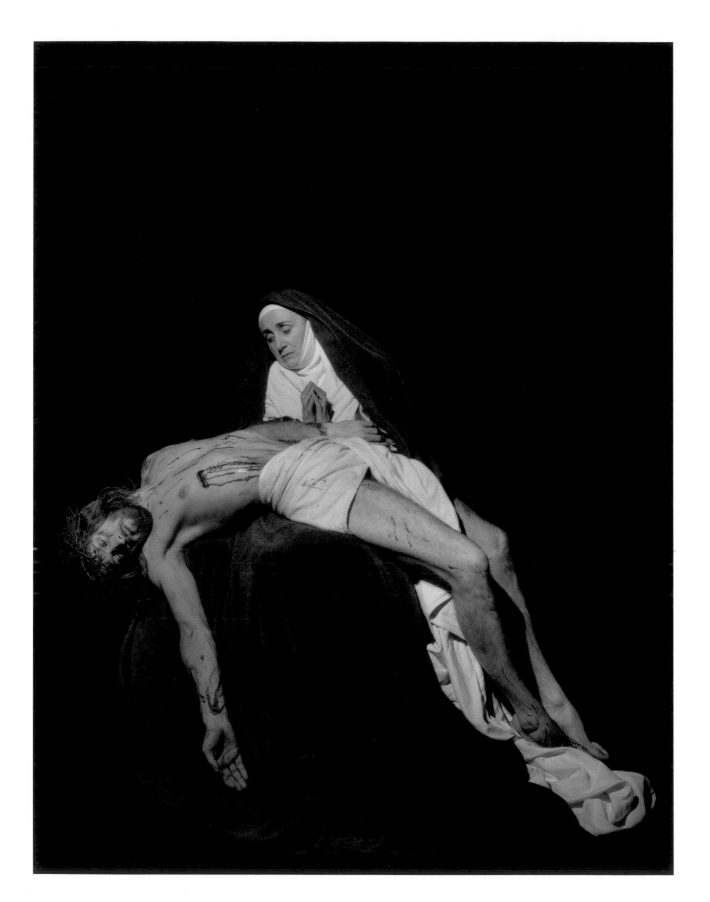

Raymond Voinquel (French, 1912–1994), *Sketch for La Divine Tragédie by Abel Gance*, 1949
gelatin silver print, Ministère de la Culture, Paris

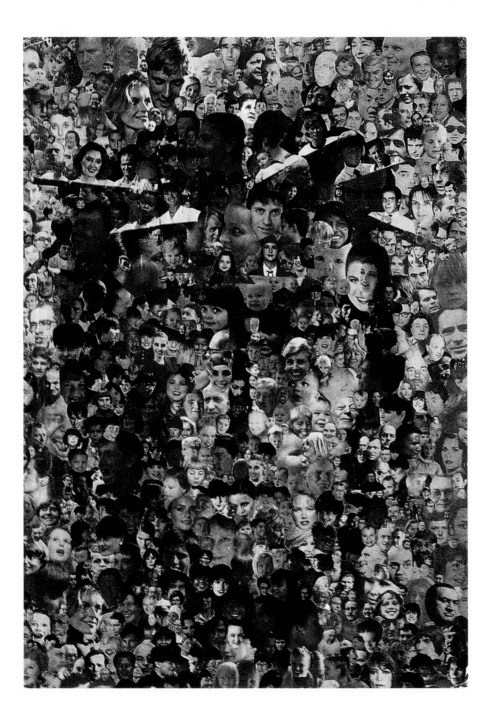

Unidentified, *Je cherche ton visage*, 1989
offset print, The Israel Museum Collection, Jerusalem, gift of Gérard Lévy, Paris

Orlan (French, b. 1947), *Madonna at The Garage in Assumption on a Pneumatic*, 1990
Cibachrome print, lent by the artist, Paris

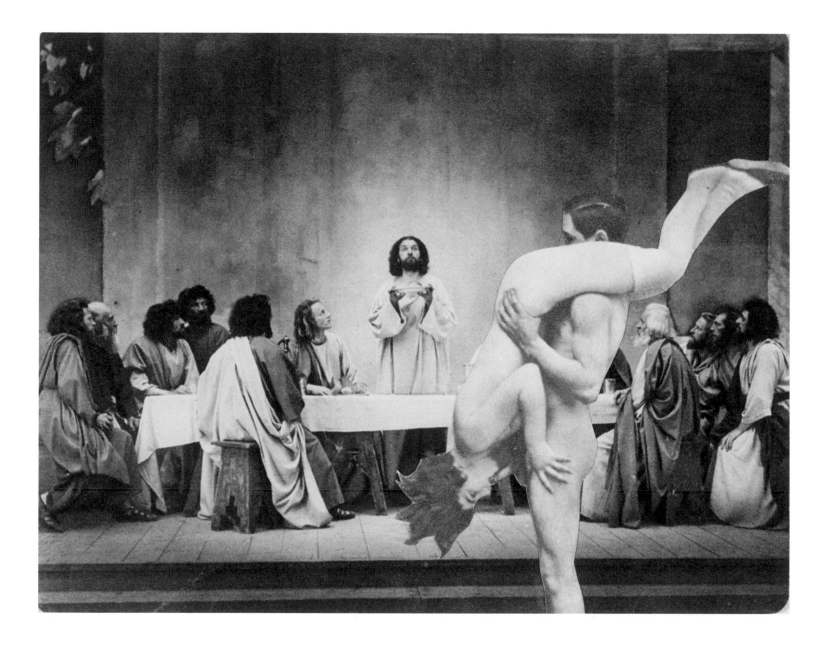

Georges Hugnet (French, 1906–1974), *Last Supper*, 1934
collage, Gérard Lévy Collection, Paris

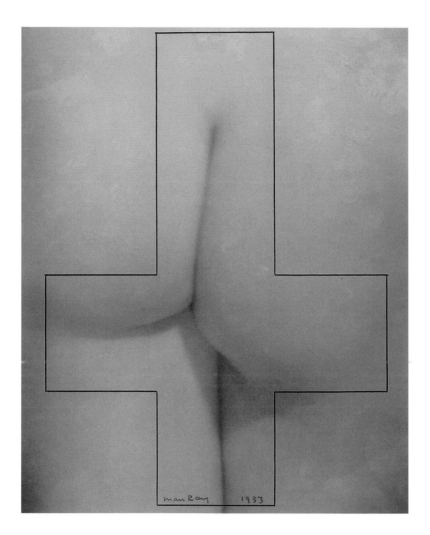

Man Ray (American, active France, 1890–1976), *Monument à Sade*, 1933
gelatin silver print and ink, The Israel Museum Collection, Jerusalem, The Vera and Arturo Schwartz Collection of Dada and Surrealist Art

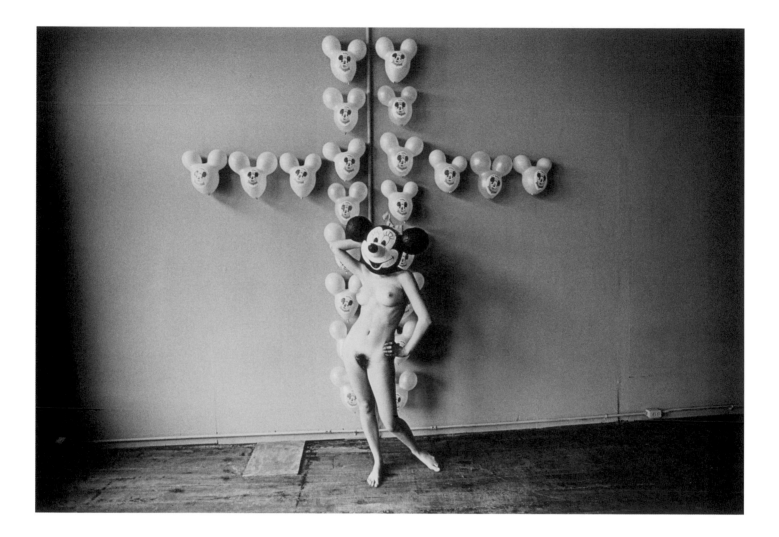

Les Krims (American, b. 1943), *The Static-Electric Effect of Minnie Mouse!!!*, 1968/2001
archival inkjet print, lent by the artist, New York

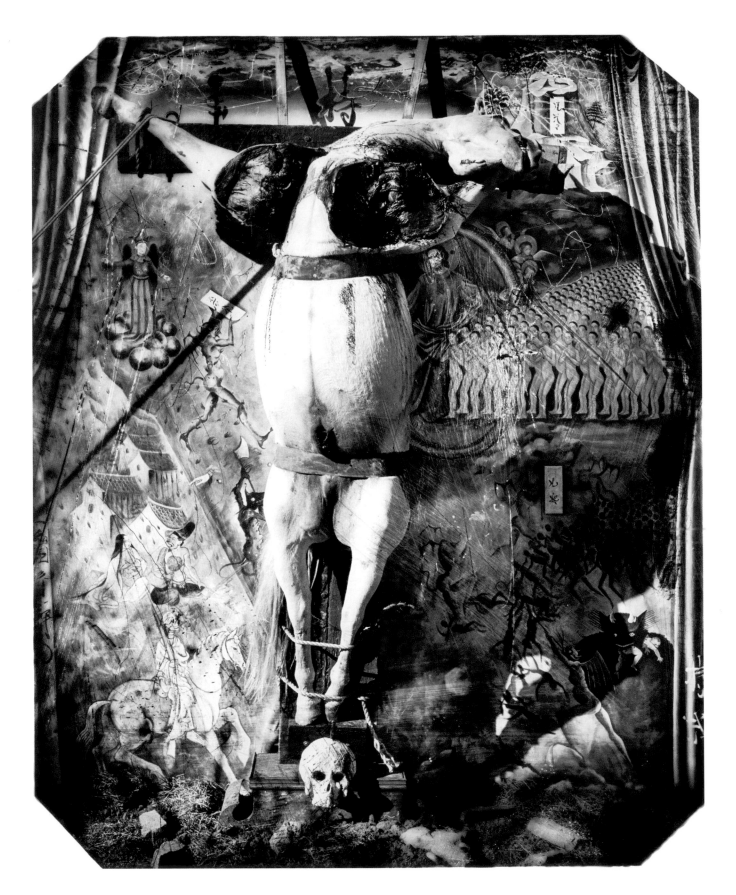

Joel-Peter Witkin (American, b. 1939), *Crucified Horse, NM*, 1998
gelatin silver print, Fraenkel Gallery, San Francisco

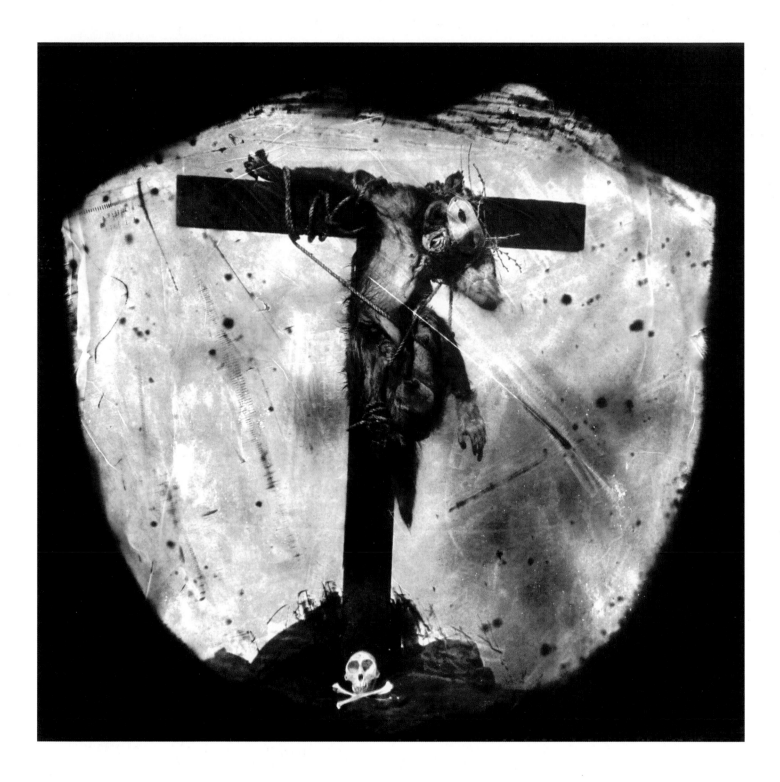

Joel-Peter Witkin (American, b. 1939), *Saviour of the Primates, NM*, 1982
gelatin silver print, Fraenkel Gallery, San Francisco

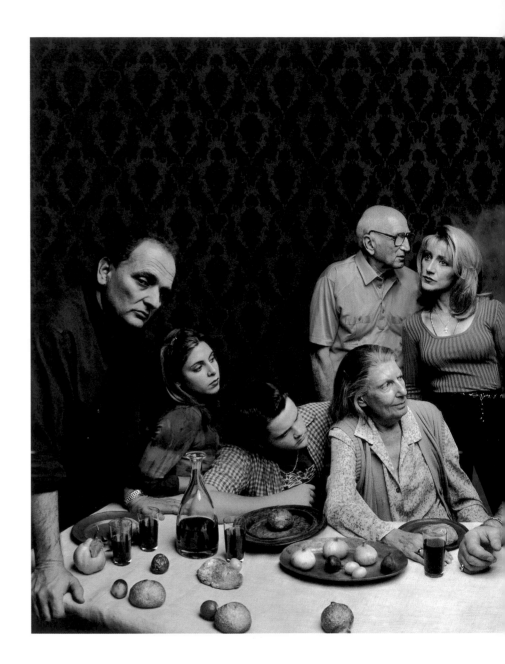

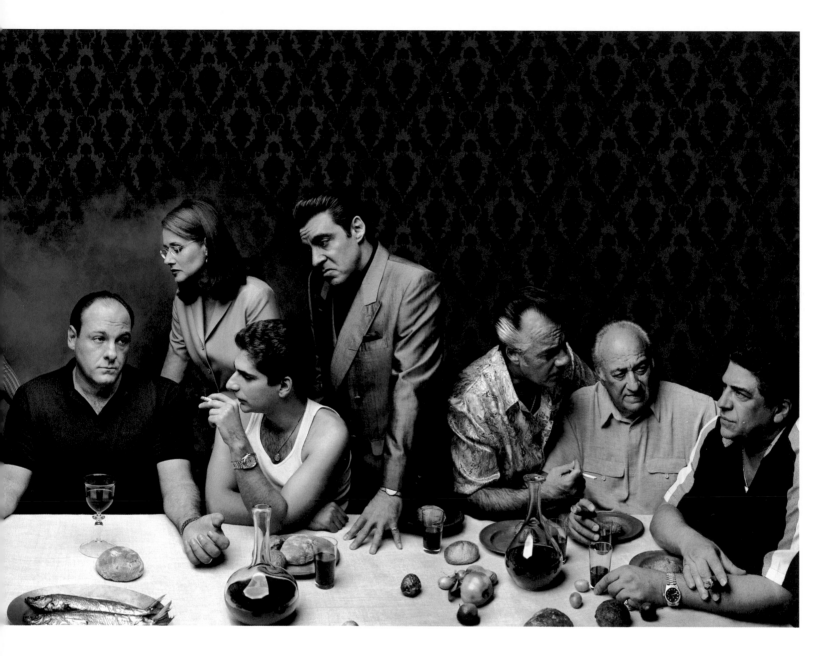

Annie Leibovitz (American, b. 1949), *The Sopranos*, 1999
chromogenic print, lent by the artist, New York

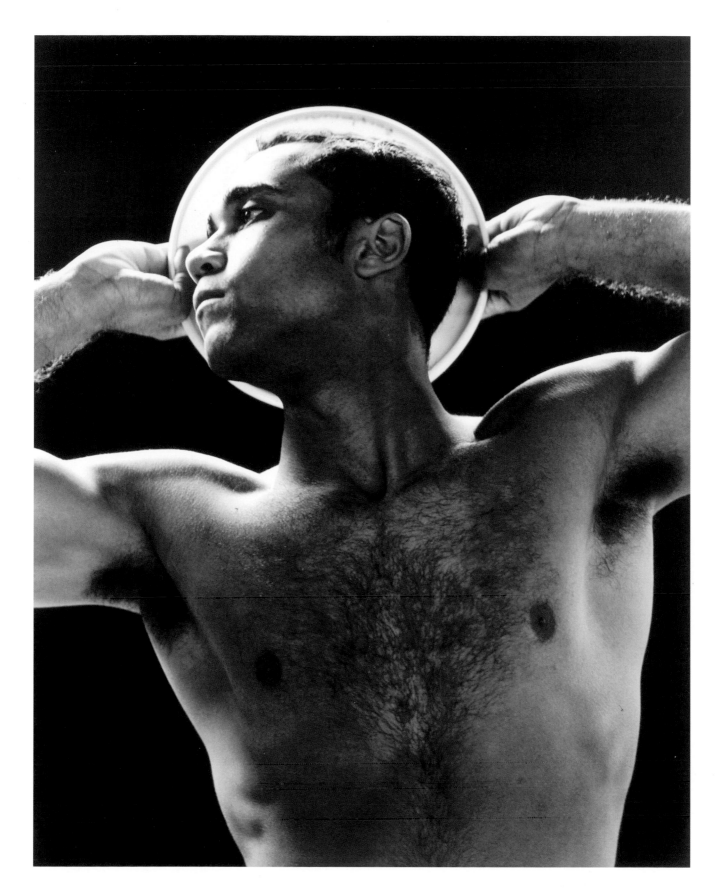

Kurt Markus (American, b. 1947), *Ultimate Frisbee Great Brian Harriford*, 1999
gelatin silver print, toned, lent by the artist, Roundup MT

J. Roseman (French), *Untitled (Dr Charles Villandre's Crucifix)*, c. 1934
gelatin silver print, Bibliothèque de Fels, Institut Catholique de Paris

E.C. Templier (French), *Untitled (Crucifixion of Cadaver by Dr Barbet)*, c. 1934
gelatin silver print, Bibliothèque de Fels, Institut Catholique de Paris

Frederick T. Zugibe (American, b. 1928), *Steve on Cross*, n.d.
gelatin silver print, lent by Dr Frederick Zugibe, New York

Frederick T. Zugibe (American, b. 1928), *Subject on Cross*, n.d.
chromogenic prints, lent by Dr Frederick Zugibe, New York

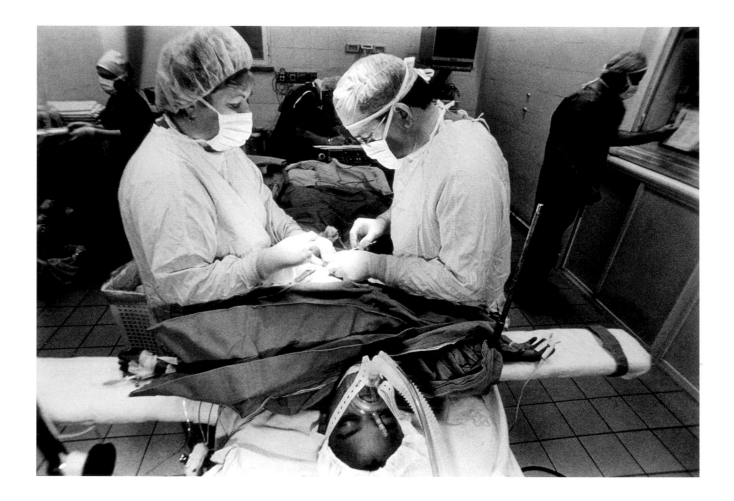

Ilan Mizrahi (Israeli, b. 1973), *Circumcision*, 1998
gelatin silver print, lent by the artist, Jerusalem

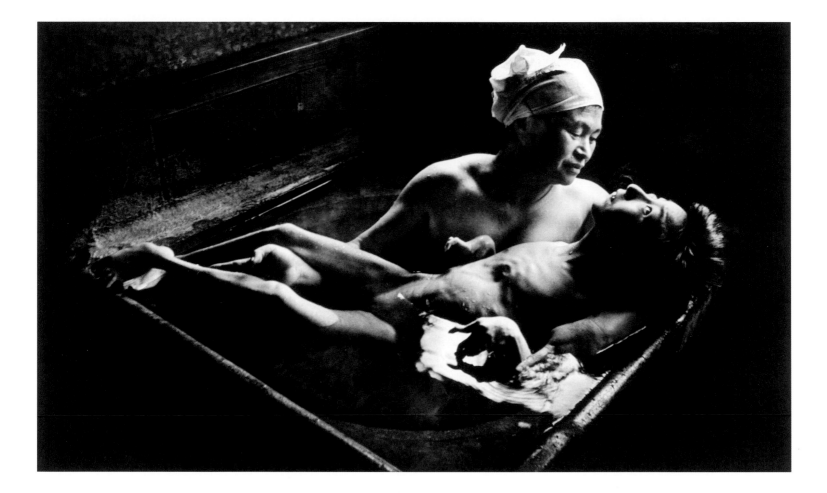

W. Eugene Smith (American, 1918–1978), *Tomoko in her Bath*, 1975
gelatin silver print, The Israel Museum Collection, Jerusalem, gift of Mr and Mrs Dan Berley, New York, to American Friends of The Israel Museum

Micha Kirshner (Israeli, b. Italy, 1947), *Aisha el-Kord, Khan Younis Refugee Camp*, 1988
gelatin silver print, The Israel Museum Collection, Jerusalem, purchase, Lynn Honickman Fund, New York

Herlinde Koelbl (German, b. 1939), *Intifada*, 1987
gelatin silver print, lent by the artist, Munich

Lewis Hine (American, 1874–1940), *Tenement Madonna*, 1908
gelatin silver print, Prints & Photographs Division, Library of Congress, Washington, D.C.

Dean Tokuno (American, 1953), *Dad*, 1996/1999
chromogenic print, lent by the artist, Yuba City CA

CHRIST IN NEW YORK

Christ is sold on television by a religious hypocrite.

Duane Michals (American, b. 1932), *Christ in New York*, 1981
gelatin silver print, courtesy of the artist and Pace/MacGill Gallery, New York

Christ cries when he sees a young woman die of an illegal abortion.

Duane Michals (American, b. 1932), *Christ in New York*, 1981
gelatin silver print, courtesy of the artist and Pace/MacGill Gallery, New York

3

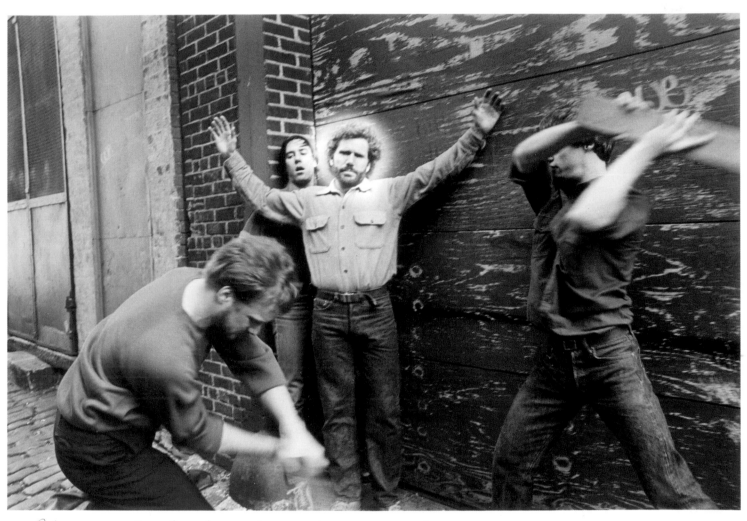

Christ is beaten defending a homosexual.

Duane Michals (American, b. 1932), *Christ in New York*, 1981
gelatin silver print, courtesy of the artist and Pace/MacGill Gallery, New York

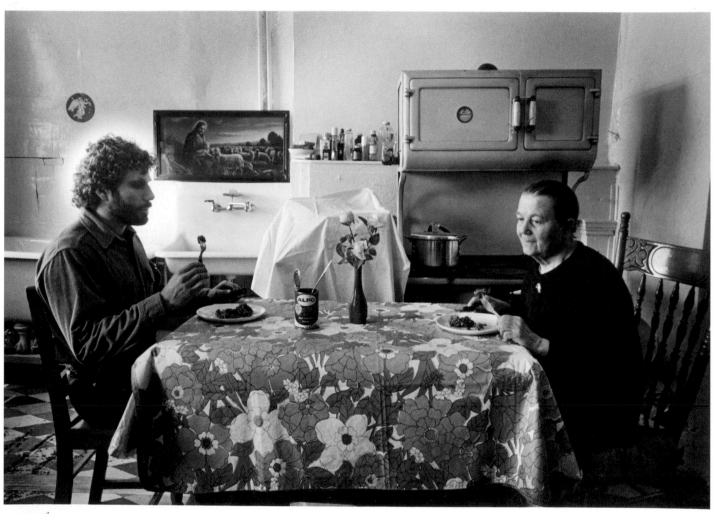

Christ eats dog food with an old Ukrainian lady in Brooklyn

Duane Michals (American, b. 1932), *Christ in New York*, 1981
gelatin silver print, courtesy of the artist and Pace/MacGill Gallery, New York

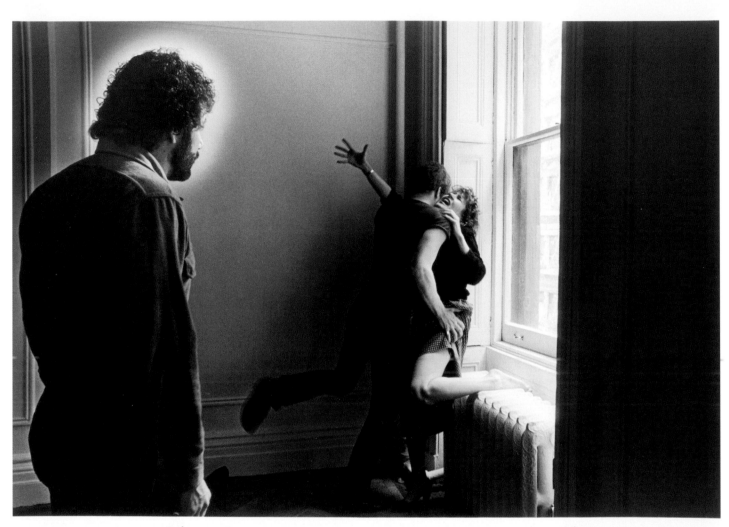

Christ sees a woman being attacked.

Duane Michals (American, b. 1932), *Christ in New York*, 1981
gelatin silver print, courtesy of the artist and Pace/MacGill Gallery, New York

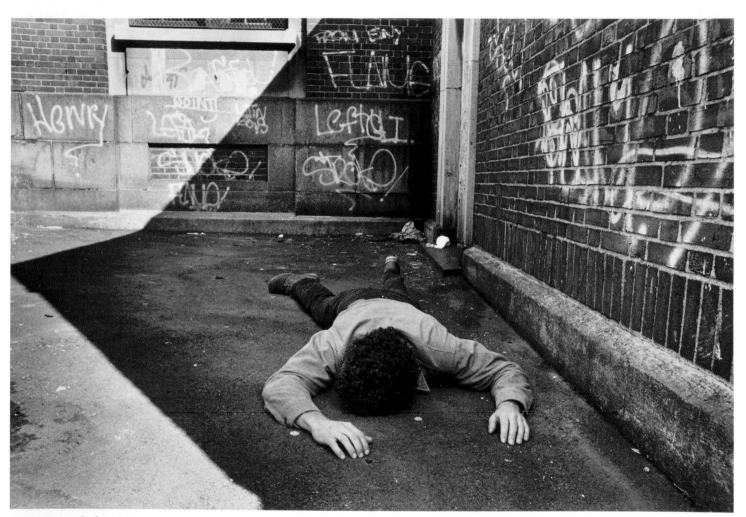

Christ is shot by a mugger with a handgun and dies.
The second coming had occurred and no one noticed.
Duane Michals

Duane Michals (American, b. 1932), *Christ in New York*, 1981
gelatin silver print, courtesy of the artist and Pace/MacGill Gallery, New York

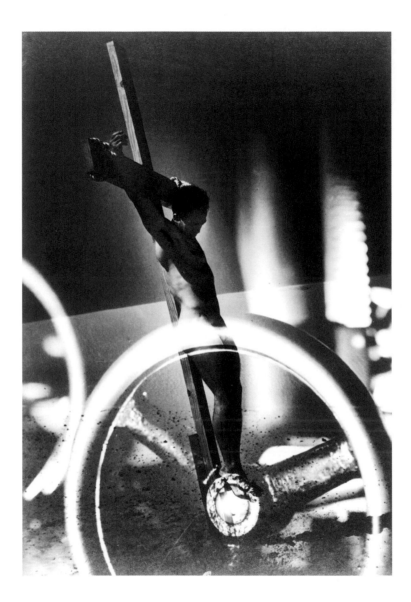

Max Dupain (Australian, 1911–1992), *Doom of Youth*, 1937
gelatin silver print, courtesy of National Gallery of Australia, Canberra

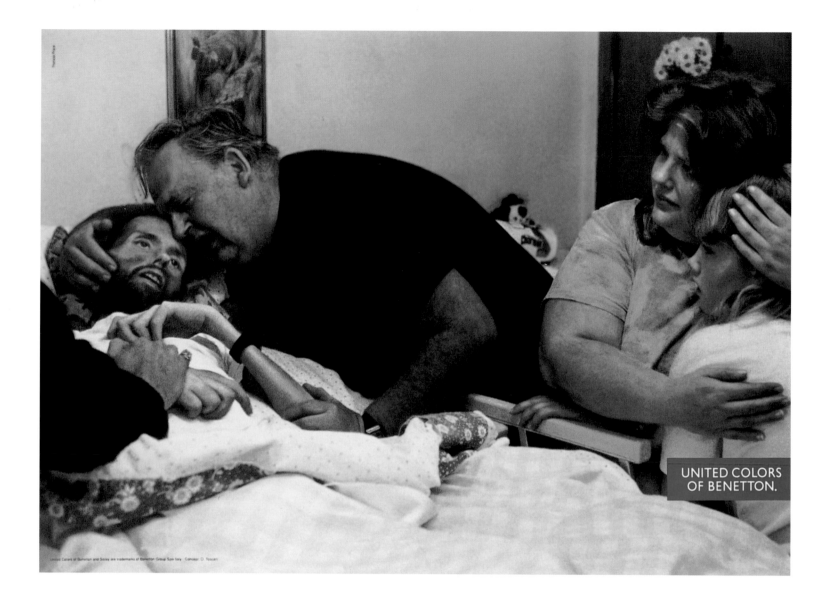

Therese Frare (American), *Pietà*, 1990
offset print, lent by the artist, Seattle

Adi Nes (Israeli, b. 1966), *Untitled*, 1995
chromogenic print, The Israel Museum Collection, Jerusalem, gift of America–Israel Cultural Foundation

Boris Mikhailov (Ukrainian, b. 1938), from the 'Case History' series, 1999
chromogenic print, courtesy of the artist and Pace/MacGill Gallery, New York

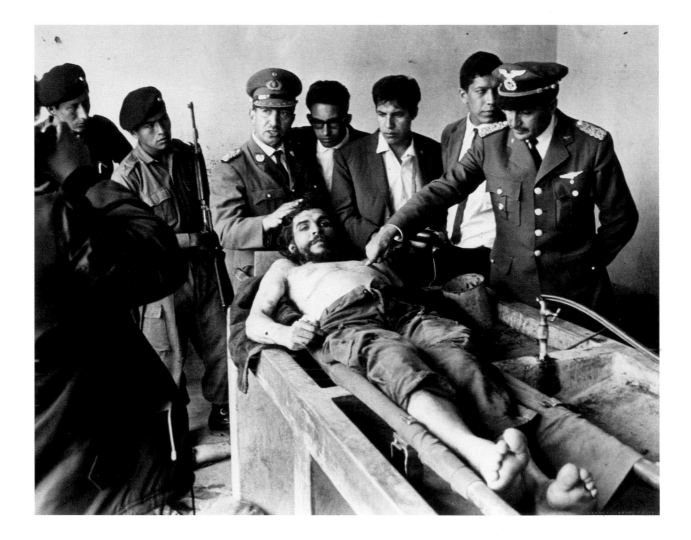

Freddy Alborta (Bolivian, b. 1932), *Che Guevara*, 10 October 1967
gelatin silver print, lent by the artist, La Paz, Bolivia

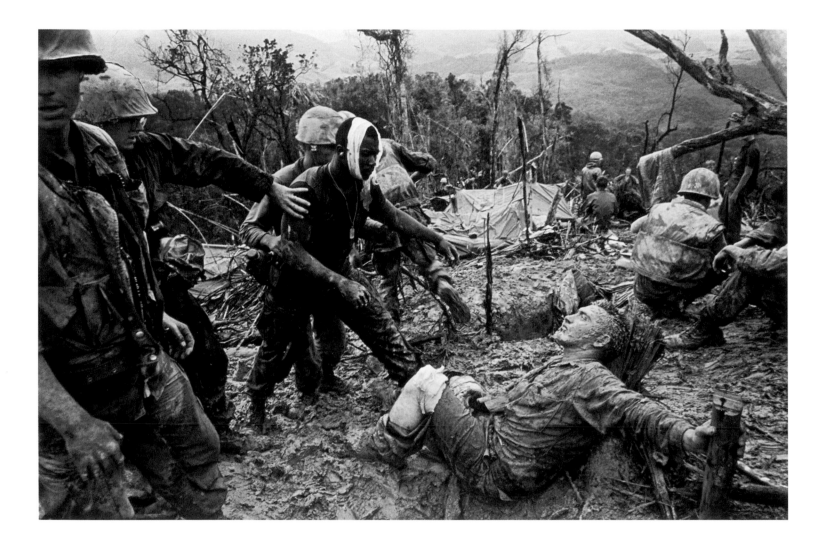

Larry Burrows (English, 1926–1971), *Reaching Out, the DMZ, South Vietnam*, 1966
dye transfer print, Russell Burrows and Laurence Miller Gallery, New York

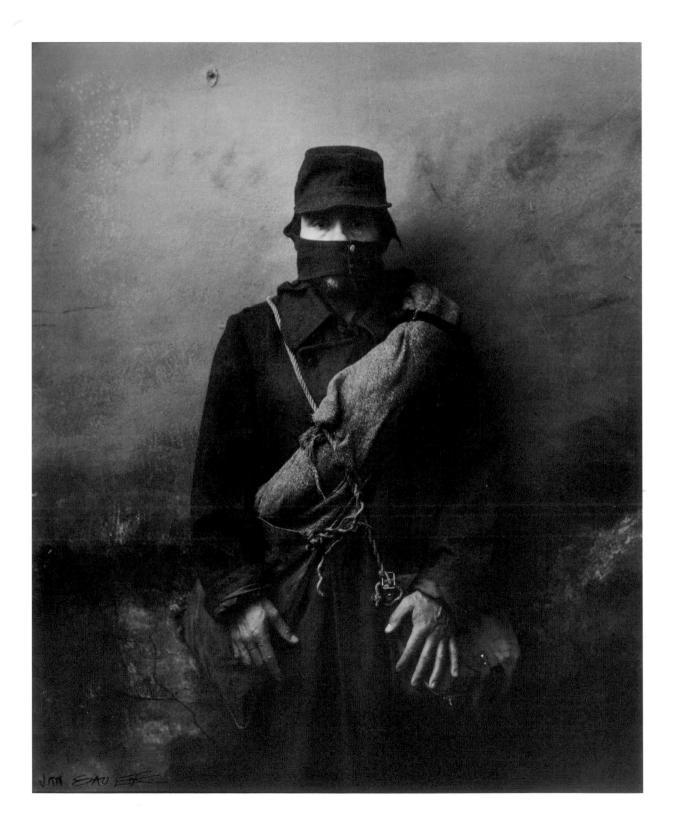

Jan Saudek (Czech, b. 1935), *Target, Death of a Soldier*, 1984/1988
hand-coloured gelatin silver print, The Israel Museum Collection, Jerusalem, gift of Robert Koch, San Francisco

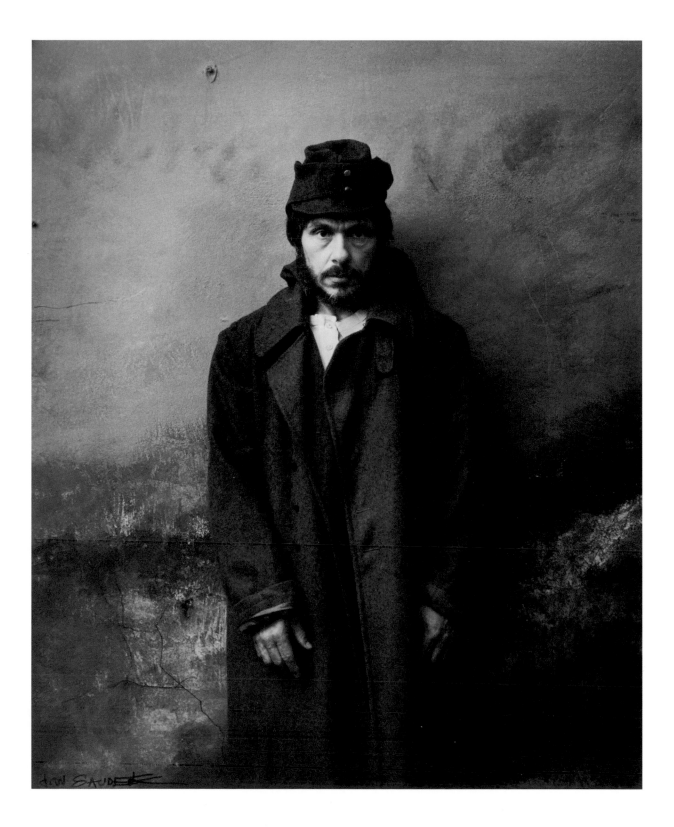

Jan Saudek (Czech, b. 1935), *Target, Death of a Soldier*, 1984/1988
hand-coloured gelatin silver print, The Israel Museum Collection, Jerusalem, gift of Robert Koch, San Francisco

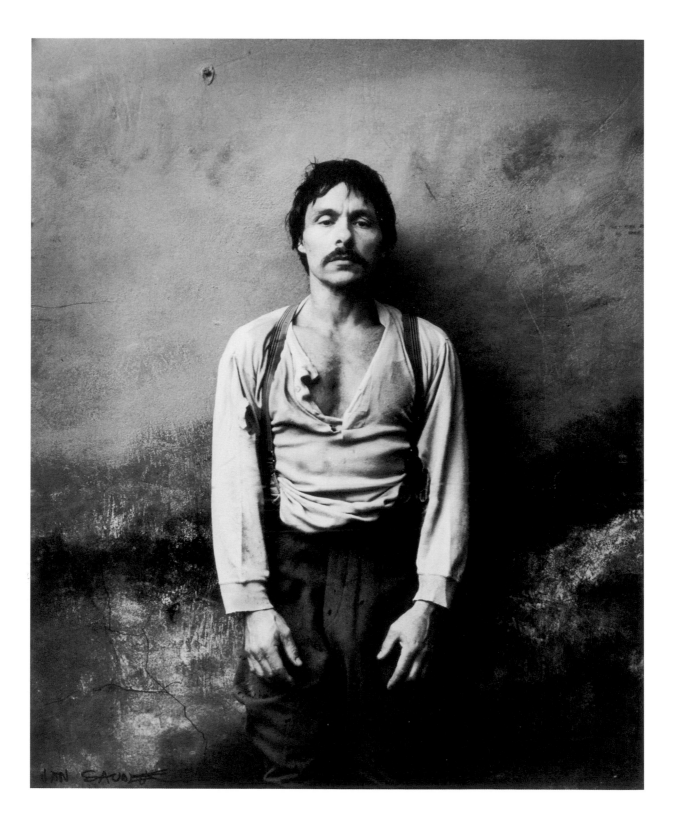

Jan Saudek (Czech, b. 1935), *Target, Death of a Soldier*, 1984/1988
hand-coloured gelatin silver print, The Israel Museum Collection, Jerusalem, gift of Robert Koch, San Francisco

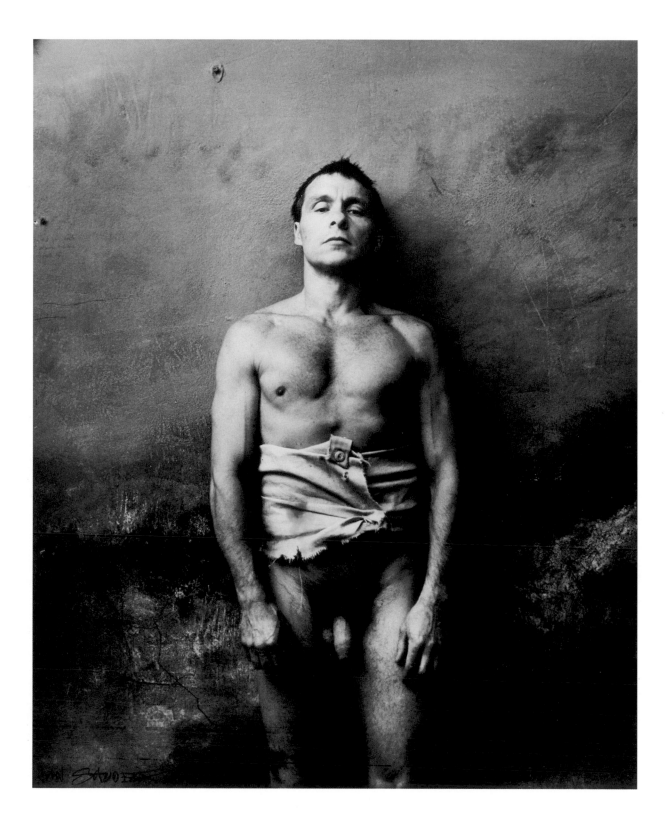

Jan Saudek (Czech, b. 1935), *Target, Death of a Soldier*, 1984/1988
hand-coloured gelatin silver print, The Israel Museum Collection, Jerusalem, gift of Robert Koch, San Francisco

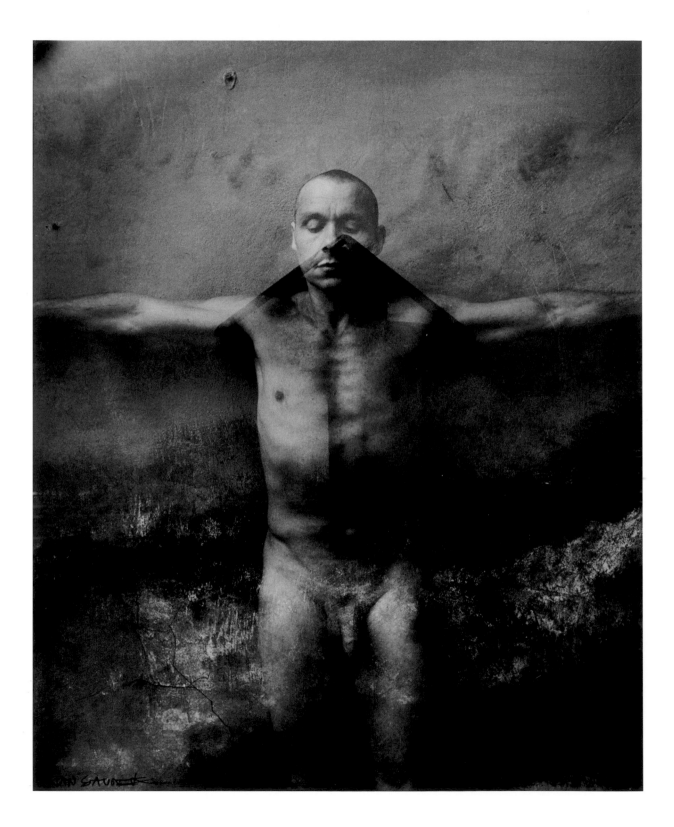

Jan Saudek (Czech, b. 1935), *Target, Death of a Soldier*, 1984/1988
hand-coloured gelatin silver print, The Israel Museum Collection, Jerusalem, gift of Robert Koch, San Francisco

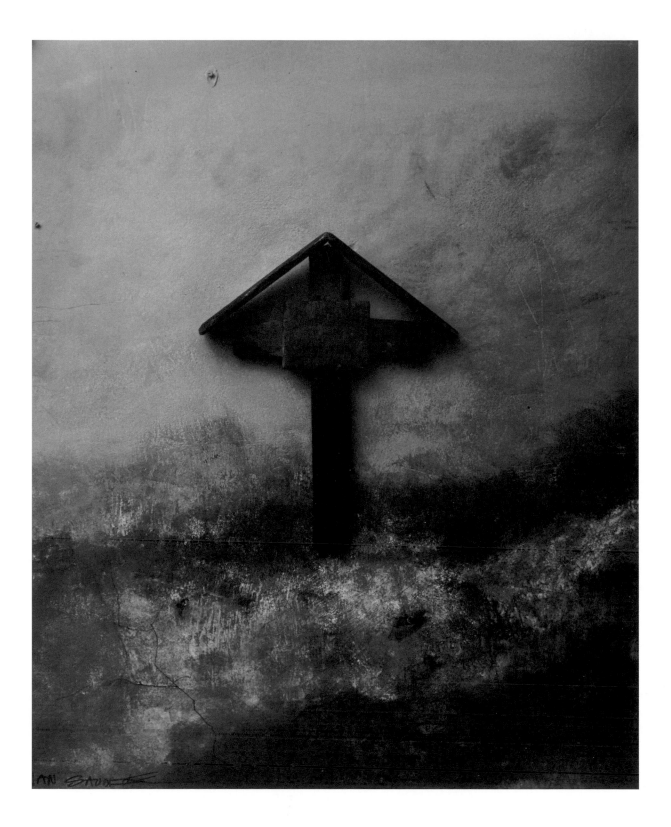

Jan Saudek (Czech, b. 1935), *Target, Death of a Soldier*, 1984/1988
hand-coloured gelatin silver print, The Israel Museum Collection, Jerusalem, gift of Robert Koch, San Francisco

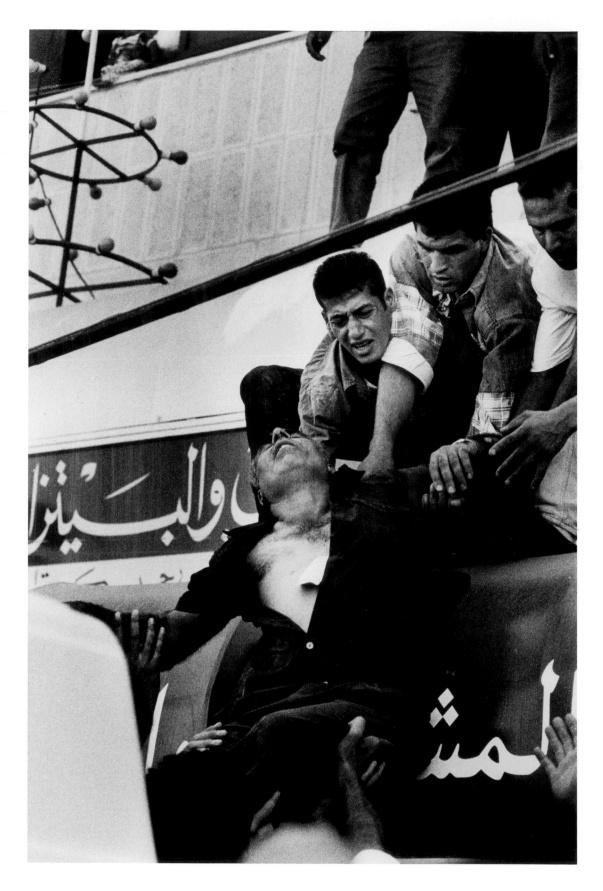

Miki Kratzman (Israeli, b. Argentina, 1959), *Untitled*, 1996
gelatin silver print, lent by Schocken Collection, Tel Aviv

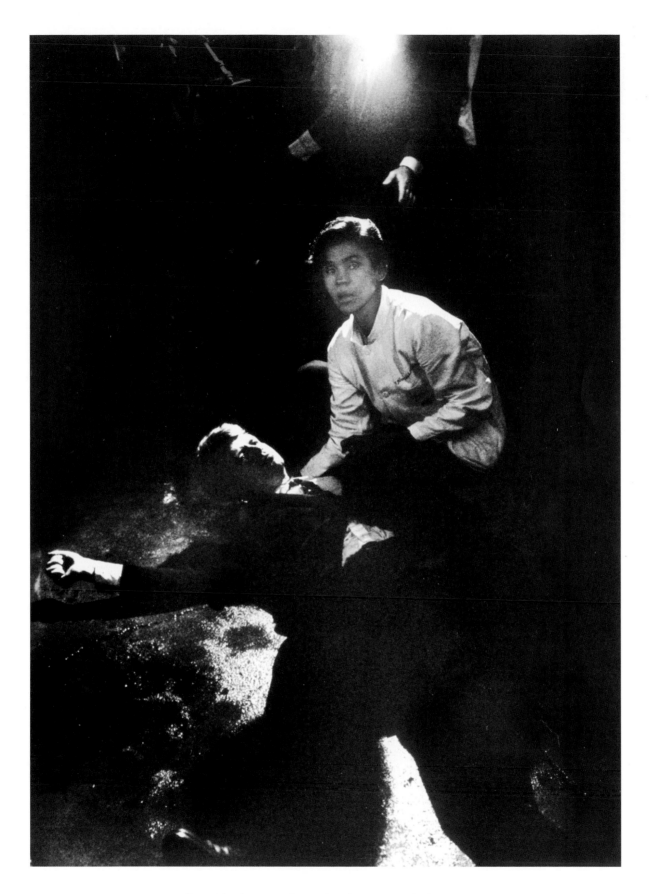

Bill Eppridge (American, b. 1938), *Robert F. Kennedy Shot*, 1968
gelatin silver print, courtesy of Bill Eppridge/TimePix Representing the Life Collection, New York

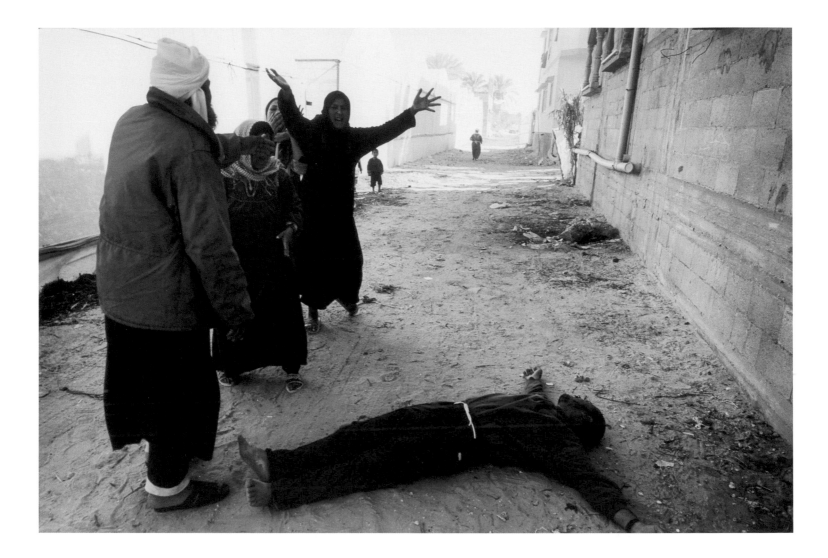

Pavel Wolberg (Israeli, b. Russia, 1966), *Gush Katif*, 2001
chromogenic print, The Israel Museum Collection, Jerusalem, gift of America–Israel Cultural Foundation

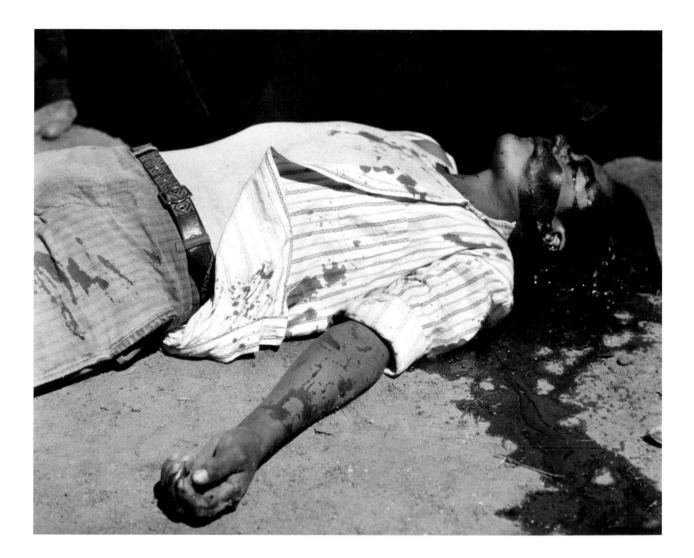

Manuel Alvarez Bravo (Mexican, 1902–2002), *Striking Worker, Murdered*, 1942
gelatin silver print, The Israel Museum Collection, Jerusalem, gift of Martin Pomp, New York, to American Friends of The Israel Museum

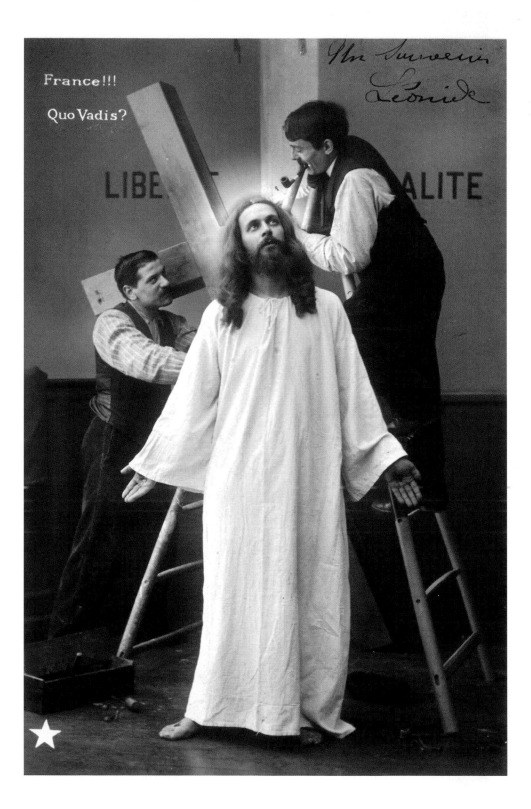

Unidentified, *France!!! Quo Vadis*, 1910 or 1912
gelatin silver print, The Israel Museum Collection, Jerusalem, gift of Gérard Lévy, Paris

Marinus (French), *Hitler/Cross*, c. 1940
gelatin silver print, Gérard Lévy Collection, Paris

John Heartfield (German, 1891–1968), *As in the Middle Ages … So in the Third Reich*, May 1934
photomontage, courtesy of Stiftung Archiv der Akademie der Künste, Berlin

Paul Strand (American, 1890–1976), *Skeleton/Swastika, Connecticut*, c. 1936
gelatin silver print, lent by Gale Anne Hurd, Los Angeles

JESUS ON THE SILVER SCREEN

Adele Reinhartz

Revelation: Representations of Christ in Photography allows us to glimpse Jesus in many diverse guises. The photographic images attempt to bridge two distinct arenas: the Jesus of history and faith, and the needs and desires of humanity in the Modern and Post-modern eras. In doing so, they allow for the interplay of a variety of factors, including the visual tradition, based in large measure upon European art, the individual vision of the artist, and the emotional, intellectual and spiritual responses of the viewer.

These same elements are present in the many portrayals of Jesus in film from the silent era through to the present day. In contrast to most photography, however, film-making is a highly collaborative enterprise. The final product expresses the vision not of a single artist but of the entire team, including producer, director, actors, camera operators, editors and many others. The results are also influenced by numerous external factors, including budget, production codes, formal and informal censorship, and marketing strategies.

The most significant difference between cinematic and photographic depictions of Jesus is the presence of narrative. Photographs, like paintings, will often imply a story, and often prompt their viewers to create a narrative around the images that these pictures present. The genre of film, however, explores the narrative potential of the visual more explicitly, owing to the very basic fact that films provide a sequence of images rather than a single image. This sequence is an ideal vehicle for narrative or story-telling. In the case of the Jesus films, however, film-makers do not invent their narrative. Rather, they must relate to not one but four well-known and venerable works, the Gospels of Matthew, Mark, Luke and John, that constitute the first four books of the New Testament, even if they are prepared to be creative, and inventive, in the ways in which they use the Christian scriptures.

As a result of the contradictions among these four versions of the Jesus story, film-makers must make some important decisions at the outset. One of these involves choice of source text: does the film-maker harmonize or in some other way draw upon all four accounts, or choose a single Gospel as the basis of the film? Most films take the former route. The film versions of Jesus' birth

and infancy, for example, almost always combine Matthew's infancy narrative, in which the magi play a central role, with that of Luke, in which shepherds arrive at the stable to pay homage to the child. The popular Christmas crib scenes therefore show shepherds as well as magi, along with a variety of farm animals, crowded into the stable in which Mary has given birth. Which incidents should be emphasized? As in all film adaptations, Jesus films cannot portray each and every element of their source texts; decisions must be made as to which incidents to omit, whether to add, how to develop the characters, as well as on a broad range of questions regarding visual portrayal. Another crucial decision concerns the visual aspect of Jesus himself. Is he to be the blond-haired, blue-eyed, Nordic-looking Jesus of Western art, or a dark-haired, darker-skinned, more Semitic-looking Jesus who resembles the majority of the contemporary inhabitants of the land in which he lived? It is easy to see that the making of a Jesus film is a daunting task indeed.

Nonetheless, many film-makers have risen to the challenge since the birth of the film industry in the late nineteenth century. This essay will provide a brief introduction to the multitude of Jesus figures that have appeared on the screen, in roughly chronological order.

Silent films

The early silent films about Jesus, such as *From the Manger to the Cross* (1913) and *Christus* (1917), are static and highly episodic. They present a series of intertitles, usually quotations from the Gospels, illustrated by slow-moving tableaux that are in effect devotional paintings come alive. Jesus is invariably a very solemn and majestic figure, dressed in white, bearded, his eyes encircled with black makeup. These films rely on the viewers' prior knowledge of the Gospels or at least of the general outline of Jesus' life, as the tableaux are not connected to one another but simply illustrate the relevant Gospel scenes.

One exception to this general pattern is D.W. Griffith's classic, *Intolerance* (1916). The story of Jesus is one of four narrative threads that are woven together throughout the film in order to illustrate the struggle between tolerance and intolerance through

the ages. The lengthiest and most important of these stories is "The Modern Story", which focuses on the trials and tribulations of "the Boy" and "the Dear One" at the hands of an intolerant, pious and meddling group of powerful women called "the Uplifters". Though brief, "The Judean Story" of Jesus is crucial to the theme of intolerance as a whole. Originally this story was to occupy a considerable portion of the film as a whole. Following strong protests by the Jewish organization B'nai Brith, however, Griffith removed a large number of segments depicting the Jewish leaders as crucifying Jesus. These changes reduced "The Judean Story" to a mere twelve minutes of this three-and-a-half hour opus. On its release, the film included only seven segments of "The Judean Story". Several scenes focus on the wedding at Cana, which, for Griffith, demonstrates Jesus' compassionate tolerance for wine-drinking and merrymaking over against the Pharisees' harsh intolerance of revelry. The remaining segments portray Jesus' crucifixion and draw a direct line from his suffering to that of "the Boy" and "the Dear One" in "The Modern Story".

The most famous Jesus film of the silent period is Cecil B. de Mille's *King of Kings* (1927). In this film the intertitles do not simply quote from scripture or provide background information but convey dialogue and commentary that are often witty and aid considerably in the development of the characters. Two significant differences from most earlier silent films not only contributed to the long popularity of de Mille's film but also blazed the trail for all subsequent Jesus films. First, in contrast to earlier films, *King of Kings* is not merely a series of episodes or tableaux but rather a unified narrative in which events are linked to one another through cause and effect. Secondly, the film does not simply illustrate biblical passages but also creatively expands upon Gospel scenes and characters in ways that often seem remote from the Gospels themselves. One amusing example occurs at the beginning of the film, where Mary Magdalene, a wealthy and scantily clad courtesan, sets off in her chariot, pulled by a team of zebras, to retrieve her lover, Judas, who has deserted her for the company of a carpenter from Nazareth. Mary's life and personality are altered forever when she encounters Jesus. He exorcises her seven demons, as hinted at in Luke 8:1–2, and she instantly becomes a demure, modestly dressed and faithful believer, all thoughts of Judas apparently forgotten.

The Jesus whom we encounter in these silent films is simply an animated version of the stereotypical Jesus – solemn, aloof, European-looking – found in popular Bible illustrations or greetings cards. No doubt one element that contributed to this representation was the fear of offending; another was the limitations of the silent genre itself, which was to pass away soon after de Mille's film was completed.

Epics

The success of de Mille's *King of Kings* was not rivalled for more than three decades, until the height of the biblical epic genre in the 1960s. Two epics have Jesus as their focus: *King of Kings* (1961), directed by Nicholas Ray, and *The Greatest Story Ever Told* (1965), directed by George Stevens. Like de Mille's film, these movies work hard to develop a plausible cause-and-effect narrative that would explain why Jesus died. In the process they also expand upon a variety of secondary characters and plots. Their two Jesus figures, however, are very different from one another. The Jesus of King of Kings, played by Jeffrey Hunter, is youthful and attractive, breaking the mould of solemn Jesus figures and thereby spawning the film's derisive nickname "I was a Teenage Jesus". The star of *The Greatest Story Ever Told* was Max von Sydow, a then unknown European actor, who took Son-of-Man solemnity to new heights. Von Sydow stands out as the most perfectly coiffed Jesus in history of cinema, though with some competition from the Jesus figures of the silent era.

Closely related to the epic genre are a number of films in which the story of Jesus is a secondary plot element rather than the focus of the main narrative. Examples include *The Robe* (1953), *Demetrius and the Gladiators* (1954) and *Barabbas* (1962), which focus on either fictional characters (Demetrius) or those about whom little is known (Barabbas). These films are set primarily in the period after Jesus' death. Jesus appears in flashbacks, mostly in a reverential mode that employs images of popular piety. The flashbacks often accompany the speeches of Peter, who takes on a much larger role in these films than he does in the Jesus films as such. Christian faith and martyrdom are major themes, with emphasis on the spiritual strength of the Christian. This strength is clearly implied by the peace and joy with which Diana and Marcellus, the Christians sent to their deaths in the arena in *The Robe*, face martyrdom in expectation of life everlasting.

The most famous film of this genre, and one of the all-time cinematic classics, is *Ben-Hur* (1959). The main plot of this film traces the conflict between a Jewish prince named Judah Ben-Hur and a high-ranking Roman officer named Messala. In the background, and concurrent with the main plot, is Jesus' own life story and his ability to transform the lives of those who believe in him. The two stories intersect only occasionally, but significantly. Jesus is never seen full face, but only from a distance, very indistinctly, or partially, as when he offers water to the parched and enslaved Ben-Hur. Later, Ben-Hur returns this gesture, when Jesus is on his way to the cross. Not surprisingly, in this film, as in the others of this category, the non-Christian hero sees the light before the final credits roll.

This genre allows for more narrative freedom than do the Jesus movies *per se*, because the films do not have to remain close

to a source text or a well-known set of traditions. Although they do not focus primarily on Jesus' life story, they illustrate the power of the Christian message and posit some sort of immortality or afterlife for Jesus through the impact that he has on people's lives.

Musicals

The year 1973 saw two attempts at a musical Jesus. Both of these films originated as Broadway musical productions. *Jesus Christ Superstar* depicts the staging of a Passion play in the Negev Desert in southern Israel. The most interesting character in the film is Judas, portrayed as a man of colour who invokes the politics of race in his objections to Jesus' behaviour and his popularity. The occasional shots of fighter planes and tanks encouraged an analogy to contemporary conflicts in Israel and Vietnam. The high priests and Pharisees are represented in a disturbing way, as stereotypically sinister Semitic types who unceasingly plot against Jesus. The Superstar himself is a weak and unimposing Jesus who has no clear sense of identity, and who seems overly preoccupied with his own posterity and the fear that his followers will forget all about him. His high-pitched and whiny voice grates on the nerves, as does the fawning of Mary Magdalene who takes care of him body and soul; a sexual relationship is intimated but never made explicit.

The Jesus of *Godspell*, on the other hand, is a winsome clown, brimming with warmth, friendship and ethical maxims. This film makes no attempt to be realistic. The clown Jesus is surrounded by a group of young men and women who frolic with him through the streets, parks and back alleys of a strangely quiet New York City. With the exception of Jesus, the figures in the film are not matched with figures known from the Gospels. The narrative line is very loose. The film sets the texts of the parables and other teachings of Jesus to a wide variety of musical styles. Matthew 23, Jesus' diatribe against the Pharisees, is directed against a big monster, and the events of the Passion can be discerned, but otherwise there is no clear causal development or plot. Nevertheless, the Jesus clown is appealing for his sense of humour and his gentle but compelling message.

Though the music from these two shows is catchy, the musical genre seems somewhat ill-equipped to handle the complexities and drama of the Jesus story. It is therefore not surprising to note that there have been no commercially released Jesus musicals since 1973.

Feature dramas

Most of the Jesus films made from 1966 to the present day have been feature dramas, for release either in cinemas or on television. There are many European contributions to this genre, including Pier Paoli Pasolini's *The Gospel According to Saint Matthew* (1966) and Roberto Rossellini's *The Messiah* (1975). American-produced examples include Franco Zeffirelli's lengthy made-for-TV series called *Jesus of Nazareth* (1977) as well as the iconoclastic *The Last Temptation of Christ* (1988) directed by Martin Scorsese. These films continue some of the trends of the earlier films by attempting to create a plausible narrative based on causality, and by expanding upon characters and incidents in the Gospels themselves. They frequently also invent new scenes and characters as required for either plot or characterization. Each film presents its own distinct Jesus, from the angry and passionate young man drawn by Pasolini, to the compassionate but rather aloof Jesus of Zeffirelli, to the adept carpenter Jesus of Rossellini, and, most dramatically, the tortured and self-questioning Jesus of Scorsese. These more human Jesus figures still convey an aura of reverence but also encourage viewers to identify with them and their experiences.

Two sub-genres of this category can be identified. One consists of animated feature films, and the most recent contribution to this field is *The Miracle Maker* (2000), a British–Russian co-production. The film, which tells the story from the perspective of Jairus' daughter (Mark 5:22–43) is aimed at all age groups and uses many elements of earlier films, particularly Zeffirelli's Jesus of Nazareth. A second, more specific, sub-genre consists of narrative films that, similar to the musical *Jesus Christ Superstar*, portray a group of actors who put on a Passion play. Two superb examples are *Celui Qui Doit Mourir* (*He Who Must Die*) (1956) and *The Master and Margherite* (1972). In both of these, the Passion play serves to identify the main plot as an allegory of Jesus' life, with the characters who act in the Passion play also acting out their respective roles in their own 'real-life' dramas.

The most recent entry into this category is *Jesus of Montreal* (1989). This film portrays a group of actors commissioned by the priest of St Joseph's Oratory in Montreal to refresh the Passion play that has been performed on the church grounds for decades. In the process of preparing and performing the play, the actors themselves take on the personas of the characters in the Gospel story. The result is not only a refreshing account of the Passion of Jesus but also a highly developed allegory in which many of the elements in the frame narrative parallel those of the Gospels. Jesus in this film is one of the most compelling Jesuses to be seen on the screen: he is warm, has a gentle sense of humour, relates well to children, draws out the best in his friends, and sticks quietly but firmly to his principles.

No feature-length narrative Jesus film has appeared in cinemas since *Jesus of Montreal*. The Jesus film genre seems to have migrated successfully from the silver screen to the television screen, and even then primarily in the form of multi-part documentaries. This shift may be evidence of the increased sophistication of both film-makers and audiences, insofar as documentaries allow multiple points of view, and thus provide a more direct forum in which to assess the Jesus of history and the Christ of faith.

Christ-figure Films

The dearth of more recent feature films does not however, signify, the disappearance of Jesus from the silver screen. In fact, there are numerous films in which Jesus is not portrayed directly but is represented symbolically or at times allegorically. Christ figures can be identified either by particular actions that link them with Jesus, such as being crucified symbolically (*Pleasantville*, 1998), walking on water (*The Truman Show*, 1998) or wearing a cross (*Nell*, 1994; *Babette's Feast*, 1987). Indeed, any film that has redemption as a major theme (and this includes many, if not most, recent Hollywood movies) is liable to use some Jesus symbolism in connection with the redemptive hero figure.

A famous example of the Christ-figure film is *Cool Hand Luke* (1967), in which the lead character, played by Paul Newman, lies in classic cruciform position on a table after consuming fifty eggs in the space of an hour, to the amusement of his fellow prisoners. Other cinematic Jesus figures are Chance the Gardener, the main character of Peter Sellers's *Being There* (1979), who speaks in parables and walks on water though he does not quite understand how or why; Andy Dufresne, of *The Shawshank Redemption* (1994), who gathers followers and gives them hope; and, in an entirely different mode, "Neo" (also known as "the One"), hero of *The Matrix* (1999), who is singled out to redeem humankind, and undergoes death and resurrection in the spaceship called Nebuchadnezzar.

One fascinating sub-group in this genre consists of films in which the Christlike characteristics and symbols are associated with the villain. A striking example is Martin Scorsese's 1991 film *Cape Fear*, a remake of an earlier film by that name (1962) directed by J. Lee Thompson. The plot concerns Max Cady, recently released after serving a prison term for assault, who stalks Sam Bowden, the lawyer who had acted as his defence attorney at the trial. Cady is clearly a psychopath, bent on threatening not only Bowden but his wife and daughter and anyone else close to him. Yet he recites the New Testament, has New Testament passages tattooed all over his body, and is even portrayed in cruciform position. The association of Christian texts and symbols with this diabolical figure contributes strongly to the atmosphere of horror and suspense that Scorsese is aiming for.

Christ-figure films explicitly draw a line from Jesus to the present day, intimating that the modern world too has its saviour figures who mediate the divine drama of redemption and deliverance. A connection to the contemporary world is implicit, however, in Jesus films of all genres and all time periods. Indeed, the very existence and popularity of films of the life of Jesus suggests that the Jesus story, in all of its visual and aural expressions, remains significant twenty centuries after the events themselves. In this respect the cinematic Jesus strongly resembles his photographic and other artistic counterparts, as testimony to the power of this set of images to entertain, to disturb, and to speak to humankind throughout the ages.

BIBLIOGRAPHY

Aubenas, Sylvie, 'Les Photographies d'Eugène Delacroix', *Revue de l'art*,
 no. 127/2000–2001, pp. 62–69

Arnheim, Rudolf, *Towards a Psychology of Art*, Berkeley CA and Los Angeles
 (University of California Press) 1966

Audi, Paul, *Crucifixion*, Fougères (Encre Marine) 2001

Barbet, Pierre, *Les Cinq Plaies du Christ*, Paris (Editions Dillen & Cie) 1935

Barthes, Roland, *La Chambre claire*, Paris (Gallimard) 1980

Barzun, Jacques, *The Use and Abuse of Art*, Princeton NJ and London
 (Princeton University Press) 1974

Bataille, Georges, *Théorie de la religion*, Paris (Gallimard) 1973

Berger, John, 'Che Guevara Dead', *Aperture*, III, no. 4, pp. 36–38

Bonzon, Arièle, *Ecrits dans le noir: Chère absente: Fondations/Epiphanie*,
 Lyon (Environ Infini) 1994

Breton, André and Paul Eluard, *L'Immaculée Conception*, Paris
 (Editions Surréalistes) 1930

Buci-Glucksman, Christine, *Orlan: Triomphe du Baroque*, Marseille
 (Images en Manoeuvres Editions) 2000

Burson, Nancy, *Seeing and Believing: The Art of Nancy Burson*, Santa Fe NM
 (Twin Palms Publishers) 2002

Cadava, Eduardo, *Words of Light*, Princeton NJ (Princeton University Press) 1997

Chavot, Pierre and Jean Potin, *L'ABCdaire de Jésus*, Paris (Flammarion) 2000

Clark, Kenneth, *The Nude: A Study in Ideal Form*, Princeton NJ
 (Princeton University Press) 1972

Cohn, Haim, *The Trial and Death of Jesus*, New York (Ktav Publishing House, Inc.) 1977

Crump, James, *F. Holland Day: Suffering the Ideal*, Santa Fe NM
 (Twin Palms Publishers) 1995

Didi-Huberman, Georges, 'The Index of the Absent Wound
 (Monograph on a Stain)', *October*, no. 29, Summer 1994

Ehrens, Susan, *A Poetic Vision: The Photographs of Anne Brigman*,
 Santa Barbara CA (Santa Barbara Museum of Art) 1995

Ferguson, George, *Signs and Symbols in Christian Art*, London, Oxford, New York
 (Oxford University Press) 1977

Flusser, David, *Jesus*, Jerusalem (The Magnes Press) 1998

Flusser, Vilém, *Pour une philosophie de la photographie*, Paris (Circé) 1996

Frantisek Drtikol: fotograf, malir, mystik, Prague (Galerie Rudolfinum) 1998

Frizot, Michel (ed.), *A New History of Photography*, Cologne (Könemann) 1998

Fulton, Marianne (ed.), *Pictorialism into Modernism: The Clarence H. White School
 of Photography*, New York (Rizzoli) 1996

Gernsheim, Helmut, *Creative Photography: Aesthetic Trends 1839–1960*,
 New York (Dover Publications) 1962

Getlein, Frank and Dorothy, *Christianity in Modern Art*, Milwaukee
 (The Bruce Publishing Company) 1961

Hulik, Diana Emery (ed.), *Photography: 1900 to the Present*, Upper Saddle River NJ
 (Prentice Hall) 1998

Janus, Elizabeth (ed.), *Veronica's Revenge: Contemporary Perspectives on
 Photography*, Zurich, Berlin, New York (Scalo) 1998

Junod, Philippe, '(Auto)portrait de l'artiste en Christ', in Erika Billeter (ed.),
 *L'Autoportrait à l'âge de la photographie: Peintres et photographes
 en dialogue avec leur propre image,* Lausanne (Musée Cantonal des
 Beaux-Arts) 1985

Klein, Kelly, *Callway*, New York (Cross) 2000

Koelbl, Herlinde, *Opfer*, Heidelberg (Edition Braus) 1996

Kristeva, Julia, *Au commencement était l'amour: Psychanalyse et foi*,
 Paris (Hachette) 1985

—— *Histoires d'amour*, Paris (Editions Denoël) 1983

Lacan, Ernest, *Esquisses photographiques*, Paris 1856

Mailer, Norman, *The Gospel According to the Son*, New York (Ballantine Books)
 1997

Mamedov, Raoef [Rauf], *Het Laatste Avondmaal*, Aalburg (Pictures Publishers) 1999

Marin, Louis, *De la représentation*, Paris (Gallimard–Le Seuil) 1994

Michaels, Barbara L., *Gertrude Käsebier: The Photographer and her Photographs*,
 New York (Harry N. Abrams) 1992

Miles, Jack, *Christ: A Crisis in the Life of God*, New York (Alfred A. Knopf) 2001

—— *God: A Biography*, New York (Alfred A. Knopf) 1995

Modern Art: A Misrepresentation, Toronto (The Art Gallery at Harbourfront) 1985

Nietzsche, Friedrich, *Beyond Good and Evil*, London (Penguin Books) 1973

—— *Twilight of the Idols/The Anti-Christ*, London (Penguin Books) 1968

O'Reilly, John, *Occupied Territories*, Boston (Howard Yezerski Gallery) 1999

Pelikan, Jaroslav, *The Christian Tradition: A History of the Development of Doctrine:
 Christian Doctrine and Modern Culture (since 1700)*, Chicago and London
 (The University of Chicago Press) 1989

—— *The Illustrated Jesus Through the Centuries*, New Haven CT and London
 (Yale University Press) 1997

—— *Imago Dei: The Byzantine Apologia for Icons*, Princeton NJ
 (Princeton University Press) 1990

—— *Jesus Through the Centuries: His Place in the History of Culture*,
 New Haven CT and London (Yale University Press) 1999

Pessach, Gill (ed.), *Landscape of the Bible: Sacred Scenes in European Master
 Paintings*, Jerusalem (The Israel Museum) 2000

Polizzotti, Mark, *Revolution of the Mind: The Life of André Breton*, New York
 (Farrar, Straus and Giroux) 1995

Ribettes, Jean-Michel and Gérard Wajcman, *Narcisse Blessé*, Paris
 (Passage de Retz) 2000

Rops, Daniel, *De l'amour humain dans la Bible*, Strasbourg and Paris
 (Editions f.-X. Le Roux) 1950

Rouillé, André, *L'Empire de la photographie: 1839–1870*, Paris
 (Le Sycomore) 1982

Russell, Bertrand, *Pourquoi je ne suis pas chrétien*, Paris (J.J. Pauvert) 1960

Le Sacré, Pontault-Combault (Centre Photographique de l'Ile de France) 1991

Saramago, José, *The Gospel According to Jesus Christ*, London (The Harvill Press)
 1993

Scharf, Aaron, *Art and Photography*, New York (Pelican Books) 1975

Spector, Jack J., *Surrealist Art & Writing 1919/39: The Gold of Time*, Cambridge
 (Cambridge University Press) 1977

Steinberg, Leo, *The Sexuality of Christ in Renaissance Art and in Modern Oblivion*,
 Chicago and London (The University of Chicago Press) 1996

—— *Leonardo's Incessant Last Supper*, New York (Zone Books) 2001

Steinberg, Shlomit, 'Mishima and the St Sebastian Syndrome', *Muza Art Quarterly*,
 January 2001 (in Hebrew)

Talvacchia, Bette, *Taking Positions: The Erotic in Renaissance Culture*, Princeton NJ
 (Princeton University Press) 1999

The Image of Christ, London (National Gallery Co.) 2000

The Clandestine Mind: Photographs by John Dugdale, *The Journal of
 Contemporary Photography*, III, 2000

Vasari, Giorgio, *Lives of the Most Eminent Painters, Sculptors and Architects*,
 London (G. Bell and Sons) 1914, II

Vignon, Paul, *Le Linceul du Christ: Etude scientifique*, Paris (Masson & Cie) 1902

von Dewitz, Bodo, 'Bilder – Vortbilder – Leitbilder: Photographie und Wirklichkeit
 im 20. Jahrhundert', *Nachdenken – Vordenken: Evangelische Perspektiven
 zur Jahrhundertwende*, Rheinbach (CMZ) 2001

Webber, F.R., *Church Symbolism,* Detroit (Gale Research Center) 1971

Zoppis, Natale, *Reliquiari*, Tavagnacco (Art&) 1996